Wolfgang Muchitsch (ed.)
Does War Belong in Museums?

Editorial

Das Museum, eine vor über zweihundert Jahren entstandene Institution, ist gegenwärtig ein weltweit expandierendes Erfolgsmodell. Gleichzeitig hat sich ein differenziertes Wissen vom Museum als Schlüsselphänomen der Moderne entwickelt, das sich aus unterschiedlichen Wissenschaftsdisziplinen und aus den Erfahrungen der Museumspraxis speist. Diesem Wissen ist die Edition gewidmet, die die Museumsakademie Joanneum – als Einrichtung eines der ältesten und größten Museen Europas, des Universalmuseum Joanneum in Graz – herausgibt.

Die Reihe wird herausgegeben von Peter Pakesch, Wolfgang Muchitsch und Bettina Habsburg-Lothringen.

WOLFGANG MUCHITSCH (ED.)

Does War Belong in Museums?

The Representation of Violence in Exhibitions

[transcript]

Bibliographic information published by the Deutsche Nationalbibliothek
The Deutsche Nationalbibliothek lists this publication in the Deutsche Natio-
nalbibliografie; detailed bibliographic data are available in the Internet at
http://dnb.d-nb.de

© 2013 transcript Verlag, Bielefeld

Cover layout: Kordula Röckenhaus, Bielefeld
Layout: Sophie Koller
Editing by Sabine Fauland and Sophie Koller
Proofread and Translations by Mark Miscovich
Printed by Majuskel Medienproduktion GmbH, Wetzlar
ISBN 978-3-8376-2306-2

Content

Military History, War Museums and National Identity

Does War Belong in Museums?
The Representation of Violence in Exhibitions

Wolfgang Muchitsch

In 2011, the Universalmuseum Joanneum, Austria's oldest and second largest museum complex, celebrated its 200th anniversary. In preparation of this special event, we decided to dedicate each month of the year 2011 to one of our museums. Thus the focus in September 2011 was on the Landeszeughaus, the Styrian Armoury, considered to be the world's largest historic armoury and one of the most important monuments of Styrian history.

Built by the Styrian Diet between 1642 and 1645, the building was the most important armoury in the south-east of the Habsburg Empire and played a crucial role in the defence of the Austrian frontier provinces of Styria, Carinthia and Carniola against the threat of attack from Ottoman armies and Hungarian anti-Habsburg rebels.

When under the reign of Maria Theresa (1740-1780) the Austrian military administration was reformed and centralized in Vienna, the empress resolved to give up all armouries in the Austrian provinces and in 1749 she proposed to the estates that they relinquish all usable weapons to the war ministry and sell all obsolete arms as scrap metal. The Styrian Diet objected and argued that in addition to its material value, the armoury had symbolic importance, for it was dear to them as a memorial to the history of their country and to the valour of their forefathers. Maria Theresa, not wanting to offend the Styrians unnecessarily and respecting their tradition of defending the frontiers, allowed them to keep the armoury.[1]

Since 1880, the armoury has been open to the public and in 1892 became part of the Styrian State Museum Joanneum, now the Universalmuseum Joanneum. Seeing as the Landeszeughaus itself is a unique historical monument with its historic building and its collection of about 32,000 objects and due to the fact that there is no

1 | See Peter Krenn (1991): »The Landeszeughaus Graz and its Place in History«, in: Peter Krenn/Walter J. Karcheski Jr. (ed.): Imperial Austria. Treasures of Art, Arms and Armor from the State of Styria, Houston: Museum of Fine Arts Houston, p. 20.

space there for temporary exhibitions, we agreed on two special projects for the 200 year anniversary of the Joanneum:

The first project is an art project in public space dealing with the question of Graz as a "bulwark" against the East. An international jury chose the project "The Unknown Knight" by the Turkish artist Nasan Tur.[2]

And, as a second project, we invited the Museum Academy of the Universalmuseum Joanneum as well as ICOMAM, the International Council of Museums and Collections of Arms and Military History to organize a joint international conference on the fundamental question posed in the title of the conference: "Does War Belong in Museums? The Representation of Violence in Exhibitions".

More or less every museum is at one time or another confronted with displaying topics of war and violence. And, in most cases, the presentations of war and violence oscillate between, on the one hand, the fascination of terror and its instruments, and on the other hand the didactic urge to explain violence and, by analyzing it, make it easier to come to terms with or prevent.

When dealing with topics of war and violence, museum professionals have to consider questions such as: What objectives and means are involved when they present war in museums? How can they avoid trivializing or aestheticizing war? How can they avoid, for example, in the case of the Landeszeughaus, transforming violence, injury, death and trauma into main tourist attractions? What images of consternation, shock and horror do they generate? What can they make accessible in terms of understanding the dialectic of friend and foe? Do they frighten off, warn, ponder, shock, emotionally manipulate, compare, historicize and/or promote learning?

The call for papers for this conference was more than successful, receiving more than 80 proposals for papers from colleagues from all over the world, which made it difficult to choose only 17 for reasons of time. Therefore, we would like to apologize to all colleagues whose papers could not be accepted.

The conference started with a most inspiring key-note by the Yale historian Jay Winter, who, on the one hand, gave an overview on the history of war and military museums since the First World War and, on the other hand, stressed one of the main dilemmas of war and military museums, namely that especially those dedicated to the history of the 20th century have to serve as museums as well as memorials at the same time. Winter pointed out that war dominates museum space in representing history, but that all war museums fail to represent war and that they are never politically neutral as the conference showed later on. On the contrary, one has to ask who owns the memory of war. For Winter, war museums are important steps on the map of remembrance, which should avoid the fetishisation and glorification of war. This can be achieved by offering a series of alternative ways of approaching the terror of the battlefield and by changing the gender balance of representations of populations at war. For Jay Winter war museums are sites of contestation and interrogation,

2 | For more details, see the paper of Werner Fenz in this volume.

which should also link their visitors with the numerous sites of memory that the violence of the two world wars and later conflicts have produced around us.

"If War Does Belong to Museums: How?" was the question to which the following speakers responded. Peter Armstrong, director of the Royal Armouries in Leeds, focused on the question of whether a national museum like the Royal Armouries can act as an agent of social change and make a positive impact on individual lives. He highlighted the museum's program of using its collection to work within the communities, especially since the UK's law banning the use of hand guns and the carrying of knives.

Barton C. Hacker gave an overview of the development of the military collections within the Smithsonian Institution and the US and stressed that the military museum exhibitions have undergone a major shift from the 1980s onwards as they began to draw on military social history with its stress on the common soldier, the experience of war and the place of the armed forces in society.

Focusing on the topic of "Displaying War", Gorch Pieken from the newly opened Bundeswehr Museum of Military History in Dresden gave a virtual tour through the largest military history museum and its new extension by the American architect Daniel Libeskind, which tries to break new ground. Full of contrasts and with a Libeskind architectural extension, which is an object in its own right, the museum tries to combine a chronological as well as a thematic approach, using interventions by renowned contemporary artists as well as personal memories and biographies. The multiperspectivity of the permanent exhibition with its branching out into social history and cultural history offers many ways to interpret German military history while focusing on the human being and the anthropological side of violence. On a similar but smaller scale, Ralf Raths from the German Tank Museum in Munster described the dilemma he has been facing. Since 2008 he has been trying to transform a traditional museum that specializes in huge pieces of military equipment and is situated in a town dominated by its military complexes into a more critical contextualization to counteract the strong technical aura and the fetishisation of the objects. The new concept aims to deconstruct convenient myths. It sees the objects as opportunities to not only expand the scope of the historical context, but also to focus on the human experience, a process which has sparked heated debates and criticism from various sides. Christian Ortner from the Heeresgeschichtliches Museum Vienna offered an insight into the changes of the history and the structure of his institution.

Under the title "The Beauty of War and the Attractivity of Violence" more examples of current museum work were provided by Carol Nater from the Museum Altes Zeughaus in Solothurn, who presented the concept for the new permanent exhibition. This was followed by three colleagues from the educational service of the Royal Museum of the Armed Forces and of Military History in Brussels, who in their programs try to explain mainly to children and adolescents that war is not a game. They try to make children ponder and reflect by drawing their attention to the

realities and impacts of war. Per Björn Redkal from the Museum of Cultural History at the University of Oslo presented a temporary exhibition project about weapons as aesthetic objects and the beauty of war, combining fascination, beauty, war and ambiguity. This session ended with Susanne Hageman from Berlin who did a survey of 40 German city museums and how they deal with the Second World War and the destruction of German cities through air raids. The different approaches where illustrated by a "canonical" object: the bomb.

How the trauma of war and violence can be part of the object was illustrated by Robert M. Ehrenreich, whose institution, the United States Holocaust Memorial Museum, is unique in that it is one of the few institutions that focus primarily on noncombatants. Through the use of artefacts that were prized and protected by Jews fleeing the annihilation, the museum tries to effectively transmit the experiences of the Jewish population during the Holocaust. Alexandra Bounia from Cyprus has done a case study on how five war-related museums in the divided South and North Cyprus communities and countries use the perceived objectivity of museums and photography as a means to construct strong narratives within museums to form and reinforce official historical narratives, explain violence as a necessary form of sacrifice and construct a sense of national identity and pride. While the photographs and the events depicted are similar, the messages change according to the accompanying text, the context, the museum's central narrative and visitors' preconceptions. Werner Fenz, former head of the Institute of Art in Public Space in Styria, presented three different projects in Styria, in which contemporary artists had to deal with topics like the Holocaust, the National Socialist regime and Graz as a "bulwark" against the south-east. Similar to Alexandra Bounia's paper on museums in Cyprus, three more examples in the final session "Military History, War Museums and National Identity" showed how war-related museums, especially in countries where the conflict is still fresh and unresolved, can and are being used and misused to create and influence national identity and how museums, like armies, are instruments and means of politics. Kristiane Janeke presented the new Museum of the Great Patriotic War in Minsk/Belarus. This large-scale museum project, planned for 2013, shows the important role the liberation from the National-Socialist occupation as well as the resistance movement play as the founding myth for a new national identity. The final paper by Patrizia Kern showed the outstanding importance of the Turkish War of Independence within the national imaginary, as well as the role of the military within Turkey's society and its cultural politics, taking the Atatürk and War of Independence Museum in Ankara, established in 2002, as a case study.

Summing up, the conference provided a vivid picture of the dilemma of war and military museums to present the unpresentable, to exist within the ambiguity of being museums as well as memorials and the necessity of overcoming their national perspectives. Despite lively discussions, the conference, like a good exhibition, left visitors with more questions than answers.

Introduction

Piet de Gryse

Ladies and gentlemen,
it is my pleasure to welcome you all here in Graz for this thirty second ICOMAM symposium.[1] In 1957, our predecessor, IAMAM, started what has since become a tradition. IAMAM indeed became an official International Committee of ICOM in 2003 and changed its name; the newly constituted ICOMAM perpetuated the tradition. Not bad, for an organization run exclusively by volunteers and representing a network rather than an actual institution! Thirty two congresses, no less: I am so free as to draw your attention to the implications of that figure. It indicates that our association has withstood the test of time, that it has now definitely come of age and that it undoubtedly acquired experience. These thirty two international meetings have, in most cases, led to full-blown publications providing written accounts of the various lectures and papers; some of these proceedings are still available. For the newcomers amongst you I would like to point out that ICOMAM's fiftieth anniversary in 2007 was, amongst other things, celebrated with a rerun of the most successful contributions in a rather luxurious publication.[2]

The importance of these very accessible meetings in our specific field of interest – military and arms history and museology - cannot be stressed enough. They create close links between institutions and between participants, sometimes even evolving into long and warm friendships. The networking facilities provided by these symposiums also have to be taken into account. The primary aim of these conferences is and remains the exchange of research results, the confrontation of ideas and the critical evaluation of what our colleagues are currently working on. With this in mind, these conferences simply have to reach out to and specifically address young researchers, young museum professionals and young academics. Those at the beginning of their

1 | Until 1999 IAMAM organised only triennial meetings, called Congresses, since then the policy has changed and also annual conferences have been introduced. Taking them all together we come up with a total of thirty two conferences and congresses.

2 | ICOMAM 50 (2007): Papers on arms and military history 1957–2007. Edited by R. Smith, Leeds: Basiliscoe Press.

careers often possess a knack for evaluating and approaching our sector with greater open-mindedness and candour. I feel that we should reflect upon ways to motivate young researchers and small institutions to participate in our meetings, especially in these times of financial hardship and budgetary restrictions.

The fact that we assemble in Graz this year is linked to the celebration of another respectable and important jubilee. In 1811, that is to say, 200 years ago, Archduke Johann of Austria, brother of Austrian Emperor Franz I, founded, in collaboration with the Styrian estates, the Styrian State Museum Joanneum here in this town. He saw this as an "inner Austrian national museum" with an extremely varied collection encompassing art, nature, industry, technology and practically all of human activity. The museum was to "bring these things to life so it would make learning easier and stimulate a thirst for knowledge"[3]. After several reorganizations, the Universalmuseum Joanneum grew into the largest of its kind in Central Europe, housing more than 4.5 million objects covering the fields of natural history, art, technology and folk culture. The Landeszeughaus, the famous Graz armoury, well known to all weapons historians for its extraordinary collection presented in an exceptional setting, is, of course, older than the Joanneum. The armoury dates back to the middle of the 17th century, when it was constructed to defend the borders against Turkish attacks. However, by the middle of the 19th century, the armoury was incorporated into the Joanneum and thus also plays an active role in the activities organized for this quite festive year.

On behalf of all those present here today and on behalf of the entire ICOMAM family, I would like to congratulate the organizers and especially director Dr. Muchitsch and his team on this special anniversary and this remarkable event. Moreover, I would like to thank him most heartily for presenting ICOMAM with the opportunity of joining in the celebrations organized for this bicentennial. It is both an honour and a pleasure to learn that this conference is on the list of official activities set up by the Joanneum. It is also an honour and a pleasure to spend a few days in this lovely and friendly Graz, to take time to discuss and debate and to discover the many faces of the Joanneum, with the Landeszeughaus as a magnet for all those interested in old weapons and armour. Thank you.

The global theme for this meeting is certainly both inspiring and intriguing. "Does war belong in museums?" It is an open-ended question with a strong philosophical undercurrent, but the subtitle "the representation of violence in exhibitions" definitely paves part of the way. ICOMAM has already taken an interest in exhibition arts and techniques on several occasions in the past, but then tended to focus more specifically on technical matters or actual internal and external transformation processes encountered when refurbishing old museum galleries or old-fashioned presentations. There is one notable exception, although that workshop cannot really be

3 | Quoted from the website of the Universalmuseum Joanneum: http://www.museum-joanneum.at/en/joanneum/about-the-joanneum

categorized as a pure IAMAM/ICOMAM activity. Indeed, when the former Director of the Legermuseum in Delft, Jan Buijse, retired in 2002, his museum organised a small symposium with the intriguing title "Presenting the Unpresentable. Renewed Presentations in Museums of Military History". The Legermuseum wanted to open a reflection and a debate on how to think about and deal with the processes of re-building and renewing old-fashioned military museums. The Legermuseum there-fore invited six directors and staff members of international military museums who had already gone through renewal. Some fundamental and critical questions were put forward. Is there still a need for military museums? What about and how to pres-ent the "darker" pages in our national (military) history? How to incorporate more history into military museums?[4] The last question obviously illustrated the (frus-trating?) fact that a lot of these old-fashioned military museums were pure object-museums in which war was often reduced to a pure "Materialschlacht" without any human interaction or activity. We will learn more about this soon, as it is the topic of a lecture questioning and explaining how a military museum had for many years been able to speak about war while keeping war completely out of the museum, not in spite of the objects shown, but actually because of them.

The theme of the present conference probes much deeper and is more up to date than ever. What about the phenomenon of war in arms and armour museums and other military museums? How do we deal with violence, with conflict? What about the aggression and exploitation so often linked to war? How can we present an atrocity such as war in an acceptable way and in what kind of a setting, and finally in what kind of museum?[5] For people who have gone through a war, the experience proves extremely traumatic and painful. It has left ineradicable scars. Therefore, war is considered as something to be avoided at all costs, as it invariably leads to human drama, economic upheaval (we will not consider the armament industry) and social

4 | Presenting the Unpresentable. Renewed Presentations in Museums of Military History, Delft: Legermuseum, 2002. The six speakers were L. Milner of the Imperial War Museum (London), P. Lefèvre of the Museum of the Armed Forces and of Military History (Brussels), T. Scheerer of the German Army Museum (Dresden), J. Engström of the Army Museum (Stockholm), P. Sigmond of the Rijksmuseum (Amsterdam) and G. Wilson of the Royal Armouries (Leeds).

5 | It is not the first time that a reflection on violence in museums has taken place. By way of example: C. Creig Crysler (2006): »Violence and Empathy: National Museums and the Spectacle of Society«, in: Traditional Dwellings and Settlements Review, Vol. XVII, no. II, pp. 19–38. In his article the author compares the United States Holocaust Memorial Museum in Washington D.C. with the Apartheid Museum in Johannesburg, South Africa and the new World Trade Center Memorial Museum in New York. While dealing with different historical contexts, these institutions seek to embody models of tolerant national citizenship in their visitors by immersing them in narratives of collective violence, death and ultimately, national rebirth.

regression. War is synonymous with death, poverty and destruction. But war also gives people the opportunity to rise above themselves. Sacrifice, courage and heroism are also an integral part of the story of war. This makes me say that yes, war indeed has its place in a museum. There is of course no single right and final answer on how to present violence and war in museums. The museums and the collections we represent are so diverse as are our origin, history and mission statements.[6]

The representation of violence and war situations in showcases and dioramas nevertheless remains extremely risky. The various informative and explanatory texts make clear that there is an unbridgeable gap between the *real* past and the *reconstructed* past as it is presented in a museum. Time and again it becomes apparent that it is extremely difficult to reconcile past and present. Rendering the past is and always will be ambivalent. One only has to consider the dangers inherent in the aesthetic presentation of war, and, by extension, of the past. Bringing *war* to *life* in a museum (even this can be interpreted in various ways) implies striking a fragile balance between aesthetics and historically accurate representations. No one will blame a curator for selecting an aesthetically pleasing set-up. Of course, the curator wants a nice and attractive place - but the visitor might very well start confusing the aestheticism of the display with an inaccurate view of the past. Aesthetics can lead to wrong conclusions. A fiercely business-like approach (that is, one presenting weapons as purely utilitarian or technical objects, or one that looks at them through the eyes of an engineer) can, however, also lead to these false conclusions. In that way, a streamlined technical presentation can erase the feelings of the past and its sensations, a situation much too common in military museums.

However, and this is perhaps comforting, military museums are not the only ones faced with this double-edged situation. A few years ago, the sociologist of arts and culture, Pascal Gielen, wrote a very interesting book about the presentation, the dangers and the pitfalls of cultural heritage.[7] The book neatly ties in with our central theme today. Through different examples, the author demonstrates the dangers of museum displays steeped in nostalgia. Folklore museums are particularly prone to this danger, although museums concerned with agriculture, industrial and economic activities or ethnography are also more or less confronted with the same issue. We all have to avoid over-simplified presentations, because these invariably lead to an overly romanticized image of the past. Gielen cites the example of the representation of a late 19th century schoolroom with its blackboard and children quietly sitting

6 | See also C. Mardini, What kind of museum for the city of Beirut? s.l.n.d.

7 | Pascal Gielen (2007): De Onbereikbare Binnenkant van het Verleden. Over de Enscenering van het Culturele Erfgoed. Leuven: Lannoo Campus. P. Gielen (1970) is the director of the research center "Arts in Society" at the Groningen University where he is an associate professor of the sociology of art. He also leads the research group and book series 'Arts in Society' (Fontys College for the Arts, Tilburg). Gielen has written several books on contemporary art, cultural heritage and cultural politics.

on their benches. This scene could easily lead visitors to believe that life at that time used to be simple and peaceful and could make them forget that that same era was characterized by widespread child labour where learning and going to school were reserved for the happy few, to the economically and sociologically better-off classes. The example shows the dangers of an involuntary romanticizing of the past through museum displays. Museum presentations have to strike a careful balance: the less enjoyable sides of history also have to be put on display, even if this disturbs the romantic and nostalgic images some people love to cultivate. I would like to refer to Pascal Gielen one last time: He also talks about the "unattainable inside of the past", and especially about how difficult it is to touch the soul of the past in museum presentations. Even re-enactment, which, when it is done well, confronts us with a real-life experience, runs the risk of excessive nostalgia and aestheticism, thus losing touch with the past. This highlights an interesting paradox inherent to each and every well-established museum set-up. An accurate historic framework referring to basic facts, with historic and social contextualisation, is of the essence if only to put the presentation in perspective and to stress that a museum presentation will always be and remain an interpretation. It will always be a contemporary view of the past, a few steps removed from true facts and actual history.

I will limit myself to these few observations for now. Nevertheless, I hope that I have been able to awaken your curiosity. Just like you, I eagerly await the lecture by the eminent guest speaker, Prof. Jay Winter, who is famous for his innovative research into the First World War. Considering his experience as co-producer, co-writer and chief historian for, amongst others, the successful television documentary about the First World War, *The Great War and the Shaping of the 20th Century*, he is undoubtedly the person *par excellence* to explain how to reach out to or get in touch with the unattainable inside of history. I look forward to hearing his views on how and why to introduce war in museums.

I wish you an exciting and interesting few days and look forward to all that is to come.

As ICOMAM chairman, I now officially declare this symposium open.

Piet de Gryse
ICOMAM Chairman

DOES WAR BELONG IN MUSEUMS?

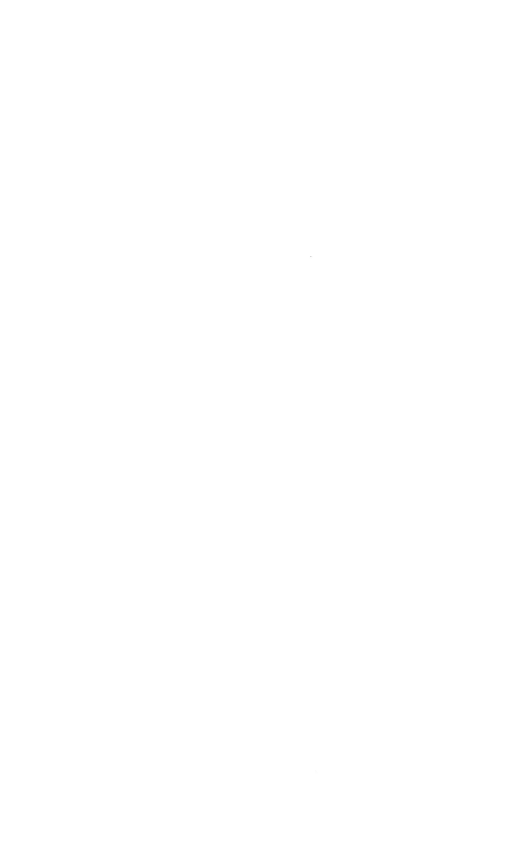

Museums and the Representation of War

Jay Winter

1. War Museums: Semi-Sacred Sites

The following will begin by considering how war museums are constructed, will then turn to a survey of the constellation of war museums in various parts of the world, which have been up and running for considerable time, and finally will pose some questions about the dangers and pitfalls that lie in the path of anyone working in the museum world.

Let us begin by considering the example of the Auckland, New Zealand War Memorial Museum. Shortly after the Armistice, the City Council took a decision to transform an already existing Municipal Museum, opened in 1856 to display the history, flora and fauna of the North Island, into a war memorial museum. It was to honor the 129,000 men who joined up in New Zealand and the 16,000 who died on active service. A design competition took place in 1920. The winners were a team of three disabled veterans who met while recuperating from their wounds in Gallipoli and northern France. As far as it is known, this is the only war museum designed and built by disabled veterans.[1] The museum opened in 1929, and is a thriving institution today.

It is not the image of the museum itself that is important, but a caricature which described the early days of the project. (Figure 1) The title of the caricature from the Auckland Star is: "Selected design for a memorial by our infant prodigy" – that is, the cartoonist, not the architects. It appeared on 18 September 1920, just before the winners were announced.

At the top left, the sketch of the disappointed architect committing suicide by jumping off the roof of a sketch of the museum, a bit of Borgesian humor or rather an anticipation of post-modernism in miniature. Below that image is the caption: "Statue of prominent citizen to be changed every week". Third, smack in the middle

1 | Auckland War Memorial Museum Archives, Museum design and competition, 1920–21.

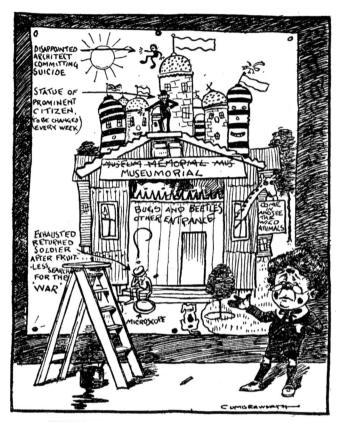

SUGGESTED DESIGN FOR MEMORIAL, BY OUR
INFANT PRODIGY.
(Submitted with no apologies to the Architects' Association.)

*Figure 1: F. H. Cumberworth, published in "Auckland Star", 18 September 1920
courtesy of the Alexander Turnbull Library, Wellington, New Zealand.*

of the building, on the lintel over the entrance, there are three crossed-out names for
the proposed museum: first jettisoned is museum; then memorial; then a fragment
MUS, before the triumphant name appears: MUSEOMEMORIAL. This bit of non-
sense captured a very serious matter: what is war doing in a museum? Shouldn't war
be marked in a memorial? Where does the profane stop (MUSEO) and the sacred
begin (MEMORIAL)?

Secondly, the cartoon addresses another headache. War museums are capital
projects, and thus inevitably enter the realm of urban, regional and national politics
on the one hand, and business, on the other. They are also sacred sites, and hence not
quite museums in the sense of collecting and displaying interesting objects; hence
the hemming and hawing about a title, which winds up as a hybrid impossibility.

It is also worth mentioning that the name war memorial museum in Auckland is a clear precedent for the choice of the name of the Holocaust memorial museum in Washington, DC, and reflects the same mixture of the sacred and the profane in the thinking of the planners. But let us not pretend the profane is not there: notables have to be mobilized; money has to be raised; designs chosen; contracts tendered and signed; and when (inevitably) more money is needed, public support must be rallied again. All this happened in the ten years it took to build the Auckland war memorial museum. When the cash ran out, a public subscription was launched to pay for the Cenotaph standing in front of the entrance.

There are further mundane and entirely profane questions which this cartoon poses. Further down, we see comments on the other two elements of building a war museum: the twin tasks of selecting and displaying representative objects and images, and the unavoidable objective of attracting the public to come into it. "Come in and see the wild animals" is one pitch on the right, near a giraffe; "Bugs and beetles – other entrance", is the sign over the entry. And seated, towards the bottom of the cartoon, in front of an extra large microscope, useful in searching for work, is an "Exhausted returned soldier after fruitless search for the war".

Of particular interest is the figure of the returned soldier who, presumably after viewing the museum, is prostrate from the sheer effort to find traces of the war, whatever that means. Here we confront a series of dilemmas about how to represent war, about what is necessary to illustrate armed conflict, and what is left out of such representations. Should it be a place soldiers approve of? What should be done if they don't approve? Do they have a veto on representations of 'their war'? Second World War veterans did just that in the United States, when in 1995, they forced the director of the National Air and Space Museum in Washington to tear up one representation of the Enola Gay, the airplane which bombed Hiroshima, and provide another. Who owns the memory of war?

In a nutshell, this one droll cartoon goes directly to the fact that war museums entail choices of appropriate symbols and representative objects, arrayed in such a manner as to avoid controversy especially among veterans, to hold the public's attention and to invite sufficient numbers of visitors to come so that the bills can be paid. Aesthetic choices, matters of selection, and designating pathways for visitors to trace the history of war are all part of the operation of creating a war museum. If visitors wind up, as the returned soldier in the cartoon says, incapable of finding the war in the museum, then it will not appeal to him and most likely will not appeal to others.

And yet, one fundamental conclusion anyone who has ever worked in a war museum knows in his entrails; it is that all war museums fail to represent 'the war', because there was then and is now no consensus as to what constituted the war, *wie es eigentlich gewesen war* – as it actually was. In this sense, war museums are like cloud chambers in particle physics; they represent the traces and trajectories of collisions that happened a long time ago. They never describe war; they only tell us about its footprints on the map of our lives.

Many of those footprints lead us back to the battlefields on which men fought and the cemeteries where the casualties lie. That is why they describe a kind of semi-sacred space, a memorial museum. In France, there is a project that adds a third element to the mix: the museum is called the Historial de la grande guerre, a historical, memorial museum of the Great War. This neologism suggests the field of force between history and memory which surrounds the subject of war and the need to respect the multiple registers of emotion touched on by representations of war. War museums are about real events they can never adequately describe, not because the designers are limited, but because the subject bursts through the limits of any conventional set of parameters to control it. If a war museum shows or suggests the protean nature of war, its tendency to escape from human comprehension and human control, then it will have done well. If it acts as a site of interrogation, forcing visitors to ask the question: is it possible to represent war, it will put off some viewers, but it will capture the curiosity of others. And if a war museum acts as a kind of cultural compass, pointing to other sites and other traces of war on our landscape, then it has a chance of becoming a permanent element in the memory boom of our own times.

War belongs in a museum because they have a semi-sacred aura. They are the repositories of the stories we tell ourselves about who we are and how we have come to be who and where we are. In light of the fading of the conventional churches in many parts of the world to retain its previously central place in our moral lives, where else can we find a venue for posing difficult moral questions concerning war? Museums are places where we pose questions the liturgy and the clergy no longer reach.

2. WAR MUSEUMS OF THE TWO WORLD WARS

Now after considering the social and moral function of war museums, let's take a quick tour of some of them. All we need to do is to look around in order to appreciate that there were war museums well before the age of total war, but it was the 1914–18 and 1939–45 conflicts that spread them worldwide. Alongside cemeteries, war museums sprang up while the conflict was still ongoing. In 1917, an Imperial War Museum was established, settling a decade later in a home in Lambeth for the collection and preservation for posterity of the ephemera of war, ranging from weapons to correspondence. Ironically, the museum was located on the grounds of the former Bedlam lunatic asylum.[2] In France, a similar wartime initiative to preserve traces of the Great War produced one of the great libraries and archives still in use today, the Bibliothèque du documentation internationale contemporaine in the University of

2 | Gaynor Kavanagh (1988): »Museum as memorial: The origins of the Imperial War Museum«, in: Journal of Contemporary History, XXIII, pp. 77–97; Alan Borg (1991): War Memorials: From antiquity to the present, London: Leo Cooper, p. 140; Charles Ffoulkes (1939): Arms and the Tower, London: John Murray.

Paris – X, Nanterre. The Australians established a War Museum (now the Australian War Memorial) in October 1917. Soldiers were invited to submit objects for display. Ken Inglis reports one Digger's reply: "The GOC recently made a request for articles to be sent to the Australian War Museum, especially those illustrating the terrible weapons that have been used against the troops in the war. Why not get all the Military Police photographed for the Museum?"[3]

It took another 25 years before the Australian War Memorial opened in the nation's capital, Canberra. Charles Bean, the official Australian war historian, had been with ANZAC troops at Gallipoli and in France. He directed the construction and design of the museum, which was the national war memorial as well. The main building was designed in the form of Hagia Sofia, and extended walls, now pointing to the Australian parliament, list all the names of the men who died in the two world wars. In the museum there are dioramas, or scale models of battlefields in Gallipoli, Palestine and Germany. These carefully constructed installations were powerful and accurate renderings of the physical landscape of battle, showing dead and wounded men on both sides.

Referring to the Auckland War Memorial Museum again, this war museum differs in one important respect from the Australian War Memorial in Canberra. The Auckland museum is the property of the Home Office, whereas the Canberra museum is run and maintained by the Ministry of Veterans' Affairs. The difference is palpable, in that the Auckland museum has a large space recounting the history of the Maori wars, whereas the Australian War Memorial has no trace whatsoever of the long campaign of racial violence against aborigines which has accompanied the whole of Australian history, since white settlement began in the eighteenth century. The Australian War Memorial is a sacred site, telling a sacred story, without the blemishes which a full account of the history of warfare in Australia would necessarily introduce. The Auckland museum is a sacred site too, but it is one which acknowledges a brutal past in explicit ways. Could this openness be both a cause and an effect of the greater degree of integration of New Zealanders of color into their society as compared to the Australian experience? It would seem so. War museums matter.

The Auckland and Canberra museums show clearly that war museums were always to some degree also war memorials, but the balance between honoring the dead and displaying objects representing war was different in every case. The private initiative of a German industrialist, Richard Franck, led to the creation of the Kriegsbibliothek (now the Bibliothek für Zeitgeschichte) in Stuttgart.[4] The Director of the Historical Museum in Frankfurt was responsible for yet another German collection

3 | Aussie, 16 February 1918, as cited in Ken Inglis (1985): »A sacred place: The making of the Australian War Memorial«, in: War & Society, III, 2, p. 100.

4 | R. Frank: Eine Bitte. Mitteilungen von Ihrer Firma und Ihren Kollegen, 13 November 1915.

of documentation and ephemera related to the Great War.[5] The Cambridge University Library invited readers and dealers to send in for preservation printed books and pamphlets on the war; these are now held in the form of the Cambridge War Collection.[6] Similar efforts produced a war collection in the New York Public Library. The Canadian War Museum was formally established in 1942, and houses both archives and objects related to Canada's war experience.

War museums were intended to be tributes to the men and women who endured the tests of war. They have little room for recording the history of anti-war movements, and in their presentation of weapons and battlefield scenes, they do tend to sanitize war. In the first decades after the Armistice of 1918, the fear of offending those still in mourning established codes of selection of 'appropriate' representations of war. War museums are never politically neutral.

After the war, the bellicose character of some collections was criticized powerfully by the pacifist activist Ernst Friedrich, who set up an Anti-war Museum in Berlin in 1924. Its collection of documents and gruesome photographs showed everything the official collections omitted. By displays of savage images of the brutality of men at war, Friedrich pointed out graphically the selectivity of war museums, and their unstated but powerful censorship of disturbing images of war.[7] It is hardly surprising that the museum was destroyed when the Nazis came to power. In 1982, Friedrich's grandson re-opened the museum in Berlin.

Second World War museums by and large followed the example of Great War museums. The note they struck was one of gratitude for the service and sacrifice of the men of all ranks who together defeated the Axis powers. There was an unstated rule of decorum in representation, ruling out ugly or shocking images; when bodies were represented, they were intact. Many place guns or airplanes at the center of their exhibition space, which remain attractive to large numbers of visitors, especially schoolchildren.

Museums of the Second World War were built in part to provide orientation to visitors to the battlefields. For example, it is possible to follow museums from London to Paris as a way of retracing the invasion of Europe on D-Day, 6 June 1944, and the subsequent liberation of Europe, leading to VE (Victory in Europe) day on 8 May 1945. Here museums function as stations on a pilgrimage to sacred sites. In London's Imperial War Museum, part of the ground-floor permanent exhibition is known as the Blitz experience, opened in 1990, alongside the Trench experience referring to

5 | Detlef Hoffmann (1976): »Die Weltkriegssammlung des Historischen Museums Frankfurt«, in: Ein Krieg wird ausgestellt. Die Weltkriegssammlung des Historischen Museums (1914–1918). Themen einer Ausstellung. Inventarkatalog, Frankfurt: n.p.

6 | This collection is now available on microfilm from Adam Matthew Publications, Marlborough, Wiltshire.

7 | Ernst Friedrich (1987): War against war!, Seattle: The Real Comet Press.

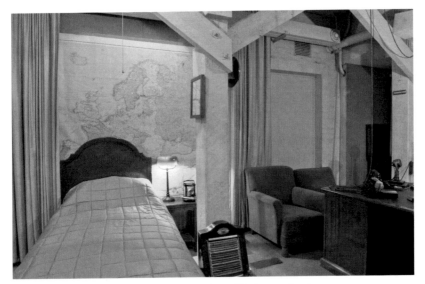

Figure 2: Churchill's underground bedroom, Cabinet War Rooms, London
© *Imperial War Museum, London.*

the First World War.[8] This display ushers visitors into a dark space in which they see and hear a re-enactment of the aerial bombardment of London in 1940-41, replete with admonitions from a museum guide, with an appropriate Cockney accent, about the need to watch out for falling debris. He invites visitors to serve as volunteers to provide tea for emergency workers and displaced Londoners. A few miles away, the Imperial War Museum has preserved the underground offices used by Winston Churchill and his staff during the bombardment. (Figure 2) Further to the east, on the River Thames, HMS Belfast is a floating museum, permanently moored, a place in which visitors can stroll around one of the warships which bombarded the Normandy coast on D-Day.

An hour north of London, pilgrims can visit two important Second World War sites. The Imperial War Museum houses at Duxford near Cambridge many aircraft which took part in the Battle of Britain. A few miles away is the American war cemetery at Madingley, in which are buried many of the men who flew these planes and who died in the war.

A half hour's drive to the west, we can visit a museum run by a private trust at Bletchley Park. This museum recounts the successful effort there to break the German codes guarding privileged communications from Hitler to his German High Command and from commanders to their men on land, sea and air. There visitors can see the devices built to decipher the Enigma machines, encoding devices which

8 | Dan Todman (2005): The Great War: Myth and Memory, London: Hambledon, pp. 216–17.

used a system of from three to twelve rotors set randomly every day, and which were considered by the German High Command to be unbreakable at the time. British intelligence had some of the machines, and set about reversing the order of encoding, in effect taking the coded messages step by step backwards in order to find the original message in German. The key was to find the rotor settings used in each message. A team of British, Polish and American code breakers broke the code, in part through the construction of Colossus, one of the first computers, now in part on display in the museum. Astoundingly, Winston Churchill had Hitler's battle orders on his desk a day after they had been radioed in code to his troops, and the Nazis never knew it. The heroes in this secret war were civilians, including the great British mathematician Alan Turing, whose work helped save many lives, in particular those of seamen in the North Atlantic convoys keeping the supply lines open. Convoys knew where U-boat packs were and when and where they were going to attack. To a degree, the outcome of the Battle of the Atlantic turned on this secret war, the story of which is set out in this museum.

Pilgrims can then proceed south to Southwick House, near Winchester. This was Supreme Allied Headquarters at the moment the decision to proceed with the invasion was made by General Eisenhower. The map of southern England and Normandy used at this critical juncture by the high command has been preserved and restored to the wall on which it hung at the time. (Figure 3) In Portsmouth, there is a D-Day museum, which includes the Overlord Embroidery, a direct descendent of

Figure 3: Map Room, Southwick House © Royal Military Police Museum, Chris Lowery.

the famous Bayeux tapestry on the other side of the English Channel. This modern-day embroidery tells the story of the Normandy landings in comic-book form.

Following the landing on the Normandy coast at D-Day is made easier for visitors by a number of museums located at key points in France. There is a Paratroopers' Museum at Sainte Mère Eglise, where the 82nd and 101st American Airborne Divisions landed on the night preceding the landing, to protect the flanks of the invaders and prevent German reinforcements from arriving on the scene. There is a museum adjacent to Utah Beach, as well as a Battle of Normandy museum in Bayeux. At Arromanches in the British sector of the landing, there is a Musée du Débarquement, showing the engineering feats surrounding the construction of 'Mulberry harbours', vast floating docks, constructed piecemeal in Britain, floated across the English Channel, and sunk in place to provide a site to offload troops and supplies from D-Day + 1 on. A second such harbor was put in place in the American sector of the beachhead, but it was destroyed in a powerful storm in mid-June 1944. Vast rusting metal structures, links in the installation that once formed this man-made harbor, still lie just on the beach and just off the coast, monuments in their own right. (Figure 4)

The point of this particular trajectory is to highlight the military character of most museums and exhibitions associated with the Second World War. There are many similar museums in other countries and in other places which highlight the story of military personnel and combat in their visual narratives of war. Herein lies an important continuity in representations of the two conflicts.

And yet it is important to note that war museums began to change in the fourth quarter of the twentieth century. They began to privilege non-combatant victims of war alongside civilian and military mobilization in the war efforts of combatant countries. Crucial to this development was the emergence of the subject of the Holocaust as a central element in the history of the Second World War.

Why the Holocaust has come to be a central theme in contemporary cultural life is a complex question, beyond the scope of this paper.[9] What matters for our subject is that over time it has become impossible for public exhibitions and museums on the Second World War to ignore the Holocaust. Some make passing reference to it; others redesign their space to provide visitors with images and narratives of civilian war victims, including the murdered Jews of Europe.

In 2000, the Imperial War Museum opened a permanent Holocaust exhibit on a separate level of the museum, above the floors holding its other, more military, galleries. It has a long and detailed diorama, or detailed architectural scale model, of a part of Auschwitz, including the point of entry of railway trains and the trajectory leading to one of the gas chambers. Those who want to see the war as a military encounter between armed forces can still do so on the ground floor, but they have the choice now to take an elevator to another level and another kind of war. (Figure 5.)

9 | Annette Wieviorka (1998): L'ère des Témoins, Paris: Plon.

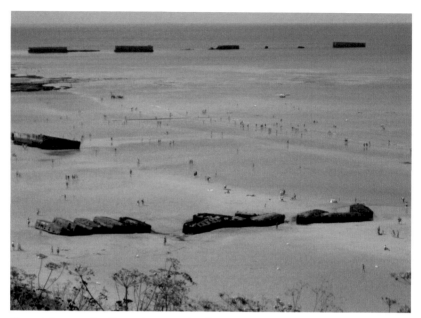

Figure 4: Arromanches Coasts, Remains of Mulberry Habors
© www.panoramio.com/photo/49022263 (Uncle Steve)

Between the older exhibits and the new one on the Holocaust, there is a floor de-
voted to war art. On one side is a display of art produced during and about the two
world wars over the past century. Most, though not all of it, centers on the soldiers'
war. Facing it in 2009 was a gallery displaying art from the museum's permanent
collection entitled "The unspeakable: The artist as witness to the Holocaust". This
braiding together of the military history of the Second World War and the history
of the Holocaust is a major development in public representations of war. Following
the same broadening of the reach of the museum, there is a further exhibition on a
floor above the Holocaust exhibition on the theme of war, armed conflict, human
rights and genocide since 1945.

Elsewhere, similar trends are in evidence. In the Mémorial de Caen, a museum
of the Second World War in a city almost entirely obliterated during the Battle of
Normandy in 1944, there is a section recounting the history of the Holocaust. In
addition, visitors are given a Human Rights Passport, pointing clearly to a linkage
between representations of war and the new human rights regime in Europe as a
pacifist rejection of the past. In Amsterdam there is a museum at the Anne Frank
house, where she and her family hid during the Second World War. The top floor
is devoted to three glass display cases, in which are housed the original text of her
diary. On the ground floor of the museum is a film on the theme of tolerance in
contemporary Holland.

Some museums are devoted to honoring the victims of Nazi war crimes at the sites where the crimes took place. The town of Lidice was obliterated after Czech agents parachuted into the country from their training bases in Britain and fatally wounded Reinhard Heydrich. There is a museum there recounting these events. In France, the German Das Reich division, veterans of war in Russia, travelling north from Toulouse to take part in the defense of Normandy in 1944, herded 600 people into the church of the small French town of Oradour-sur-Glane and burnt the church down. The ruins have been left as a permanent memorial to the victims. Visitors can learn more about the story at a Centre de la mémoire in the rebuilt town. There are museums at the concentration camp at Dachau near Munich and at the site of the death camp at Auschwitz near Cracow.

The story of the victims of war is not restricted to the murder of the Jews of Europe. Earlier museums focused on this facet of war. The city of St Petersburg has a vast cemetery and monuments to the nearly one million men and women who died in the siege of their city from 1941 to 1943. The city of Hiroshima has a peace memorial museum which was established as early as 1955. But these sites of memory were funereal in character; what has changed in recent decades is the narratives museums of all kinds use to describe the nature of war.

Clearly, visual representations of the two world wars have evolved alongside changes in public perceptions of their character and consequences. One effect of the entry of the Holocaust into the narrative of the two world wars is the reconsideration of previously occluded facets of the First World War. An Armenian genocide

Figure 5: The Holocaust Exhibition, Entry, Imperial War Museum, London
© Imperial War Museum, London

museum opened in Yerevan, the capital of Armenia, in 1995. A similar museum will open in Washington D.C. in 2011. In Valence, a city in southern France where many survivors of the Armenian genocide rebuilt their lives, there is a museum recounting this crime against humanity.

By the end of the twentieth century, the shadow of the Holocaust was indirectly evident in new representations of the First World War. The Imperial War Museum opened a new exhibition space on the First World War in 2008, 90 years after the Armistice. It is entitled "In Memoriam: Remembering the Great War". Its design is much more international than the story told in the older Second World War galleries, and much more focused on suffering and loss. Two of Käthe Kollwitz's etchings of mothers and children are displayed there, providing a very different message than that found in the ground floor displays dealing with the 1914-18 conflict. (Figure 6)

The same somber tone marks the French museum of the First World War, L'Historial de la grande guerre, located in Péronne, on the River Somme, where one of the massive and inconclusive battles of the Great War was fought over six months between July and November 1916. There the horizontal axis dominates the displays, providing visitors with less of the uplift and vertical heroism of other war museums. The museum was opened in 1992, the year of the Maastricht conference, a major step towards European integration. Visitors see war – the disintegration of Europe at peace in 1914 – as the bloody history today's Europe is meant to transcend.[10] We will return to this museum, and to its detractors, in a moment.

The effort to construct war museums describing the shattering consequences of the two world wars has left us with a wide and varied range of visual narratives. Local conditions and stories vary considerably, and in the space of this paper, we can only refer to a few examples. The Heeresgeschichtliche Museum in Vienna has on display the bloody tunic worn by Archduke Franz Ferdinand on the day he was assassinated in Sarajevo on 28 June 1914. The car in which he sat is also there. In 2008 the same museum launched an exhibition on the bombing of the city in the Second World War, showing the heroic work of SS units in saving the lives of civilians whose homes had been destroyed.

Not far away, there is an entirely different representation of the same war. In the 1970s, a group of young Austrian medical students and doctors exposed the experiments on Jewish children conducted in the Nazi period by Dr. Heinrich Gross in the Spiegelgrund Children's Hospital in Vienna. He never went to jail, hiding behind his reputation as a scientist and his advanced age, but the victims of his crimes have their memorial. In the grounds of the hospital where these children were killed, there is a

10 | For the story of the design of this museum see: Jay Winter (2006): Remembering war: The Great War between history and memory in the twentieth century, New Haven: Yale University Press, ch. 11.

*Figure 6: IN MEMORIAM, Imperial
War Museum, London
© Imperial War Museum, London.*

set of about 300 glass batons, three feet or so high, arrayed in a square, one for each of Gross's victims. There is luminescent material in the batons. At night they glow.[11] This brief survey of sites of remembrance is only a partial account of the preservation of the material culture of war. There are other sites – battlefield sites – which are half-way between cemeteries and museums. Some sections of the trench system on the Western Front have been preserved. The same is true for some of the places in which decisive battles occurred during the Second World War.

These battlefield sites enlarge the catchment area of museum reference; that is, they enable (indeed they require) visitors to situate themselves geographically as well as temporally and thematically in a particular region or landscape marked by war. In addition, the location of war memorials and war cemeteries nearby can provide a third and fourth vector of remembrance to those who visit war museums.

3. RISKS AND PITFALLS. BOYS AND THEIR TOYS

Those who design and run war museums have a moral responsibility to avoid the glorification of war. This is no trivial matter, since among the millions of visitors to war museums there are many looking for the blood and guts of the victims, and the

11 | Thanks are due to Helmut Konrad, University of Graz, who took the author to see this memorial.

weapons that tear them apart. This kind of voyeurism is not uncommon, and may be more widespread today than ever before, due to the ubiquity of internet war games. The search for war as it really was/is presents a second set of pitfalls, all of which have a gender component to it. Let's take as an example the criticism of a museum in which we hear an indirect statement as to what a war museum should be:

> Although the Historial de la grande guerre in Peronne is the unofficially crowned kind of WW1 museums in France, it doesn't quite live up to the expectations. The location of the museum – the historic fortress in the town centre is impressive enough, but the exhibits aren't as thrilling as you'd expect. After you've paid the exaggerated entrance fee you'll be somewhat let down with the lack of diorama and the movie feature, which audio-system doesn't quite work out (the original French audio will over stem the puny sound of the English audio-guide you're handed).
> So if you're on a WW1 battlefields-coach trip heading towards Peronne, make sure you bombard the driver with enough lager cans, sharp objects and personal belongings until he steers in the direction of the Musée vivant 1914–1918 or the Somme 1916 Trench museum, which are much better museums! Have a quick butcher's in the Historial if you've got enough time to spare.[12]

Clearly, the thrill of battle, and the sense of being there are what the anonymous writer of this message was searching for. The fact that he did not find them in the Historial is not accidental. It was precisely to fight against this kind of thinking about war that it was designed differently.

First, a horizontal axis is used as a principle of the organization of space. As far as it is known, this is not the case in any other war museum. This choice came out of an accident. The design of the museum was influenced by the great Hans Holbein painting in the Kunstmuseum in Basel, Christ in the Tomb. This is an entirely, relentlessly horizontal portrait of an entirely, undeniably dead man. There are no angels or marias in attendance. This man is realistically portrayed, to the point of dislocated fingers in his crucified hands. The painting is justly celebrated as a masterpiece of the Reformation. In order to believe in the Resurrection, you need to leave your senses and your experience behind, and simply believe. Salvation is indeed by faith alone. The fact hat the designers of the museum were so moved by this painting is in no sense unique or original. It was after seeing this painting that Dostoyevsky's Prince Mishkin told his friends that he saw something that almost made him lose his faith. Almost, but not quite.

This presented a different angle, a different way of configuring a war museum: why not use the horizontal, the language of mourning, to displace the vertical, the language of hope, in countering the voyeuristic dangers of representing war as

12 | http://www.warmuseums.nl/gal/141gal.htm, 20 March 2012

thrilling, life-enhancing, full of positive meanings? Why not use the horizontal to challenge clichés about war and the tendency for those light in intelligence to get their chance to see war as it really is? This was implemented by digging fosses or rectangular dugouts about 30 centimeters in depth, and by displaying in them the objects soldiers used in their daily lives – weapons, bullets, lice powder, harmonicas, votive objects, uniforms. (Figure 7) This stylized representation of war is deliberately remote from those displays which pretend to bring you right into the front line, as if that were even remotely possible. Contemporary film footage of the objects on display is used, but these videos add further to the puzzlement over that eternal question, how is it possible to represent war? *Starker Tabak*, as Kaiser Wilhelm liked to say. Too strong stuff for many conventional war lovers.

Note the pub or rugby club language too in the critique. Bombard the driver with beer cans or other objects to divert him to a real museum; the author of this busman's tour guide of First World War sites urges his customers that, should some spare time remain, they might indeed go to the Historial to "have a butcher's", meaning in London slang, have a quick look, as if glancing at a butcher's hook displaying meat for purchase. Or in this case, dead men's remains. "Have a butcher's" peek at war is what men do when they do not have the imagination or the courage to stare it straight in the face.

We should not at all underestimate the number of visitors to war museums who come with such expectations and such wild distortions of the thrilling nature of war. We should also not underestimate the way such visitors gender war from the start,

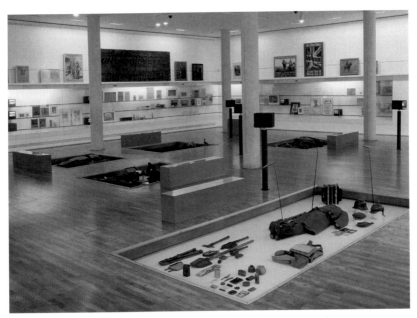

Figure 7: Historial Museum of the Great War-Péronne (Somme) ©Yazid Medmoun

and look for confirmation of their prejudices in the sites and museums they visit. If they do not find the narrative of war configured as the story of boys and their toys, then they are perplexed, annoyed, or disappointed.

To their credit, the designers of the Imperial War Museum have reacted indirectly to this kind of voyeuristic stupidity among its millions of visitors. Although the way in which the Imperial War Museum in London has updated its exhibition space in recent years is quite impressive, there are still two displays in its basement which cater for those looking for clichés: the Trench experience with a plastic rat among the model trenches; and the Blitz experience, with a Bobby or warden urging children to be quiet lest the Germans hear them, and with smoke rising from bombed-out sites.

Years of criticism have borne fruit. These exhibition halls are still there, but above them, there is a new exhibition In remembrance, inaugurated in 2008. It is one the British critic of the Historial will not like one bit: it has no thrilling displays, and highlights both the European character of the war and its staggering human costs. It is also not accidental that this display is close to the entrance to a new display in the Imperial War Museum on the Holocaust. Nor that above the museum's excellent account of the Holocaust is a space on war and war crimes since 1945.

What the Imperial War Museum offers is a multi-vocal approach to the problem of how to represent war. As such, it deserves its pride of place as the premier war museum, reinforced by its outstanding archives including manuscripts, films, and photographs of unparalleled richness. It is a place anyone interested in contemporary history has to go. Its flexibility in changing its character leaves space for plural visions, but none goes unquestioned. The fact that it is housed in what was one of London's central lunatic asylums, Bedlam, adds another dimension of reflection, or irony, on which visitors can reflect at their leisure.

3. CONCLUSION

War museums face a stark choice: either they aim at an interrogation as to how war can be represented or they continue to deepen lies and illusions about it. The most serious pitfall in this cultural domain is what might be termed pseudo-realism, the false claim of those who write about war or design museums about it that they can bring the visitor into something approximating the experience of combat. All such claims are false, and sometimes dangerously so. There are many good reasons for skepticism. The first is that there has never been a single entity or events, appropriately entitled the experience of war; the word experience is best understood not as a physically embodied memory but as a set of memories drawn from a subject-position, that of a participant in war, which has myriad variations. It is not only that war itself is too protean to be reduced to clichés, but that experience is something we all have, and which always changes over time. As our lives change, so do our memories, and with them our notion of what being there, what war was really like, changes

too. Ernst Jünger was wrong on many things, but for our purposes the error that really matters is his essentialist position on Kriegserlebnis. War experience is not in your belly, unless you were wounded there; for everyone else it is in your mind and in your memories, and they never remain fixed. They are collages of retrieved and recombined traces of the past which we put together to make sense of our lives. As our lives change, so do the stories we tell about who we are and how we got here. As Joan Scott has argued, experience is dynamic, and never fixed.[13]

The lager hurling critic of the Historial de la grande guerre is one of those who is under the delusion that you can get near to the thrill of battle, whatever that is, by getting near to the weaponry of war. The stuff of killing, the real core of war: these are the fantasies of stunted imaginations. It is the business of war museums to resist the temptation to appeal to this kind of stylized fascination with combat and to offer a series of alternative ways of approaching the terror of the battlefield.

One way to do so is to ensure that for every weapon on display there is an image or an object pointing to the injury or mayhem that weapon causes to the human body. All armies have had surgeons in tow, and the stuff of military medicine and the trappings of physical and psychological rehabilitation are readily available in both material and digital form. Photographs and films now open up possibilities to make weapons real in the sense of showing what they do to arms and legs and the rest of us.

Another way to avoid the fetishization of weapons is to change the gender balance of representations of populations at war. Women of all kinds – nurses, farmers, prostitutes, and so on – have attended war since Mother Courage's time, and their traces matter not only intrinsically, but also because they increase and complicate the range of possible identifications visitors can share across the gender divide.

In conclusion, war museums are sites of contestation and interrogation. They can be vital and essential parts of our cultural environment if they enable visitors to ask questions about the limits of representation of violent events which cause human suffering on an unfathomable scale. And if they point elsewhere, if they lead people to link what they see in a museum with sites of memory which are all around us and which museum visitors should be invited to see. There are war memorials, battle sites, cemeteries, destroyed and reconstructed synagogues within walking distance of our meeting today. The violence of the two world wars and later conflicts produced a shower of such sites; our job as museum professionals is to map them, and thereby to show young and old alike that the colors and shapes we see in the contemporary world are shaded and shaped by the staggering consequences of war.

13 | Joan W. Scott (1991): »The Evidence of Experience«, in: Critical Inquiry, 17, pp. 773–97.

If War does Belong in Museums: How?

Military Museums and Social History

Barton C. Hacker, Margaret Vining

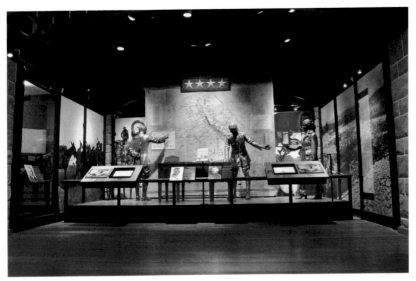

Frontispiece: Furniture from General Pershing's headquarters at Chaumont, France, framed the original map displaying allied and enemy dispositions on 11 November 1918 in this recreation of the general's map room for the 2002 exhibition West Point in the Making of America at the National Museum of American History.
© Armed Forces History Division, National Museum of American History, Washington, DC.

Armies have always played central roles in civilized societies and so the material culture associated with them – weapons, uniforms, medals, trophies, flags and all the other trappings of martial endeavor – has regularly attracted the interest of collectors and the public. Displaying this material culture to the public became the main purpose of the modern military museum as it emerged in the 19th century, initially to foster national pride, later to memorialize fallen heroes. More recently still, exhibition in military museum has undergone a major shift, from simply displaying artifacts to using them to tell stories. Although the old concerns for national pride

and memorialization remain salient, they no longer dominate the scene. Military museums since the 1980s have increasingly drawn for their exhibitions on the new military history, with its stress on the common soldier, the experience of war, and the place of the armed forces in society. This shift in scholarship coincided with the emergence of the new museum studies, which not only made museums and their work themselves subjects of study but also transformed museum practice. The last three decades have clearly seen the appearance of a new kind of military museum taking its place alongside a new kind of military history. We have discussed this process as it took place primarily in European museum elsewhere.[1] Here we focus on the American scene.

ORIGINS OF MODERN MILITARY MUSEUMS

The relatively new field of museum history has so far had little or nothing to say about military museums.[2] Part of the reason may be the well-known academic distaste for military studies, but the neglect of the history of military museums may also stem from their origins unlike other museums. Military museums have two main lines of ancestry. One sprang from private or restricted collections of arms and armor amassed by wealthy, often titled, collectors; when they went public (mostly in the 19th century), they formed what were usually called armory museums, though often such collections came to reside in art museums. The other ancestral line of military museums derived from the obsolete firearms and other military materiel stored in state arsenals; these became the so-called arsenal and artillery museums. Although the categories were hardly exclusive – firearms found their way into arms and armor collections, just as edged weapons, polearms, and armor accumulated in arsenals – they were distinct. Arms and armor collections tended to emphasize objects unique, unusual, and often beautiful, while arsenal collections were more likely to amass work-a-day weapons and equipment.[3]

1 | Barton C. Hacker/Margaret Vining (2007): »Toward a History of Military Museums«, in: Robert Douglas Smith (ed.), ICOMAM 50. Papers on Arms and Military History 1957–2007, Leeds: Basiliscoe Press, pp. 3–22.

2 | Edward P. Alexander's highly regarded Museums in Motion: An Introduction to the History and Functions of Museums (1979), Nashville: American Association for State and Local History, for instance, makes no mention whatsoever of military or naval museums of any kind. For a very useful introduction to the field of museum history as part of the late 20th-century transformation of museum studies (though also omitting military museums), see Randolph Starn (2005): »A Historian's Brief Guide to New Museum Studies«, in: American Historical Review 110, no. 1, pp. 68–98, especially pp. 71–80. See also Sharon Macdonald (2006) (ed.): A Companion to Museum Studies, Malden, MA: Blackwell.

3 | Frederick P. Todd (1948): »The Military Museum in Europe«, in: Military Affairs 12,

In the late 19th and early 20th century, collections of arms and armor and of gun-powder weapons began to be amalgamated in national military museums open to the public. These museums were primarily historical technology museums intended to collect, preserve and display military material culture. They showed militaria in classified displays, usually arranged in chronological order. Significant military collections of the same kind that found their way into the new military museums also went to other kinds of museums, especially art museums, which tended to emphasize the decorative arts over military-historical interest.[4] The splendid arms and armor collection in the Metropolitan Museum of Art in New York is a case in point. Rather than growing from an existing historic collection, it was assembled at the turn of the 20th century largely through gift and purchase. Its curators explicitly eschewed what they called military paraphernalia in favor of a more artistic assemblage, "the rich gear of the hunt and chase, the panoply of the tournament and joust, and the pag-eantry of court life".[5] Although the Metropolitan's collection remains unrivaled, oth-er American art museums have also acquired significant collections through similar means with similar outcomes.[6] A 1960 worldwide survey by the newly established Association of Museums of Arms and Military History, as ICOMAM was initially

no. 1, pp. 36–45, p 38; Ian G. Robertson (1994): »Museums, Military«, in: André Corvisier (ed.): A Dictionary of Military History and the Art of War, trans. C Turner, English edition revised, expanded and edited by John Childs, Oxford: Blackwell, pp. 540–43, p. 540.

4 | Robertson: »Museums, Military« (note 3), p. 540. See also J. Lee Westrate (1961): European Military Museums: A Survey of Their Philosophy, Facilities, Programs, and Management, Washington, DC: Smithsonian Institution, pp. 177–200.

5 | Association of Museums of Arms and Military History (1960): Repertory of Museums of Arms and Military History, Copenhagen: AMAMH, p. 143. See also Bashford Dean (1915): Handbook of Arms and Armor: European and Oriental, including the William H. Riggs Collection, New York: Metropolitan Museum of Art; Helmut Nickel/Stewart W. Pyhrr/Leonid Tarassuk (1982): The Art of Chivalry: European Arms and Armor from the Metropolitan Museum of Art. An Exhibition, New York: American Federation of Arts; Stephen V. Grancsay (1986): Arms & Armor: Essays from the Metropolitan Museum of Art Bulletin, 1920–1964, New York: Metropolitan Museum of Art.

6 | John H. Beeler (1985): »The John Woodman Higgins Armory (Higgins Armory Museum)«, in: Military Affairs 49, no. 4, pp. 198–202; Chuck Arning (2009): »Review of Higgins Armory Museum, Worcester, Massachusetts«, in: Public Historian 31, no. 4, pp. 124–27; Donald J. LaRocca (1985): »Kienbusch Centennial. Carl Otto Kretzschmar von Kienbusch and the Collecting of Arms and Armor in America«, in: Philadelphia Museum of Art Bulletin 81, no. 345, p. 2/pp. 4–24; Claude Blair (1992): Studies in European Arms and Armor: The C. Otto Von Kienbusch Collection in the Philadelphia Museum of Art, Philadelphia: Philadelphia Museum of Art; Walter J. Karcheski Jr. (1995): Arms and Armor in the Art Institute of Chicago, Chicago: Art Institute of Chicago.

known, underscored the persistent diversity of museums-military, art, general-that housed significant military collections.[7]

MILITARY MUSEUMS IN 19TH-CENTURY AMERICA

For complex historical and political reasons, the United States has never created a national military museum. The United States Military Academy at West Point established an Artillery Museum in 1854, which later became the public West Point Museum. Although it included in its remit a requirement to house trophies of the American Revolution, the War of 1812 and the Mexican War, its chief function long remained giving hands-on ordnance instruction to academy cadets. Its relatively remote location may have precluded its playing a larger role, even after it became public.[8] The US Army sponsored a few other museums in the late 19th and early 20th centuries, but then retired from the museum business for several decades.[9] Private, local, and state military museums also proliferated, but none ever moved beyond their founding purpose in the direction of becoming a national military museum.[10] Perhaps the closest approximation to a national military museum in 19th-century America was the short-lived Museum of the Military Services Institution of the United States in New York, inspired by the British Royal United Service Museum.[11]

7 | AMAMH: Repertory of Museums of Arms, (note 5). Subsequent surveys of individual countries tend to confirm this diversity: Jean M. Humbert/Lionel Dumarche (1982): Guide des Musées d'Histoire Militaire: 400 Musées en France, Paris: Charles-Lavauzelle; Terence Wise/Shirley Wise (1994): A Guide to [British] Military Museums and Other Places of Military Interest, 8th ed., Powys: Imperial Press; Steve Rajtar/Frances Elizabeth Franks (2002): War Monuments, Museums and Library Collections of 20th Century Conflicts: A Directory of United States Sites, Jefferson, NC: McFarland.

8 | Robertson: »Museums, Military«, (note 3), p. 540; Philip K. Lundeberg (1994): »Military Museums«, in: John E. Jessup/Louis B. Ketz (eds.): Encyclopedia of the American Military: Studies of the History, Traditions, Policies, Institutions, and Roles of the Armed Forces in War and Peace, New York: Charles Scribner's Sons, pp. 3:2133–57, pp. 2134–35. See also Richard E. Kuehne/Michael J. McAfee (1987): The West Point Museum: A Guide to the Collections, West Point, NY: United States Military Academy

9 | Joseph H. Ewing (1979): »Military Museums and Collections«, in: John E. Jessup, Jr./ Robert W. Coakley (eds.): A Guide to the Study and Use of Military History, Washington, DC: Center of Military History, US Army, pp. 339–47; R. Cody Phillips (1992): A Guide to U.S. Army Museums, Washington, DC: Center of Military History; Lundeberg: »Military Museums«, (note 8), pp. 2140–46.

10 | Benjamin H. Kristy (1998): »Museum Collections as Historical Sources«, in: Robin Higham/Donald J. Mrozek (eds.): A Guide to the Sources of United States Military History: Supplement IV, North Haven, CT: Archon Books, pp. 543–80, especially pp. 571–80.

11 | E. Altham (1931): »The Royal United Service Institution, 1831–1931«, in: Journal of

Figure 1. In 1884, the Military Services Institution of the United States opened its museum on Governor's Island in New York Harbor; shown here is the title page of the museum's first catalogue. © The Catalogue of the Museum, 1884 [Governor's Island, NY: Military Services Institution of the United States, 1884].

In 1884, it opened a sizeable military heritage museum and park on Governor's Island in New York Harbor (Figure 1), where it displayed "trophies and relics to promote patriotism, invention and historical research". Declining attendance forced the museum to close in 1924.[12] Various plans to establish a national museum since the late 19th century have failed to materialize, although work is now underway on a National Museum of the United States Army located at Fort Belvoir, Virginia, and scheduled for a 2015 opening.[13]

the Royal United Service Institution 76, no. 502, pp. 234–45; E. Altham (1900): History of the Banqueting House, London: Royal United Service Institution; L.E. Cowper (1935): »British Military Museums«, in: Museums Journal 35, no. 2, pp. 40–49; W.A. Thorburn (1962): »Military History as a Museum Subject«, in: Museums Journal 62, pp. 187–93; Peter Thwaites (1996): Presenting Arms: Museum Representation of British Military History, 1660–1900, London: Leicester University Press, pp. 28–29. See also Arthur Leetham (1924): Official Catalogue of the Royal United Service Museum, Whitehall, S.W., London: Royal United Service Institution.

12 | Military Services Institution of the United States (1884) (ed.): The Catalogue of the Museum, 1884, Governor's Island, NY: Military Services Institution of the United States; Edmund Banks Smith (1913): Governors Island, Its Military History under Three Flags 1637–1922 , New York: The Author, pp. 147–49; Lundeberg: »Military Museums«, (note 8), p. 2138.

13 | For a review of early attempts to create a national army museum in America, see Lundeberg: »Military Museums«, (note 8), pp. 2138–40. On current plans, see the website

A much more significant American contribution to the public display of the military past has been battlefield interpretation and the construction of related site museums. The great impetus for their emergence in the late 19th century was the American Civil War (1861–1865). They were conceived at first as typical war memorials or tributes to the dead, like the 1863 Soldiers' National Cemetery at Gettysburg.[14] Battlefield parks followed later in the century: Chickamauga-Chattanooga (1890), Shiloh (1894), Gettysburg (1895), and Vicksburg (1899).[15] The U.S. National Park Service, created in 1916, eventually took charge of these parks and many more. Nearly half the major historical military areas now administered by the National Park Service preserve and interpret Civil War sites. The Civil War battlefield parks smoothed the way for a number of parks associated with other American wars, including the American Revolution, the War of 1812 and the Indian wars. The National Park Service also took responsibility for many of the military collections that accumulated in such historic properties as forts, armories, and arsenals before ending up as public museums. Battlefield museums early evinced a propensity to address soldiers' experiences and the local effects of war, a practice that may well have influenced the later development of social historical approaches to displaying military history. Path-breaking efforts to engage their audiences more directly through battlefield re-enactment and living history have also proved useful in more conventional military museums.[16]

The closest American approximation to a national military museum has, in fact, been the Smithsonian Institution. Military objects began flowing haphazardly to the Washington institution from its founding in 1847, but the major military collection originated, as did many other Smithsonian collections, in the 1876 United States Centennial International Exhibition held in Philadelphia to commemorate the hundredth anniversary of the Declaration of Independence. Elaborate displays of military material (Figure 2) proved popular at the international expositions and

of the Army Historical Foundation at http://www.armyhistory.org/ahf.aspx?pgID=868, 20 March 2012.

14 | Robertson: »Museums, Military«, (note 3), p. 542; Annette Becker (1997): »War Memorials: A Legacy of Total War?«, in: Stig Förster/Jörg Nagler (eds.): On the Road to Total War: The American Civil War and the German Wars of Unification, 1861–1871, Washington, DC: German Historical Institute; Cambridge: Cambridge University Press, pp. 657–80.

15 | Herman Hattaway (2001): Gettysburg to Vicksburg: The Five Original Civil War Battlefield Parks, Columbia: University of Missouri Press.

16 | Ronald F. Lee (1973): The Origin and Evolution of the National Military Park Idea, Washington, DC: National Park Service; Edwin C. Bearss (1987): »The National Park Service and Its History Program: 1864–1986: An Overview«, in: Public Historian 9, no. 2: The National Park Service and Historic Preservation, pp. 10–18; Joseph E. Stevens (1990): America's National Battlefield Parks: A Guide, Norman: University of Oklahoma Press.

Figure 2. In 1876 Krupp gun-making machinery was displayed in the machinery hall at the Centennial International Exhibition in Philadelphia.
© Photographic print on stereo card. US Library of Congress Washington, DC.

fairs that proliferated in Europe and America during the late 19th century. Like exhibitions in the new military museums, they were more evocative than substantive, providing little context and focusing overtly on war-weaponry, flags, uniforms, battle trophies, and other war-related objects. Again like contemporary military museums, exhibition displays of militaria generally overlooked the magnitude of material – civilian as well as military – produced and used in the mundane activities other than war that concerned all branches of the armed forces.[17] Smithsonian Secretary Spencer Baird persuaded a number of Philadelphia exhibitors to save the hassle and expense of shipping their material home and instead donate it to the United States National Museum, part of the Smithsonian Institution.[18] Other major accessions followed when the army decided to leave the museum business entirely for lack of

17 | Robert W. Rydell (1984): All the World's a Fair: Visions of Empire at American International Expositions, 1876–1916, Chicago: University of Chicago Press; Robert W. Rydell/Nancy E. Gwinn (1994): Fair Representations: World's Fairs and the Modern World, Amsterdam: Amsterdam VU Press; Paul Greenhalgh (1988): Ephemeral Vistas: The Expositions Universelles. Great Exhibitions and World's Fairs, 1851–1939, Manchester: Manchester University Press.

18 | Robert C. Post (1976): A Treatise upon Selected Aspects of the Great International Exhibition Held in Philadelphia on the Occasion of Our Nation's One-Hundredth Birthday, with Some Reference to Another Exhibition Held in Washington Commemorating That Epic Event, and Called 1876, a Centennial Exhibition, Washington, DC: National Museum of History and Technology, Smithsonian Institution; Bruno Giberti (2002): Designing the Centennial: A History of the 1876 International Exhibition in Philadelphia, Lexington: University Press of Kentucky; Pamela M. Henson (1999): »Objects of Curious Research: The History of Science and Technology at the Smithsonian«, in: Isis 90, Supplement, Catching up with the Vision: Essays on the Occasion of the 75th Anniversary of the Founding of the History of Science Society, pp. S252–S254.

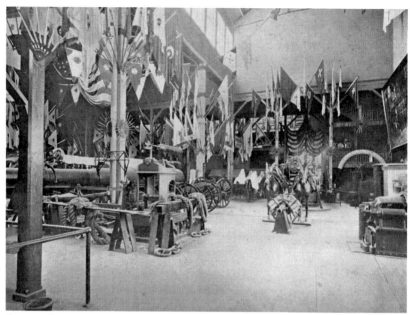

*Figure 3: The US Army organized a substantial display for the 1893 World's Columbian Exposi-
tion in Chicago, Illinois. The army later transferred much of this material to the Smithsonian.
© Unnumbered plate from H.W. Buel (1894): »The Magic City: A Massive Portfolio of
Original Photographic Views of the Great Worlds Fair and Its Treasures of Art«.*

exhibit space. Although that decision would be reconsidered after World War II,
the army meanwhile began in the 1890s a three-decade transfer of vast quantities of
military materiel, including thousands of ordnance items (Figure 3), to the national
museum. Of special significance was the mass of materiel that reached the museum
during and just after the First World War, including the historic army quartermaster
collection.[19] The 1924 closing of the National Services Institution museum brought
another sizeable collection of military objects to Washington. The US National Mu-
seum had meanwhile acquired a purpose-designed building, which sharply distin-
guished it from the many European museums housed in converted palaces, arsenals,
or castles inherently ill-suited for the purpose.[20] But it shared with its European

19 | Lundeberg:» Military Museums«, (note 8), pp. 2135, 2137, 2139; »Smithsonian
Collections: A Brief History«, in: Appendix A in Office of Policy and Analysis Study Team,
Concern at the Core: Managing Smithsonian Collections, Washington, DC: Smithsonian
Institution, pp. 299–300.

20 | The need for renovation in traditional European military museums and its difficulties
was a major theme in the symposium on military museum exhibition held at Legermuseum
in Delft, Nov. 2002. See Heleen Bronder (2002) (ed.): Presenting the Unpresentable:
Renewed Presentations in Museums of Military History, Delft: Legermuseum.

counterparts little inclination to arrange exhibits and galleries to tell stories or to explain arcane military matters to their visitors, or even attempt to display objects to best advantage. (Figure 5) Objects were simply classified and sorted, usually in something approximating chronological order, to celebrate technological progress and military valor.[21]

MILITARY MUSEUMS REDIRECTED

The First World War profoundly affected military museums, as it did virtually every aspect of Western culture. Preeminent among the institutions founded because of the Great War was the Imperial War Museum in London, which opened to the public in 1920. The idea of such a museum originated during the war partly as a propaganda effort to sustain eroding public enthusiasm for the fight, partly as a sincere attempt to meet a deeply felt need to record the war widely regarded as epochal from the outset.[22] The concept of such a museum resonated throughout the British Commonwealth (Figure 4) and even inspired an abortive attempt to found a Great War museum in Washington. Despite coming late to the war, many in the United States shared both the patriotic enthusiasm and a sense of living in historic times. But their efforts to create a comparable museum failed. The high hopes and major accomplishments of the immediate postwar years fell victim to a changed political and economic environment after 1920. The promised war museum never materialized and much of the remarkable war collections were dispersed over the next decade. What remained eventually became part of the National Museum of American History, which opened to the public in 1964 as the Museum of History and Technology.[23]

21 | G. Brown Goode (1896): »On the Classification of Museums«, in: Science n.s. 3, pp. 154–61; Sally Gregory Kohlstedt (1988): »History in a Natural History Museum: George Brown Goode and the Smithsonian Institution«, in: Public Historian 10, no. 2, pp. 7–26; Maurice Maindrou (1900): »Les musées militaires«, in: La Revue Blanche 21, pp. 259–63, pp. 601–604; Todd: »The Military Museum in Europe«, (note 3), pp. 41–43.

22 | Becker: »War Memorials«, (note 14), pp. 657–80; Gaynor Kavanagh (1994): Museums and the First World War: A Social History, London: Leicester University Press; Gaynor Kavanagh (1988): »Museums as Memorial: The Origins of the Imperial War Museum«, in: Journal of Contemporary History 23, no. 1, pp. 77–97; Susanne Brandt (1994): »The Memory Makers: Museums and Exhibitions of the First World War«, in: History and Memory 6, no. 1, pp. 95–122.

23 | Elizabeth Rankin (2006): »War Museums in the British Dominions: Conceptualising Imperial Allegiance and Colonial Autonomy«, in: New Zealand Sociology 21, no. 1, pp. 49–67; Margaret Vining/Barton C. Hacker (2008): »Displaying the Great War in America: The World War I Exhibition of the United States National Museum in Washington, DC, 1918 and Beyond«, in: Claudia Reichl-Ham (ed.): The Universal Heritage of Arms and Military

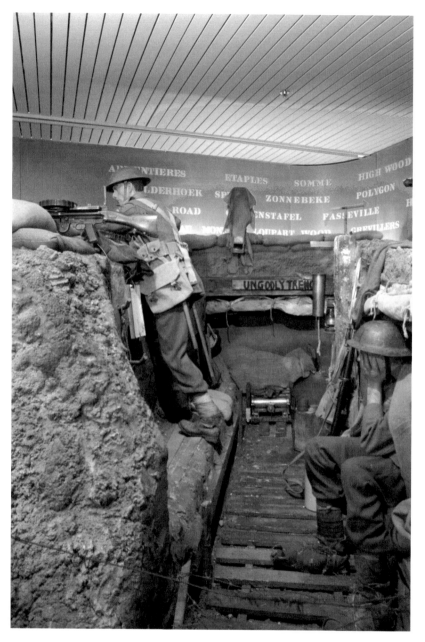

Figure 4: Like the Imperial War Museum in England, the New Zealand National Army
Museum sought to replicate a World War I trench.
© National Army Museum, Waiouru, New Zealand.

Until the 1980s, the new museum's military collections were displayed in cases with labels that merely identified objects, but offered little in the way of context, historical or otherwise. In this respect, it differed scarcely at all from military museum practice elsewhere. Traditional curators tended to prefer "the curio class of exhibit-the association item and the firsts and lasts of military history".[24] During the era of the world wars, the central mission of military museums expanded from displaying the relics of the past to include honoring the wartime sacrifice of past generations, but went no further. For a quarter-century beyond the end of World War II they also largely retained traditional approaches to presenting their subject. That only changed when the currents of the so-called new military history began to roil the waters of old museum practices in the 1980s. In place of the long-time emphasis on great captains, strategy, and combat, the new military historians in America stressed the activities of common soldiers, the structure of military institutions, and the ineractions of armed forces and their societies,[25] an approach that soon spread to Europe.[26]

The new military history also for the first time opened a window into the experience of the women who regularly formed part of armies.[27] Until the late 20th century, women's history was largely ignored by all museums, but perhaps especially by military museums. The curator of history in the United States National Museum

History: Challenges and Choices in a Changing World, Vienna: Heeresgeschichtliches Museum, pp. 27–38.

24 | Claude F. Luke (1933): »The Early Days of the Imperial War Museum«, in: Strand Magazine 82, pp. 534–41, as cited in Todd: »The Military Museum in Europe«, (note 3), p. 40; Laurie Milner: »Displaying War: The Changing Philosophy Behind the Exhibition at the Imperial War Museum in London«, in: Bronder, Presenting the Unpresentable (note 20), pp. 10–17, pp. 11–12.

25 | Richard H. Kohn (1981): »The Social History of the American Soldier: A Review and Prospectus for Research«, in: American Historical Review 86, no. 3, pp. 553–67; Edward M. Coffman (1984): »The New American Military History«, in: Military Affairs 48, no. 1, pp. 1–5; Peter Karsten (1986): »The 'New' American Military History: A Map of the Territory, Explored and Unexplored«, in: American Quarterly 36, no. 3, pp. 389–418; Peter Karsten (1986) (ed.): The Military in America: From the Colonial Era to the Present, New York: Free Press.

26 | Torbjørn L. Knutsen (1987): »Old, Unhappy, Far-off Things: The New Military History of Europe«, in: Journal of Peace Research 24, no. 1, pp. 87–98; Peter Paret (1991): »The New Military History«, in: Parameters 20, pp. 10–18; Don Higginbotham (1992): »The New Military History: Its Practitioners and Their Practices«, in: David A. Charters/Marc Milner/Brent Wilson (eds.): Military History and The Military Profession, Westport, CT: Praeger, 1992, pp. 131–44; Robert M. Citino (2007): »Military Histories Old and New: A Reintroduction«, in: American Historical Review 112, no. 4, pp. 1070–90.

27 | Barton C. Hacker (1981): »Women and Military Institutions in Early Modern Europe: A Reconnaissance«, in: Signs 6, no. 4, pp. 643–71.

Figure 5: One of the cases of Great War women's uniforms on exhibit in the United States National Museum during the 1920s displays uniforms worn, left to right: a member of the Motor Corps, National League for Women's Service; a captain in that Motor Corps; a major in the First National Service School; and a member of the American Friends Service Committee. © Armed Forces History Division, National Museum of American History, Washington, DC.

might well have been speaking for many of his successors as well as most of his colleagues when, in 1929, he dismissed women's uniforms from the World War (Figure 5) as "not of primary historical or scientific interest", and urged their removal from a decade-old display because "the space which they now occupy is urgently needed for the accommodation of material of very much greater value".[28] A female exhibition officer described much the same sentiment among her male colleagues at the Imperial War Museum seventy-five years later, observing that the museum's "team of historians are all men and don't take kindly to what they regard as peripheral subjects".[29] Although a women's work section formed part of the Imperial War Museum from the beginning, little of that material became part of the permanent

28 | Theodore T. Belote to William de Chastignier Ravenel, 9 March 1929, Smithsonian Institution Archives, as quoted in Margaret Vining/Barton C. Hacker (2005): »Uniforms Make the Woman: Material Culture and Social Technology in the First World War«, in: Bernard Finn/Barton C. Hacker (eds.): Materializing the Military, London: Science Museum Press, p. 68.

29 | Mark Liddiard (2004): »Changing Histories: Museums, Sexuality and the Future of the Past«, in: Museum and Society 2, no. 1, pp. 15–29, p. 18.

display.[30] The problem is less finding opportunities to show women's military history separately – as recent exhibits in London and Paris testify[31] – than it is integrating women into normal military history exhibits. Recent experience at the National Museum of American History illustrates this point.

RECENT MILITARY EXHIBITION IN THE SMITHSONIAN

The museum now known as the National Museum of American History opened in 1964 as the Museum of Technology and History. The new museum incorporated the institution's military collections, several hundred thousand individual items. As might be expected, the new military exhibit featured lots of weapons and uniforms arranged in more or less chronological order from the American Revolution through the 19th century-a typically traditional exhibit, including even the semi-iconic circular wall display of edged weapons surrounding the Great Seal of the United States. In 1980, the museum changed its name and altered its mission to collect, care for, study, and interpret objects that reflected the experience of the American people. It became, in short, a museum reshaped to accommodate the new social history, with its stress on race, class, and gender.[32] As elsewhere in the museum world, the caretakers of the military history collections were rather slower than their colleagues to embrace the new dispensation. Even as late as 2002, a symposium at the Army Museum in Delft on European military museum exhibition had as one of its major themes how to implement the transformation of outmoded exhibit strategies into displays that set the artifacts into larger social contexts.[33] A major physical renovation of the American museum's armed forces history hall in 1984-1985 cleaned up the old

30 | Susan Grayzel edited a collection of interpretive and explanatory essays for a digitized Imperial War Museum's Women's Work Collection under the title »A Change in Attitude: The Women's Work Collection of the Imperial War Museum«, http://www.tlemea.com/ introduction.asp, 20 March 2012. For a published sampling of the collection, see Diana Condell/Jean Liddiard (1988): Working for Victory? Images of Women in the First World War 1914–1918, London: Routledge & Kegan Paul.

31 | A latter-day temporary exhibit at the museum based on the collection produced Kate Adie (2003): Corsets to Camouflage: Women and War, London: Hodder & Stoughton. François Rouquet/Fabrice Virgili/Danièle Voldman (2007) (eds.): Amours: Guerres et sexualité 1914–1945, Paris: Gallimard, for BDIC and Musée de l'Armée, similarly documents a temporary exhibit at the Invalides.

32 | »A Browsing Bibliography in the New Social History« (1975), Chicago: Newberry Library; James B. Gardner/George R. Adams (1983) (eds.): Ordinary People and Everyday Life: Perspectives on the New Social History, Nashville: American Association for State and Local History.

33 | Bronder: Presenting the Unpresentable (note 20).

display and added a few new artifacts, but did nothing to alter the basic exhibition structure.

That changed in 1987 with the opening of a major military exhibit on an unlikely topic. Though it also displayed the heroic wartime service of Japanese-American soldiers, its main concern was the incarceration of Japanese-Americans in World War II.[34] Entitled *A More Perfect Union: Japanese-Americans & the U.S. Constitution*, the exhibit commemorated the bicentennial of the United States Constitution by addressing one of the constitution's failures, a generally well-received departure from past triumphalism.[35] It also set the Smithsonian on a new direction in military exhibition, a shift confirmed in another major exhibit that followed in 1992, a fiftieth anniversary commemoration of America's World War II. Its debt to the new military history was made explicit in its title: *G.I.: The American Soldier Experience in World War II* (Figure 6). During the 1990s a series of smaller, temporary exhibits explored such topics as American women in war, centering on their experience as prisoners of war in the First Gulf War (1991); the African-American cavalry soldiers who served in the Western army during the late 19th century; the significance of the post-World War II GI Bill; and the women allowed to enlist in the US Navy as yeoman (f) in World War I.

Despite this shift in exhibition strategy, the question posed in this conference – "Does War Belong in Museums?" – arose in an acute form when the position of armed forces history curator became vacant in 1993. The position remained un-filled for five years as the curatorial staff debated that very question. Eventually the answer was yes, but it was a narrow decision. In a sense, it was the wrong question. Museums, including military museums, rarely exhibit war. Rather they exhibit the weapons and paraphernalia of the organizations that include war-fighting among their purposes. This is an important distinction, as Jan Piet Puype, long-time curator at the Legermuseum, noted in a 2005 article.[36] This was also the implicit conclusion of the 2002 symposium held at the Legermuseum in Delft. Despite being entitled *Presenting the Unpresentable*, most of the discussion centered on how to renovate the

34 | *A More Perfect Union: Japanese-Americans & the U.S. Constitution*, exhibit in the National Museum of American History, 1987–2004. Virtual exhibit at http://americanhistory.si.edu/perfectunion/experience/index.html. See also Tom D. Crouch (1989): »Some Thoughts on Public History and Social Responsibility«, in: Illinois Historical Journal 82, pp. 195–200

35 | Philip Tajitsu Nash (1989): »A More Perfect Union: Japanese-Americans and the Constitution«, in: Radical History Review no. 45, pp. 139–42; Allen W. Austin (2005): »Review of A More Perfect Union website«, in: Journal of American History 92, no. 1, pp. 326–28;

36 | Jan Piet Puype (2005): »Arms on Display: Core Business or Illustrations? A Commentary on the Presentation of Arms and Armour in Museums«, in: Finn/Hacker: Materializing the Military (note 28), pp. 159–67.

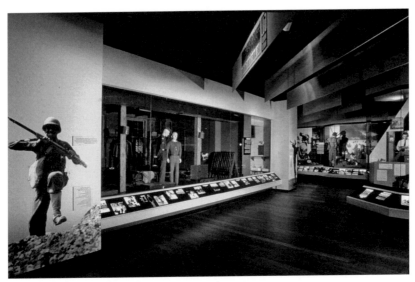

Figure 6: The 1995 exhibition at the National Museum of American History, G.I. The American Soldier Experience in World War II, offered visitors a glimpse into the World War II enlisted experience in this replica of an army barracks room, where a sergeant berates a half-dressed private.
© Armed Forces History Division, National Museum of American History, Washington, DC.

older building in which most military museums resided and how to provide military artifacts with social contexts. Presumably the unpresentable was war-caused horror, violence, and death, but the issue never surfaced in the symposium's presentations or discussions.[37]

The new military exhibits mounted at the National Museum of American History after 1998 illustrate how little the presentation of war mattered. A major exhibition in 2000 on nuclear submarines in the Cold War marked the centennial of America's submarine force. That was followed in 2002 by another major exhibit, on West Point in the making of America, which commemorated the bicentennial of the US Military Academy. Warlike activities appeared in the submarine show, *Fast Attacks and Boomers: Submarines in the Cold War*, but tended more toward technology, international relations, and the seaman's experience. One of the central themes of the topically organized submarine show was how men and women interacted with both technology (Figure 7) and the organization, although including women (primarily the wives of sailors) proved difficult to sell to the sponsors and senior museum staff.[38] The West Point exhibit was framed chronologically, from

37 | Bronder: Presenting the Unpresentable (note 20).

38 | *Fast Attacks and Boomers: Submarines in the Cold War*, exhibit in the National Museum of American History, 2000–2003. Virtual exhibit at http://americanhistory.si.edu/subs/. See also Barton C. Hacker (2005): »Objects in an Exhibition: Reflections on 'Fast Attacks

the academy's founding in 1802 through the First World War (see the frontispiece). America's wars certainly figured in the exhibit, *West Point in the Making of America, 1802–1918*, but the emphasis was on economic development, technological innovation, and the humanity of West Pointers. The exhibit relied heavily on the biographies of selected graduates, 51 in all, who had in one or another, famously or obscurely, contributed to American national development. All graduates during the period were men, of course, but the exhibit explicitly included information about their wives and families as well as their careers, another difficult sell.[39]

The latest exhibition in the National Museum of American History was essentially a complete reinstallation of the permanent armed forces history hall under the title of *The Price of Freedom: Americans at War*.[40] Although America's wars provided the framework for the exhibition, the actual displays had little direct relation to war. Like most military history exhibits, they showed visitors examples of the weapons, uniforms, and equipment of soldiers from the late colonial period through the ongoing wars in the Middle East. Context and explanation were notably lacking. In some ways, this exhibit marked a reversion to an earlier style of military exhibit, the more-or-less chronological arrangement of many artifacts to celebrate military prowess and progress, a fall from grace noted by reviewers.[41]

and Boomers'«, in: Finn/Hacker (eds): Materializing the Military (note 28), pp. 141–48; Barton C. Hacker (2007): »Reflections on Nuclear Submarines in the Cold War: Putting Military Technology in Context for a History Museum Exhibit«, in: John Schofield/Wayne Cocroft (eds.): A Fearsome Heritage: The Diverse Legacies of the Cold War, Seattle: Left Coast Press, pp. 201–30. Cf. Gary E. Weir (2003): »Fast Attacks and Boomers: Submarines in the Cold War: The National Museum of American History«, in: Technology and Culture 44, no. 2, pp. 359–63.

39 | *West Point in the Making of America, 1802–1918*, exhibit in the National Museum of American History, 2002–2004. Virtual exhibit http://americanhistory.si.edu/westpoint/. See also Barton C. Hacker/Margaret Vining (2002): West Point in the Making of America, Irvington, NY: Hydra; Margaret Vining/Barton C. Hacker (2007) (eds.): Science in Uniform, Uniforms in Science: Historical Studies of American Military and Scientific Interactions, Washington, DC: National Museum of American History; and Lanham, MD: Scarecrow Press; Barton C. Hacker/Margaret Vining (2005): »Nuclear Subs and West Point: The Rise and Fall of Two Exhibitions at the National Museum of American History«, paper presented at the annual meeting of the Organization of American Historians, Seattle, WA, April 2005.

40 | *The Price of Freedom: American at War*, exhibit in the National Museum of American History, 2004. See http://americanhistory.si.edu/militaryhistory/.

41 | Edward Rothstein (2004): »Drawing Battle Lines in Museum View of War«, exhibition review of The Price of Freedom, in: New York Times, 11 Nov. 2004. http://www.nytimes.com/2004/11/11/arts/design/11free.html; Robert Friedel (2005): »The Price of Freedom: Americans at War«, in Finn/Hacker: Materializing the Military (note 28), pp. 149–57;

Figure 7: Including a trash disposer and clothes washer in the 2000 exhibition, Fast Attacks and Boomers: Submarines in the Cold War, helped viewers to gain some sense of life aboard a nuclear submarine.
© *Armed Forces History Division, National Museum of American History, Washington, DC.*

Carole Emberton (2005): »The Price of Freedom: Americans at War«, in: Journal of American History 92, no. 1, pp. 163–65; Scott Boehm (2006): »Privatizing Public Memory: The Price of Patriotic Philanthropy and the Post-9/11 Politics of Display«, in: American Quarterly 58, no. 4, pp. 1147–66.

MILITARY MUSEUMS AND SOCIAL HISTORY

Even as the experience of the world wars made military museums more frankly memorial, it did little to change styles of exhibition. Still, the first tentative efforts at storytelling exhibits began to appear, tending to focus more on the common soldier and his gear than the great men of the past. Military museum curators and historians, observed Frederick Todd in his 1948 survey of European practice, "began to break away from the collection of military items as objects of art or of antiquarian interest; they began to discover they had a respectably serious field of their own in the techniques of warfare".[42] Yet through much of the 20th century, military museums continued to mount arcane displays of war-related objects and static chronological exhibitions of military materiel with little or no interpretation. Exhibits remained much of a piece, according to Todd: "cases of objects associated with the great or near-great, rows of armor for horse and man, dusty uniforms mounted on grotesque manikins, clusters of weapons on their walls, and ceilings of fading banners".[43] Even today, as any regular visitor of military museum will testify, such practices have scarcely vanished, though they are far less pervasive than they once were.[44]

Only in the 1980s did significant changes make themselves felt. Military museums, like other museums, benefited from the growing professionalization of staff members.[45] They also enjoyed the renovation of older structures that helped make them more suitable as museums, or even the construction of new purpose-built museums. No less significant were the new sensibilities shaped by the Second World War and the Cold War and the new thinking engendered by the growing importance of a new social history. More specifically, military museums began to draw on military social history, the new military history as it was called, emphasizing the common soldier, the experience of war, and the place of the armed forces in society. New techniques for displaying the results complemented the new ways of thinking about the past and the new venues.

42 | Camille Bloch (1920): »Bibliotèques et musées de la guerre«, in: Revue de Paris 27, pp. 608–33, as cited in Todd: »The Military Museum in Europe« (note 3), p. 39.

43 | Todd: »The Military Museum in Europe« (note 3), p.39.

44 | For a recent survey, see Barton C. Hacker/Margaret Vining (2005): »European Military History Museums: A Personal, Electronic, and Bibliographic Survey«, in: Finn/Hacker: Materializing the Military (note 28), p. 169–78.

45 | American Association of Museums (1973): Museum Studies: A Curriculum Guide for Universities and Museums, Washington: AAM; Office of Museum Programs (1976): Museum Studies Programs in the United States and Abroad, Washington: Smithsonian Institution; Alexander: Museums in Motion (note 2), pp. 231–48; Gaynor Kavanagh (1991): The Museum Profession: Internal and External Relations, New York: Leicester University Press.

Interactive exhibits and living history were only the most prominent among a range of innovations designed to engage ordinary museum visitors more effectively. Few of these developments went unchallenged and some of the issues have yet to be resolved but the last two decades have clearly seen the appearance of a new kind of military museum taking its place alongside a new kind of military history.[46]

46 | James Morrison (2008): »War and Peace«, in: Museums Journal 108, no. 11, pp. 22–27.

DISPLAYING WAR

Contents and Space: New Concept and New Building of the Militärhistorisches Museum of the Bundeswehr

GORCH PIEKEN

The Historical Military Museum of the Bundeswehr (German Armed Forces) in the north of Dresden is the largest museum in the city and the largest military history museum in the Federal Republic of Germany.

The museum looks back on more than 110 turbulent years of history. Since 1897, the main building of the arsenal in the center of Dresden's Albertstadt has housed in succession the Royal Arsenal Collection (Königliche Arsenal-Sammlung) and the Royal Saxon Army Museum (das Königlich-Sächsische Armeemuseum), after 1923/24 the Saxon Army Museum, after 1938 the Army Museum of the Wehrmacht (Heeresmuseum, after 1942 the Armeemuseum) and after 1972 the Army Museum of the GDR (Armeemuseum). Seven months prior to German reunification, the museum was renamed Militärhistorisches Museum Dresden. In accordance with the directive on the Concept for Museums in the Bundeswehr issued by the Defense Minister on 14 June 1994, the Militärhistorisches Museum Dresden was assigned the role of a leading museum in the Bundeswehr network of museums and collections.[1]

The history of the military history museums and their predecessors begins with the armories and their trophy collections which later became halls of fame and army museums with a distinct national character. They were places designed for displaying military-technical achievements accompanied by pictures of people dying brave deaths in glorious wars and patriotic stories of salvation. There was no room for critical reflection on the chosen perspective. Today, military history museums are – at best – places for individual learning and forums for public debate about the military and military history, enabling visitors to also engage in competent and controversial discussion about current politico-military developments against a historical background.

1 | Cf. 100 Jahre Museum im Dresdner Arsenal (1897–1997). An anniversary document (1997), Dresden: Militärhistorisches Museum Dresden.

Military History Museum of the Bundeswehr, Dresden, exterior facade
© MHM, Ingrid Meier

The Historical Military Museum of the Bundeswehr sees itself primarily as a histori-
cal museum, and not as a museum devoted to the history of technology. Its purpose
is to provide information about our history, to prompt people to ask questions and
to offer a variety of answers – as a museum without pathos, which endeavors to
combine reflection on history and critical debate. It should encourage thinking more
than attempt to endow meaning.

Focused on this objective, the Historical Military Museum of the Bundeswehr
is trying to break new ground both in terms of what it contains as well as how it is
constructed.

In 2001, a concept group of academics and museum specialists developed the
general exhibition concept for redesigning the permanent exhibition. American ar-
chitect Daniel Libeskind was commissioned to fundamentally reconstruct the old
building – a three-wing complex of the Semper school of the 1870s – and add a new
one in 2002. The wedge-shaped, asymmetric new building he has designed pen-
etrates the massive old building with its classical layout. A transparent front of metal
lamellas overlies the historical structure. The new architecture is a cut into the build-
ing which not just changes its external shape, but also fundamentally transforms the
internal structure. "The new structure is internally and externally in contrast to the
existing structure regarding both form and character."[2] The new building comple-
ments the horizontally aligned wings of the arsenal that are arranged in a rigid pillar
grid with cross-storey vertical halls, thus providing room for large and bulky heavy

2 | Daniel Libeskind (2003): Beyond the Arsenal, Brochure, n.d., p. 6.

exhibits. Here, space follows function. And at the same time, there are codings regarding the contents, which make the building itself the first and largest item of the exhibition. The wedge becomes an instrument of force severing the arsenal, a thorn, a symbol of war and pain, the counterpoint of the arsenal which does not accept war, but questions it. The important issue in the planning process for the new building was not to create some kind of office building, where only the number of square meters matters, but instead it was crucial for the architecture to become a symbol of our troubled past.

The framework concept establishes that not only the architectural form of the building shall be redefined, but that it is also necessary to develop a new concept for the permanent exhibition, focused on the issues of modern military history. Following the basic definition of military history coined by Rainer Wohlfeil in the late 1960s, "this discipline of historical science is an inquiry into armed force as an instrument and means of politics and concerned with the problem of leadership in war and peace. It considers war not just a pure military matter, but puts it in the context of general history [...]. Moreover, military history continues to examine the military not just as an institution, but as a factor of economic, social and general public life. Not least it is concerned with armed force as a political force. Analogous to the objective of general historical science – to study man and his sphere – military history focuses on the soldier in all his spheres of life."[3]

The multiperspectivity of the permanent exhibition with its branching out into social history and cultural history offers many ways to interpret German military history. The new exhibition focuses on the human being, the anthropological side of violence. If we want to gain a better understanding of the potential for war in our world to be able to question and overcome it, we have to approach the reasons and nature of that *share of violence* which has always been part of ourselves and all other people in all known social orders. Understood in this way, war is just one form of violence, albeit one that is particularly concise and easily comprehensible in terms of empiricism. The military is just the famous tip of the iceberg whose center of gravity is far below the water line in the field of anthropology and the cultural history of man.

A suitable place for a historical-critical cause study and search for traces that reaches a large audience, not only of experts, but also of interested laypersons, families and schools, is the museum. The Historical Military Museum of the Bundeswehr breaks new ground not only with regard to the topics it covers, but also with regard to the level at which it conveys knowledge, and strikes out in new directions in terms of museum presentations. Visitors are offered two main approaches to military history, each clearly separated from the other in terms of both space and method. On the one hand, there is the traditional chronological tour, the journey in time organized according to dates in the wings of the historical arsenal building and, on the

3 | Quoted in: »Konzeption für das Militärhistorische Museum« (14 December 2001), p. 2.

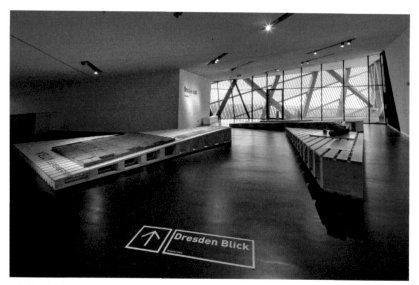

4th floor of the theme tour. In the background, the observation platform and the tip of the wedge
© MHM, David Brandt

other hand, there is the thematic cross-section, the theme tour in the new building designed by Daniel Libeskind.

THE THEME TOUR

At the intersection of the old and new buildings, where Libeskind's wedge severs the arsenal, light travels down a 28-meter shaft, penetrating well into the foyer of the old building. The new building contains a total of six such shafts, which Daniel Libeskind calls *vertical showcases*. On their way through the vertical showcase to the elevators in the new building, visitors pass a video installation called *Love and Hate* by the Scottish artist Charles Sandison. Charles Sandison projects the words Love and Hate hundreds of times on the walls. An endless loop without beginning or end, Love and Hate in a battle, where sometimes Love has the upper hand and sometimes Hate. Visitors become an integral part of the exhibition and the words Love and Hate are projected on them.

Taking the elevator, visitors can reach the fourth floor of Libeskind's wedge. Here, 28 meters above the ground, visitors enter a light-flooded room, which offers them a terrific view of probably the most beautiful object of the museum: the Old City of Dresden. A panoramic pane up to the vertex of the wedge provides an unobstructed view of the Hausmann Tower, the City Hall Tower, and the Church of Our Lady. In its geometrical form, the wedge corresponds to the area of Dresden that

was destroyed by the bomb raids in February 1945. Yet it not only recalls the history of this city, but also the destruction of other European cities in a war that emanated from German soil. Pavement stones from various European cities that show traces of bomb raids or artillery fire are embedded in the floor. There are six square meters of pavement from Dresden's Trinitatisplatz Square that was penetrated by four incendiary bombs, and from Wielun, the first town to be destroyed by German bombs in the Second World War on 1 September 1939, there are pavement stones that cracked under the weight of collapsing houses.

Close to the pavement slabs of Dresden, two biographies document the story of a boy who lost his entire family on 13 February 1945 and the fate of Henny Brenner, a writer who was one of around 200 Jews still living in Dresden in the last year of the war. Just hours before the Allied bombardment of the city, Brenner received news that she was to be taken to a concentration camp. The bombing therefore saved her life.

Visitors reach the second area of the exhibition in Libeskind's wedge via a staircase fixed to one side of a 28-meter high vertical showcase. This showroom on the third floor is completely dedicated to the topic of War and Remembrance. On the theme tour, it is not chronology that defines the direction of the presentation; instead, the exhibits are put into larger contexts of meaning, experience and function. This part of the museum is dedicated to the co-presentation and comparison of similar, identical and related phenomena, processes and memories, which are not limited to only one period.[4]

Each of the three arms of the wedge contains three massive roller shelves with covered fronts like those used in archives. Projections from three high-performance projectors are shown on the outside walls of the movable shelves and the room walls. The projections include three video exhibits from three female American artists, who have completly different approaches to the theme of violence and war. In the work by Martha Colburns, visitors are confronted with fundamental anthropological questions. In this exhibit, the hunting instinct is depicted as the primary driving force in human history. At the end of the exhibit, the hunter becomes the hunted. The artist interviewed soldiers with post traumatic shock syndrome. The flashbacks and jumps in her work are typical symptoms of the illness. This kind of modern art communicates well with people, who may not usually relate to modern art. A second video piece is by Nancy Davenport, in which the main character is shown on the construction side of the new building. In this video piece, violence appears in slapstick and comic. This is based on the roadrunner cartoons of the 1950s. The coyote is always a victim of his own violence. This piece also incorporates the German saying: "wer anderen eine Grube gräbt, fällt selbst hinein" (He who sets a trap for others gets caught in it himself).

4 | Cf. »Konzeption für das Militärhistorische Museum« (14 December 14 2001), p. 9.

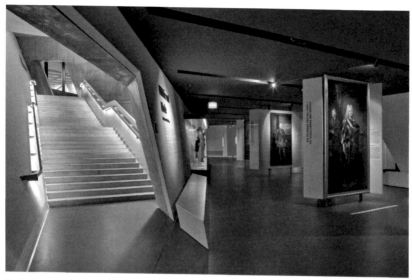

Stairs from the 3rd to the 2nd floor with the Politics and Violence exhibition area of the theme tour
© MHM, David Brandt

Each human being is full of memories. But it is not only individuals who form a memory; communities do so as well. Commemorations, monuments, myths and rituals as well as the conjuration of *prominent* figures, items or historical events – all those material and spiritual places of remembrance form the close and complicated network that is the collective memory of a nation. Which places, events and people become central reference points in the collective memory and how does their significance change in the course of history up to the present? Where does remembrance begin and where does it fail because forgetfulness, for whatever reason, proves to be stronger?

Roller shelves are used to maintain technical order in archives. They are depot systems in which documents and items of the past are stored and kept. In this room, they are not only a piece of equipment; they also refer to the museum as an institution, one which derives its legitimacy from its aspiration of being the memory of mankind.

Each roller shelve contains 16 showcases with two always facing each other. Arranging exhibits face to face is a means of showing opposite views on a topic or contrasting different perspectives. It is also possible to present a theme in one showcase and to cover it in more depth in another or to present different aspects of the same topic in chronological order in both showcases.

The second floor will be dedicated to the topics of Military and Society and Politics and Force. Politics and force are not opposed to each other, but, on the contrary, require one another. The acquisition of power leads to the exercise of rule and the

military becomes the instrument of power and the organ of the executive. Symbols of power emphasize the sovereignty of the powerful. The topic of Politics and Force is primarily presented in paintings. The individual paintings are placed in the room in such a way as to create a kind of walk-in setting. This part of the exhibition is related to theater. The exhibits in this area are not just set up; they are staged and present the pictorial language of power and images of impotence. The extensive presentation covers the entire floor and touches on the other major topic on this floor, Military and Society, in terms of space and content.

The relations between the military and civilian worlds are manifold. The title Military and Society covers a wide range of topics, which offer a particularly vivid description of the close link between the two spheres. Models of military organization and military mentalities were used in the past as models for organizing other social areas, for example, large industrial enterprises or the school system.

The sub-topic of Military and Language not only deals with an inherent means of history and military history used to describe images of oneself and the enemy, to generate hatred, to express suffering and enthusiasm, to characterize the military, superiors, military service and fellow soldiers, but also the most direct medium used to issue orders and commands. Each army, each field of military experience, each war creates its own terminology. People integrate military terms into common parlance in order to *civilize* them or they use words in the present day that were picked up in a war situation, such as the German word *Gassenhauer*, which today means a popular song. Originally, *Gassenhauer* referred to a *landsknecht* (lansquenet), who used his sword to cut a path through the enemy's forces.

Another aspect of the Military and Language topic is the invention of embossed printing or Braille. It received a major impetus from the development of a military script that could be read at night – an invention by French artillery officer Charles Barbier.

The sub-topic of Military and Fashion begins with the *Heerpauke* (trunk hose), continues with the "Rheingrafenhose" (petticoat breeches) and the ornamental trimmings of the dolman, which come from bone ornaments, and goes all the way up to the sailor suit. It includes the invention of wrist watches and sunglasses during the First World War and today's Haute Couture. The origin of modern clothing is the military uniform. Many fashion classics have their origins in the military, like the T-shirt, trench coat, flight jacket and safari fashion. The wide distribution of fashionable clothing is based on the principle of standardized uniform production. In the 18th century, uniform tailors ushered in the pre-stage of the modern clothing industry by specifying four basic sizes, which enabled them to prepare their patterns for sewing. Today's industry basically relies on four sizes, namely S, M, L and XL, for developing a rational system for the mass production of clothing.

From time immemorial, what was originally military music, that is, signal music and military marches, has influenced the relevant musical culture of a period. To point out these connections is the purpose of another topic entitled Military and

Music. Songs, signals and marches have always accompanied military service. For centuries, military music in all its forms has accentuated the glory and misery of the military like no other medium, even more directly than the spoken and written word. Signals structured everyday service; they called soldiers to attack and withdraw; the music of bandsmen directed operations; and military music spurred troops on, chanting to their marching in step, helping them to suppress fear, raising their self-confidence, mocking the enemy, accentuating triumphs and accompanying defeats and mourning.

A fourth sub-section of the Military and Society topic is entitled War and Play. This area cuts through one of the six vertical showcases in the new building, which act as prismatic, cross-storey bracing cores for transferring the load of the reinforced concrete building. Exhibits are suspended in space, like the chairs of a merry-go-round from the 1950s, which are shaped like small miniature biplanes with miniature weapons – a predecessor of modern ego shooters from today's war in children's rooms. The 15-meter deep vertical showcase is bridged by a catwalk. A table showcase near the handrail contains exhibits showing the evolutionary history of war toys. At the end of the catwalk showcase, there is only one exhibit, a doll's house that was built in 1944 and belonged to an English girl. The girl lived in London and made her doll's house fit for war by blackening the windows, using gasmasks as beds for her children dolls and setting up a so-called Anderson shelter in the garden. By then at the latest, the real war had reached the child's room. The catwalk extends into another room of the museum where a V2 rocket from World War II is on display.

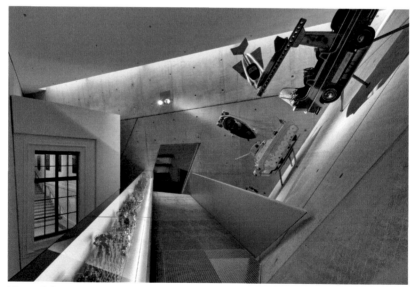

War and Play exhibition area with merry-go-round chairs and historic staircase to the left of the soldiers in file
© *MHM, David Brandt*

The three arms of the wedge on the first floor cover three topics: Formation of Bodies, Animals and the Military and Suffering from War. For centuries, the uniformed military body was the ideal of the ruling class. The principle of obedience of orders, the disciplined functioning of the individual within the whole body, was interpreted as a reflection of a prince's reign and God's divine order. Troop movements followed an almost artistic choreography whose original purpose was to improve the way in which war was fought. Today, the synchronized movements of troops on parade have a primarily symbolic meaning. They are supposed to demonstrate military discipline and governmental power. Through formation, civilians become soldiers. Drill and physical training enable them to fit into the military order and to be capable of performing military tasks. The forming of the body is accompanied by the forming of the mind. A 30-meter long table showcase that even cuts through a vertical showcase contains a line of exhibits starting from the induction order to complete military formation to the disbandment of the military body due to defeat and death. Running parallel to the table showcase, a Bavarian division of the First World War, comprising 13,000 perfect plastic soldiers and vehicles, is set up along one of the outer walls.

The second major subject on this floor is dedicated to the Military and Animals. Animals assist people in performing military tasks. Their names serve as designations and characterizations of military-technical products and are used as codenames in connection with secret operation plans, battle positions, bunkers and underground defense installations. The external appearance of animals is a model for camouflage painting of weapons, vehicles and equipment. They are commodity suppliers for the production of weapons, parts of weapons and uniforms and their ornamentation. Animals have been known to be used in military service since ancient times. Animals such as bears, elephants, donkeys, poisonous snakes, dogs, camels, oxen and horses have been used.

This area basically contains a kind of *catwalk* with 18 mounted specimens on display. These include an elephant, a dromedary from the former German colony of German-Southwest Africa, a mule that served in a Bundeswehr mountain infantry unit, and a lion, which was a symbol of power for the Egyptian pharaohs, who took lions into battle. At first glance, this collection of animals gives viewers the impression of a menagerie of unspoiled nature, a Noah's Ark of peaceful coexistence, but it does not bear a second one. Upon closer inspection, visitors discover that all the animals have a war attribute or injury. The horse is wearing a gas mask from the First World War; the sheep only has three legs because it was driven through minefields during the Falklands War; and a package of explosives is attached to the dog from the Second World War and was set to explode the moment the dog crawled under an enemy tank. The second impression reminds us more of a painting by Otto Dix, of the naked horror of war. A video display shows historical shots from a Wehrmacht laboratory during the Second World War. The shots show an experiment in which the effect of toxic gas is tested on a cat. The mortal agony of the animal gives us a

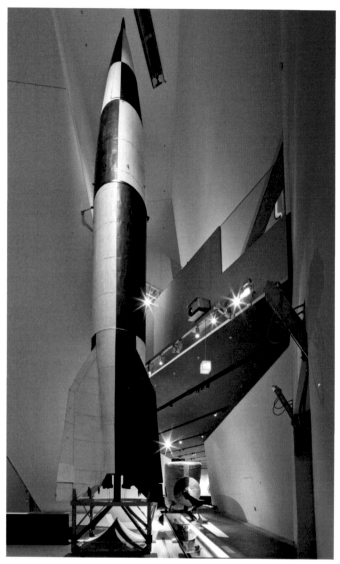

V2 rocket in the Military and Technology exhibition area of the theme tour
© MHM, David Brandt

slight idea of the agonizing deaths human beings suffer. Eventually the results of the laboratory tests are implemented into the war of people – when it comes to physiological experiments, the laboratory is not called a theater of war for no reason.

The largest exhibit in the room is bigger than an elephant and it is not an animal, although it is named after one. A military helicopter with the French name Alouette (in English lark) is presented in a 12-meter deep vertical showcase. In the end, man

has copied nature and perfected it for his purposes in an attempt to conquer nature in its entirety.

In the third and central topic of the theme tour on the first floor, Suffering from War, human specimens are exhibited – an unusual step, even for a military history museum. While visitors think exhibits of that kind from the Napoleonic Wars are rather odd, but do not question their being exhibits, this kind of internal freedom no longer exists if such objects have a closer connection to the present. The world of the Napoleonic era seems to be very far away in contrast to, say, the Vietnam War and even more to the armed conflicts of the 1990s.

The permanent exhibition, for instance, displays so-called Waterloo teeth. These are teeth of young soldiers who died in the Napoleonic Wars. They were skillfully fitted into ivory plates and used as dentures for well-to-do people before suitable porcelain teeth were invented in 1840. Another exhibit of this kind originates from the First World War. It is the retained missile in the backbone of a soldier, who lived for another 47 years with this injury. This exhibit is displayed with other evidence of injury and death, of physical and moral suffering.

In handling specimens of human origin, it is a matter of course to maintain their human dignity. In addition, we have to especially consider the recommendations of the Standing Conference of Ministers of Education and Cultural Affairs of the Federal States regarding the handling of specimens from the Nazi period.[5]

Particularly heavy exhibits will be on display on the ground floor, where the theme tour has the largest exhibition space, almost 1,200 sqm, and the greatest floor load. The close link between the military and civilian use of technical developments is explained to visitors in a wing entitled the Military and Technology. *Dual use*, the usability or use of technology for military and civilian purposes, is often the result of the conscious research objective of considering the potential military use of developments in the sponsoring of civilian research. On the other hand, there are a large number of military developments that have also been used for civilian purposes. The length of that relationship, although not without breaks, is particularly worth mentioning for the variety of opportunities for development and the close integration of the two areas in almost all fields of knowledge. It reveals the basic ambivalence of technology.

The exhibition tour starts with the *egg timer* which ticks in any time fuse, then continues with the bicycle, the military use of which was considered when it was

5 | "The dignity of the human being must be kept in all activities regarding the preparation, keeping and presentation of specimens. The specimens must be treated with respect.", quoted in: »Empfehlungen zum Umgang mit Präparaten aus menschlichem Gewebe in Sammlungen, Museen und öffentlichen Räumen« (2005), in: Der Präparator 51, p. 97. Cf. »Ständige Konferenz der Kultusminister der Länder der Bundesrepublik Deutschland, Verwendung medizinischer Präparate von Leichen von NS-Opfern.«, in: NS 112. AK. 25/26 January 1989.

first patented and tested in 1851 during the New Zealand War, and submarines, represented by the oldest preserved submersible in the world, and ends with rocket technology, which has been used for civilian and military purposes.

The topic of the Military and Technology also covers the close connection between the world of science and the military in the development of stimulants and intoxicants, the German armed forces during the Second World War serving as an example. In the period between April and July 1940, 32 million Pervitin tablets were given to Wehrmacht soldiers, the drug having been referred to as a *stimulant* to play down its risks. Today, Pervitin is better known as *ecstasy* and is widespread, above all in discos and the techno scene. Used straight, pressed in dextrose or mixed in chocolate, Pervitin suppresses fatigue and hunger, euphorizes and *refreshes*, replaces doubt and despair with aggressive, imperative confidence – until the reserves of the body are spent. Bomber pilots who remained in the air for 17 hours, submarine crews and child soldiers who after school manned the flak at night – they all used the *wonder drug*. To find the right dose for the *endsieg*, terrible experiments were conducted on concentration camp prisoners. After the end of the Second World War and the *Third Reich*, there was a pharmacological continuity – across all political borders: The NVA stored Pervitin for use in case of an emergency until it was disbanded in 1989, as did the Bundeswehr, at least up until the 1970s.

The topic of Protection and Destruction in the second wing of the ground floor deals with the competition between fire and stone, protective and destructive weapons throughout the centuries. Viewers should be confronted with the knowledge that there is no reliable protection from the destructive effect of weapons. This is particularly illustrated by a hail of bullets in the form of a ballistic curve which extends across several floors of the new building and is aimed at shelters and visitors on the ground floor of the theme tour. Exactly at this point, the artist Ingo Günther has simulated the most radical form of destruction, an atomic bomb explosion, using a strobe light, which temporarily etches visitors' shadows to a phosphoric wall for a few seconds – similar to the impressions from Hiroshima.

CHRONOLOGY

Visitors to the museum find that the Historical Military Museum of the Bundeswehr is a two-in-one museum – and that they are guided in opposite directions. The theme tour in the new building goes from top to bottom and the chronological tour in the wings of the old buildings goes from bottom to top.

The second and largest exhibition area of the Historical Military Museum of the Bundeswehr, the Chronological Tour, presents the relationship between the military and society in Germany against the background of general history through the various periods starting from the late Middle Ages up to the present. Historical exhibitions thrive on the succession of events and the language of things. Certain main

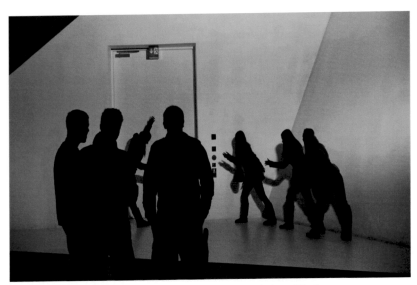

The Hiroshima. Thank You Instrument artistic intervention by Ingo Günther
© MHM, David Brandt

questions must be posed for chronology to become a mode of organization. Key questions pervade all the wings of the chronology area like loose, but coordinated threads supplementing each other, offering visitors the chance to take a fresh look at old items and topics. Although the main path is described by government actions and wars, the exhibition succeeds in overcoming the contrast between everyday history and political history without claiming to provide binding interpretations.

The chronological tour starts on the ground floor of the western wing of the old building with the period from the late Middle Ages to 1914. The exhibition is arranged on different levels and offers different depths of information. Three distinct elements or types of rooms, which are clearly different in terms of their architecture, make it easier for visitors to orient themselves on the chronological tour. A central path leads visitors through the periods in various sections. On a second level, the narrative is more extensive and the exhibits are smaller than on the main path. A third level is intended for in-depth rooms – places in which the visitors can pause, ask questions and find more subtle, detailed and additional information. According to Roland Barthes, the spatial concept represents an "architecture of information"[6] in contrast to the mere succession and addition of exhibits. One primary exhibit introduces each wing devoted to a period.

6 | Roland Barthes (1988): Das semiologische Abenteuer, Frankfurt a.M.: Suhrkamp, p. 183.

The chronological tour starts in the western wing on the ground floor with the exhibition on the *Late Middle Ages to 1914*. This hall is subdivided into the periods of 1300–1500, 1500–1806, and 1806–1914.

The first cabinet in this wing is dedicated to the topic of Force in the Middle Ages. Visitors pass the mercenary and *landsknecht* (lansquenet) systems as well as the Peasants' War and reach the early modern times. The aim is that even hurried visitors, who do not enter each room, leave out the in-depth information and basically do not stray from the wide external tour around the chronological tour, are able to experience the characteristic features of a period. Three to four major topics in each wing of the old building are covered in the form of so-called talking pictures, which are directly connected to the external tour. They allow visitors to make an abbreviated tour through the periods and are arranged in impressive mnemonic devices, which ensure that visitors will remember them for a long time.

In contrast, the in-depth rooms are intended for visitors who want to take a close look at a particular period or who want to explore a topic in more detail. The first wing of the old building contains in-depth rooms on the following topics:

- Military Technology and Tactics from the 16th to the 19th Centuries
- The Economy of War from the 17th to the 19th Centuries
- The Military and Society: Structural Changes within the Military Society

The in-depth rooms are often further subdivided to allow different topics to be addressed. The in-depth room devoted to the Military and Society, for instance, includes the following areas:

- The development of standing armies and the stabilization of an international soldier market
- The enlightened soldier
- Everyday military life in a garrison
- The unity of civilian and military architecture and engineering.

The tour guides visitors through the Napoleonic Wars, the Revolution of 1848 and the Wars of German Unification to the Wilhelminian society of the pre-war era. This wing includes several highlights, for example, the oldest preserved female uniform in a German museum, which Prussian Queen Luise had made for her appointment as honorary colonel of the Prussian Dragon Regiment No 5 in 1806, or a uniform worn by a 21-year-old soldier in the Battle of Vellinghausen during the Seven Years' War. In the battle, the soldier lost his left arm to a French cannonball. Another highlight is a petition signed by around 250 soldiers from Rastatt in March 1848. The signing of a petition was very risky at the time. After the revolution failed, many of these soldiers were arrested and imprisoned for many years. The soldiers of the democratic

Entrance to the Napoleonic Wars cabinet
© MHM, David Brandt

movement were not just soldiers, but also citizens. After the defeat of the democratic movement, these citizen-soldiers were forgotten. The last exhibit in this wing is the open gates of the *Reichsmarineamt* (German Naval Office). The former imperial *Reichsmarineamt* on the *Landwehrkanal* was the equivalent of a naval ministry and was the place where *Großadmiral* Tirpitz, acting on orders from Emperor Wilhelm II, began to systematically transform the formerly rather modest imperial navy into an instrument with which Germany could pursue its quest for world power in 1897. The main entrance doors of the building (which today houses the Federal Ministry of Defense in Berlin) opposite the *Landwehrkanal* have been replaced for security reasons. Adorned with maritime symbols, the doors emblematize the Empire's entrance into global politics, a step which eventually resulted in world war and defeats.

The core of the exhibition is surrounded by a continuous bench that offers visitors the chance to rest at any point of the exhibition. At the same time, this bench is used for electronic media in the form of interactive terminals offering a wide variety of additional information on the exhibition.

By lift or through the historical staircase, visitors reach the exhibition area devoted to the World War Era of 1914 to 1945. Recent historical research regards the period between 1914 and 1945 as a second Thirty Years' War, a renewed removal of constraints with regard to violence. A comparison of the forms, perceptions and effects of warfare in both World Wars is intended to draw visitors' attention to both the continuity as well as the differences and breaks between them.

*Central path through the 1914-1945 chronological wing with the main showcase on the
First World War*
© MHM, David Brandt

Technologization and industrialization in the First World War changed the image
of the soldier. "An entire generation is brutalized" (Hannah Arendt) in the trench
warfare and the continuous barrage on the Western Front. The course of the war on
that front is depicted just as comprehensively as that of the so-called Forgotten War
in the East and in the colonies as well as of the air and naval wars. The United States'
entry into the war and the failure of the German spring offensives of 1918 were the
beginning of the end of the fighting. The in-depth rooms show the different faces
of war, including topics such as death and injury, captivity and propaganda, war
behind the front, the war economy, the employment of women, military technol-
ogy and tactics. The in-depth showcases on the First World War extend over more
than 30 meters. Across from them are the in-depth topics of the Second World War,
which allow visitors to make a direct comparison. This elongated room with its par-
allel rows of showcases can be entered from either period. Visitors enter the history
of events and politics of the Second World War through the first post-war period
of 1918. In the Weimar Republic, people had ensconced themselves in peace for a
short time, but this period was only a reprieve in which concepts were developed on
how it would be possible to still win the First World War. The National Socialists'
policy of finding a way to revise the Treaty of Versailles, if necessary by risking an
armed conflict, met with support among many classes of society. The policy of revi-
sion changed smoothly into an unrestricted policy of conquest. With the attack on
Poland on 1 September 1939, the German Reich triggered the Second World War.

While the First World War had been a war between nations and peoples, the Second World War, under Nazi rule, was a war based on racial ideology. The Wehrmacht reached its moral low in the war with its indirect and direct participation in the genocide of the Jewish population.

From 1939 on, Hitler spoke openly of their *extermination*. Already deprived of their rights and under pressure to emigrate, Jewish citizens became the target of arbitrary murder campaigns, which gradually became systematic. After the launch of Operation Barbarossa, special murder squads (*Einsatzgruppen*) of the SS conducted pogroms against Jewish people on Soviet soil, just as they had done in Poland. They started by shooting mainly men, but they began killing women and children in autumn 1941. The Wehrmacht assisted them in this. After it had been decided to wipe out the Jewish population entirely, the organizational procedures for this were discussed at the Wannsee Conference in January 1942. Under the codename *Operation Reinhard*, the SS set up death camps containing gas chambers and crematoria in Poland, in which millions of Jewish people were murdered and burned. Those who were fit were initially forced to work in the armaments industry (*extermination through labor*). By the end of 1942 the *Einsatzgruppen* had murdered between one and two million Jewish inhabitants in the areas behind the front. A total of around six million European Jews fell victim to the genocide by the end of the war.

The opposite wing of the first floor houses the period from 1945 to the present. Visitors are led through the immediate post-war period into the bipolar world of the Cold War and the years when both German armies – the Bundeswehr and the National People's Army – were set up. A good deal of space is devoted to the history of the Bundeswehr. The subjects covered in the in-depth rooms are not only the new model of the citizen in uniform and the concept of *Innere Führung* (military leadership and civic education), but also the difficult process of establishing traditions and everyday life in barracks. The political chronicle covers the period from the heyday of the Cold War through the 1960s, when the readiness for détente and arms limitations increased, until the 1980s, when the Cold War reached another peak after the Soviet invasion of Afghanistan in 1979 and the NATO dual track decision. The fall of the Berlin Wall and the reunification of the two German states marked the beginning of the history of the new Bundeswehr.

The structural reforms of the Bundeswehr after 1990 are the answer to the challenges faced by the reunified and sovereign Germany in view of the new security situation that evolved after the end of the Cold War. Since the civil war in the former Yugoslavia and the decision of the Federal Constitutional Court of 1994 on the conditions upon which the Bundeswehr could be employed, the armed forces have increasingly been assigned "out of area" tasks. The first mission the Bundeswehr was ordered to accomplish under war conditions after the end of the Second World War in Kosovo is just as much a topic as the discussion it sparked in society. The employment of German soldiers in humanitarian, crisis management, peace enforcement and stabilization operations, which is meanwhile generally possible all over

the world, has become a tool of German foreign and security policy. The increased dangers for Bundeswehr soldiers are a consequence of this.

The exhibition depicts this changed situation by a Wolf vehicle that has been damaged in an attack in Afghanistan. The Arab text on the German flag of the vehicle is a symbol of the globalization of Bundeswehr operations and its risks. Integrated into multinational structures and committed to upholding the values set out in the United Nations Charter, the Bundeswehr is now, after several structural reforms, in a process of permanent transformation in order to adapt to the continuously changing situation – the reality of mission objectives and operational conditions.

The last exhibition area of the chronological tour is entitled *Challenges of the 21st Century*. It addresses topics like the experience of violence and human rights, security policy after the end of the East-West confrontation, conflicts about resources, pacification wars, but also international jurisdiction and a modern concept of peace, which also includes protecting and preserving the environment. Ladders from the border fence of the Spanish exclaves on African soil, Ceuta and Melilla, are both fragile symbols of hope and symbols of the separation between the south and north, between the poor and rich. At the end of the tour, visitors reencounter techniques reminding them of the Middle Ages, the simple wooden ladder, used by people to overcome the high-tech fortress Europe, often on a desperate flight from poverty and misery.

Traditions, convictions and exercises have formed conventions in museum presentations. Characteristic forms of arranging exhibitions have been developed for each type of museum. The Deutscher Museumsbund (German Museums Association) has assigned military history museums to the technology museum category. A typical feature of this category is the tendency to classify presentations of objects with typological classes and subclasses.[7] As a result, the museum presentation consists of rows of objects organized according to function and size, which sometimes reminds us of multi-level parking garages. Within this structure, there is little space for the whole range of military history.

The permanent exhibition of the new Historical Military Museum of the Bundeswehr is an attempt to break free of conventional museum presentations by permitting forms of presentations that are rather unusual for collections of military and technical items as well as traditional chronological tours. The habits by which people view museum exhibits are broken right from the beginning because – for example – all the exhibits, even extremely large and heavy items of equipment, are presented on a display belt hovering 50 cm above the floor. Although the showcases are primarily raised to ensure an even temperature in the old building, the display belt also supports the story line of the chronological tour. Even heavy weapons become part of the story and are not reduced to their technical data. Their apparently

7 | Cf. Jana Scholze (2004): Medium Ausstellung, Lektüren musealer Gestaltung in Oxford, Leipzig, Amsterdam und Berlin: Bielefeld, pp. 12 and 27.

objective treatment as purely technical objects and their presentation to visitors at eye level can prompt visitors to develop a sense of familiarity and closeness with the major exhibits, thereby leading them away from the intended story. The only real way to get in touch with the past is to maintain a critical distance to it. The elevation of the exhibits gives us a sense of distance from the objects, which are presented in a way that reminds us of an autopsy table or an anatomical microscope, allowing us to acquire a better understanding of the materiality or specific characteristics of the items or of the way in which they have been damaged.

Sparsely, but brightly furnished, the rooms devoted to the chronological tour are committed to traditional museum aesthetics. The presentation materials, such as showcase equipment, pedestals and movable walls, are unobtrusive in their appearance so as to highlight the objects and are limited to displaying and protecting the exhibits. Unlike many exhibitions of museums of technology and army museums, the presentation means used here do not play a part in communicating the contents of the exhibition.

The traditional chronological narrative contains the majority of around 10,000 objects, documents and pictures displayed in the interior of the building.

OUTSIDE AREAS AND A WALK-IN DISPLAY DEPOT

The outside areas are display areas as well. The area next to the western wing is dedicated to the history of the Bundeswehr and the NVA from 1955 to 1990. In addition to armored reconnaissance vehicles, tank destroyers, main battle tanks and armored infantry fighting vehicles are on display.

The area adjacent to the eastern wing of the old building displays the technical equipment the Bundeswehr has used in the out-of-area missions in which it has participated since 1990. Important examples for mission reality are camps, patrols and engineer support for the local civilian populations. Since the end of the bipolar Cold War world, the topic of global military challenges and relief missions supported by German armed forces has become a constant subject of public discussion. Therefore, soldiers on deployment are also a symbol for a new development in recent German military history.

The framework concept of the museum favors a close connection between changing and permanent exhibitions. The Historical Military Museum of the Bundeswehr does not define itself exclusively through its permanent exhibition, but equally through its changing exhibitions. For this reason, the ground floor houses a large hall for changing exhibitions, with excellent conditions for conservation and security.

The walk-in display depot in the listed building on the northern side of the main arsenal building will be opened at a later date; the majority of the large and heavy exhibits will be on display there.

Such a large number of objects of this kind can be displayed neither in the old building nor in the Libeskind wedge. Instead they will be presented in a large scale depot space. It is, so to speak, the large in-depth area for the topic of the Military and Technology and, like a study collection, offers a wide range of demonstration material and possibilities for comparison for those interested in the history of technology. One advantage of the new permanent exhibition is the chance it offers firm expectations both regarding the perspectives adopted towards military history and the presentation of it under question.

The museum would like to open rooms for thought and sees itself as a forum both for dealing with military history, and for discussing the role of war and the military in the past, present and future.

From Technical Showroom to Full-fledged Museum: The German Tank Museum Munster

1. ORIGIN OF THE GERMAN TANK MUSEUM MUNSTER

Munster was a garrison from 1893 until 1945 and is regarded by many as the birth-place of the tank corps of the Wehrmacht. Then, from 1956 onwards, the city be-came one of the most important training sites in West Germany, as the two main schools for combat troops were established there – the school for the tank corps and the school for mechanized infantry. Thus, Munster was the centre for modern tank warfare in West Germany and, at the same time, became the focus of the evolving memory of the Wehrmacht tank corps. Therefore, objects from the World War be-gan to trickle into Munster – uniforms and decorations at first, donated by veterans who wanted to see their tradition honoured. During the 1960s, the NATO partners returned Wehrmacht tanks and other vehicles. These two collections were unofficial at the time, but were expanded by enthusiasts nonetheless. Especially Bundeswehr (German Armed Forces) vehicles were made part of the collection now, since this army was old enough to have the first obsolete vehicles itself. In 1972, the collection was recognized officially by the Ministry of Defence and from now on served as a study collection for soldiers that were training in Munster.

But military and civilian society are closely intertwined in West German garri-sons, which led to growing public interest over the years as more and more civilians asked for permission to see the study collection. The effort soon proved too much to handle. Therefore, the Municipality of Munster and the Bundeswehr agreed to join forces to transform the collection into a public museum. The chosen structure for this project in 1983 has not changed since that time and is important for everything that will be discussed later on.

The German Tank Museum was created as a double structure. The study collection was moved into the museum as an entity, and still exists as such inside the museum. All the tanks, guns and trucks still mainly belong to the Bundeswehr. Furthermore, the study collection still has its mission to educate the soldiers that train in Munster. The Municipality of Munster, on the other hand, organises the whole operation of the public museum proper: personnel, building maintenance and the like. As a museum it has to appeal to the broader public. Basically, the institution consists of two separate organisations that are interlocked and indivisible, but, at the same time, often with aims ranging from slightly varied to radically different. Nevertheless, both sides need each other: If the Bundeswehr should decide to simply pull the vehicles of the study collection out of the museum, it would be practically empty. If the Municipality of Munster should decide to shut down the Museum, the study collection would be homeless. This situation remains unchanged until today and each side has to respect the specific needs of the other side to change anything in the museum. Each and every decision has to be a compromise to some degree.

2. REFUSAL AND RELUCTANCE (1983 TO 2008)

The concept of war as a culturally shaped, social activity was completely non-existent in the first years of the Tank Museum. The museum started as a collection of big halls that were kept so sterile that the dominating atmosphere was that of a warehouse. This cold, technical atmosphere was reinforced by the presentation of the central objects. All tanks were completely restored; no trace of their fate in war was left visible. The vehicles were also placed in neat rows, separated from visitors by coloured ropes, with signposts providing merely technical data. It ultimately was a show room for tanks; nothing more.

Why was this presentation chosen? There were simply no historians or museum experts on either the military or the civilian side. Due to a lack of expertise in creating a multifaceted concept it was basically all the founders could come up with at the time. However, this raises a very interesting question: WHY was no such expert involved? At this point, both the civilians and soldiers involved in the museum openly denied that a Tank Museum needed any concept at all. Their reasoning was a mixture of political and cultural reasons: During yet another height of the Cold War, the military and many local politicians, who often had been professional soldiers before, were very suspicious of critical views of the military and war in general and of the Wehrmacht and the World War specifically. A critical view of war and military per se was problematic, since the German Army was essential for both – the nation in the Cold War and Munster as a community shaped by the military and ex-soldiers. The problem regarding the Wehrmacht was even more serious. At that point, the Wehrmacht was still considered as a more or less innocent army, while the Waffen-SS was widely regarded as the exclusive group of villains. Since veterans

of the Wehrmacht were still numerous in the 1980s and formed a significant part of the visitors, it seemed easier not to ask too much. Left-wing political aims, pacifist motivations, academic nonsense, whistle-blowing – whatever it was called during the public debate, it was clear what was meant: A critical approach could potentially damage the reputation of the German Armies past or present. The first draft of a concept for the museum was written in 1985, mainly by the commanding officer of the study collection. It had primarily been written in order to acquire subsidies from the state of Lower Saxony[1]. Therefore, the draft concentrated almost exclusively on technical history and aimed to portray the tank as "one of the decisive war devices of the 20th century".[2] Decorations and uniforms served to show "fighting will, bravery and the willingness to bring sacrifices".[3] The Ministry for Science and Education regarded the paper as insufficient[4] and a second draft was submitted, this time written primarily by the Municipality of Munster's chief of administration. This concept was accepted by the ministry and was passed by the city council in early 1986. Although of civilian origin, it still basically followed the premise of the first paper: even though political and economic history was to be taken into consideration, in practice a purely technical presentation was chosen; obviously considered the most harmless form of exhibition. The horrors of past and future war were kept out of the museum because it was politically and socially convenient, and this was achieved by actively using the technical fascination of the objects to cloud visitors' viewpoints of the objects. Thus, war was hidden behind the war machines. This approach could remain unchallenged for a long time because the civilian employees of the museum were all retired soldiers. Therefore, they by and large had the same mindset and values as the military side. The local political opposition fought many years for a more scientific and critical concept, and for the inclusion of other topics like death, misery, militarism, war economy etc.[5] However, the political scene of Munster was traditionally dominated by the conservative Christian Democratic Union (CDU), which brought many soldiers and ex-soldiers into the city council and administration.

A principal problem of the museum supported the long lasting refusal of a critical approach: The aura of the objects is the main asset of every museum.[6] But the

1 | Niederschrift Sitzung von Vorstand und Beirat des Vereins der Freunde und Förderer des Panzermuseum Munster, 5 September 1985, p. 3.

2 | Entwurf: Die Museumsdidaktische Konzeption des PANZERMUSEUMS MUNSTER, 8 August 1985, p. 5.

3 | Ibid, p. 3.

4 | Schreiben von Stadtdirektor Peters, 21 January 1986.

5 | Museumsdidaktisches Konzept für das Panzermuseum Munster - Vorschlag der SPD-Fraktion, 3 October 1986.

6 | Dietmar Preißler (2005): »Museumsobjekt und kulturelles Gedächtnis, Anspruch und Wirklichkeit beim Aufbau einer zeithistorischen Sammlung«, in: Museumskunde 70 (1), pp. 47-53, p. 52.

Exhibition of mixed Wehrmacht Vehicles, early 1990s.
© German Tank Museum

technical aura of the objects in the tank museum is so dominating that people tend to be overwhelmed by it. The technical character of the objects often fills the mind of visitors and employees alike, leaving no mental space to come up with questions regarding the historical contexts. It then seems either inconceivable or at least un-necessary to have more than a purely technical point of view. So in the early years, a critical reflection of the objects, including war and violence, was seen by the opera-tors as both unnecessary and potentially harmful. The situation was worsened by the fact that the chosen double structure was not defined very well in the contract: In 1988, it was finally decided who was to be responsible for conceptual work between the military, the administration of Munster and the city council.[7] Only during this year, five years after the opening, was a modus operandi established to include all groups. It's not surprising that no progress was made during this phase.

In the 1990s, things began to gradually change. Pressure was slowly building from several sides. For starters, German museums had begun to professionalise their work, making the shortcomings of the Tank Museum more obvious. Due to this process, the number of visitors increased and although the old magic of technical overwhelming mostly worked, critical questions became more frequent. Additionally, the political and cultural climate in reunited Germany was changing. The public paid attention to new debates, like the furious debate concerning the Wehrmacht exhibition, which sparked new interest in modern military history.[8]

7 | Anfrage des Ratsherrn Dr. Frhr. v. Rosen zur Sitzung des Kulturausschusses, 18 February 1988.

8 | Christian Hartmann (2004): Verbrechen der Wehrmacht: Bilanz einer Debatte, Hamburg: C.H. Beck.

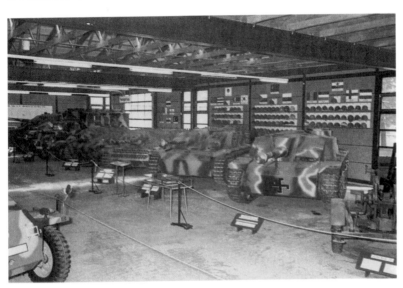

Exhibition of Wehrmacht Tank Destroyers, mid-1990s
© *German Tank Museum*

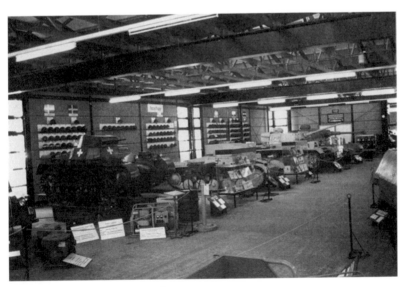

Exhibition of Wehrmacht Tanks, mid-1990s
© *German Tank Museum*

So the Tank Museum took a leap and decided to really include political and eco-nomic aspects as part of a new concept, which was written by an external historian. In this concept, historical contexts became a kind of framework for the tanks. But the realization was still very conservative and sterile, covering mostly operational history on an abstract level and classical political history, shaped by the deeds of "great men". War, if represented at all, at least had to be clean and well-organised. War in all its facets had yet to reach the peaceful halls of the Tank Museum. The view from below was not adopted, humans were absent in the presentation, and with them the history of blood, guts, misery and despair remained invisible.[9]

Furthermore, even this new approach was only made very reluctantly. The con-cept, and even the museum's catalogue, explicitly stated that broad military history had no place in the Tank Museum, as this was considered the exclusive domain of the Military Museum in Dresden.[10] Everything political had to be directly connected to the tanks themselves and even then some topics were avoided. The Waffen-SS, for example, was deliberately ignored on behalf of the Bundeswehr. Since the SS is not part of the tradition of the modern German Army, addressing it was considered too challenging for the Tank Museum, and, therefore, the topic was handed over to Dresden, despite the Waffen-SS fielding a significant portion of the German tank corps in 1944. Once again, the blinders were on – historical contexts only served to lead the visitor to the technical object, not the other way round. They were more or less an alibi. The development of the concept dragged on for the whole decade; the first draft was submitted in 1990, and the final version was accepted in 1999.[11] Obviously, the majority of decision-makers during that decade had no enthusiasm for real reform. This was made abundantly clear in 1992, when a protocol stated that no particular haste was necessary, since public funds weren't accessible for the museum anyway.[12]

In the last decade, pressure continued to build as the number of visitors steadily increased. Since the Municipality of Munster traditionally relied on the Bundeswehr as an economic factor, the ongoing reforms in the army since 1990 forced the town to consider alternatives, should the army ever leave. The Tank Museum was now seen as the main draw for tourists in the region. But for that purpose, quality had to be ensured. A first step was taken when the old concepts were completely dis-missed and a new approach was taken in 2004.[13] The new concept required the real

9 | Manfred Henkel: Didaktisches Konzept für den Ausbau und die Gestaltung des Panzermuseum in Munster, 4 March 1996.

10 | Museumskatalog (1999), p. 20.

11 | Niederschrift über Sitzung von Vorstand und Beirat des Vereins der Freunde und Förderer des Panzermuseum Munster, 17. March 1999, p. 4.

12 | Niederschrift über Sitzung von Vorstand und Beirat des Vereins der Freunde und Förderer des Panzermuseum Munster, 25 June 1992, p. 6.

13 | Konzept für den Ausbau und die Gestaltung, 14 October 2004.

inclusion of multiple and critical perspectives.[14] To expand this theoretical approach scientifically and to ensure its later realisation, a position was created for a historian in the museum.

3. REFORM (2008 TO 2011)

While the intentions were good, there are certain issues that the German Tank Museum must resolve to fulfil this mission. First of all, the Tank Museum is not a military or a war museum. It has to somehow manage to preserve its unique character as THE German TANK Museum. The museum is simply not able to drastically reduce the number of tanks shown in the exhibition. They can be reduced slightly, but the tanks will always have to remain the core of the exhibition. The Tank Museum will have to stay a specialised museum. But this always comes at the cost of keeping the aforementioned problem alive: The technical aura of the objects will continue to dominate visitors' minds, no matter how many additional aspects are added. This situation is worsened by a second factor: Tanks, like other military vehicles and weaponry, are often focuses of serious object fetishism. The object's connotation of destructive capacity and powerful machinery, intensified in many cases by war anecdotes and contemporary propaganda, results in a full-blown admiration for tank models.[15] In this respect, tanks take on mythical qualities, often expressed a) through excessive use of superlatives when it comes to describe the vehicles and b) by uttering statements that can only be described as omnipotence fantasies.[16] Interestingly enough, most visitors feel compelled to explicitly stress the fact that their admiration is purely technical. They do realise that an admiration for the historically intended use of the vehicle, that is, to maim and kill, would be socially unacceptable.[17] Therefore, they wittingly or unwittingly try to distance themselves from such potentially anti-social behaviour. In this strange mix of fascination for technology and violence, tanks are not perceived as historical objects in a museum. They are merely witnesses for the myth of the respective tank model. This does not just apply to tanks that actually were used in war, by the way. The East German and West German tanks of the Cold War are also shrouded in myth. Still, the most fascinating period for our visitors is indeed the Second World War, which leads to a fourth problem: Although

14 | Gutachterliche Stellungnahme zum Konzept für den Ausbau und die Gestaltung des Deutschen Panzermuseums Munster in der Fassung vom 10. Oktober 2004, March 2005.

15 | Eva Zwach (1999): Deutsche und englische Militärmuseen im 20. Jahrhundert, Eine kulturgeschichtliche Analyse des gesellschaftlichen Umgangs mit Krieg, Münster: LIT, p. 310.

16 | Peter Jahn (2003): »Gemeinsam an den Schrecken erinnern: Das deutsch-russische Museum Berlin Karlshorst«, in: Museumskunde 68 (1), pp. 30–36, p. 32.

17 | E. Zwach: Deutsche und englische Militärmuseen im 20. Jahrhundert, p. 308.

the objects of this era only make up about 25% of the vehicles in the whole museum, they draw the majority of visitors' interest. This stems from a widespread fascination with the Wehrmacht as a successful, very modern, very technical army, which is pretty much completely wrong.[18] However, the myth remains widespread and often also borders on fetishism. The tanks appear to be the physical witnesses to this idea. Tanks are especially important for those Wehrmacht fans. Historical research has made it more difficult from year to year to admire the Wehrmacht. The fact that this army was one of the main contributors to the national socialist genocide is very inconvenient for many fans.[19] However, the tank corps of the Wehrmacht still seems potentially admirable to them, their reasoning being that this armoured spearhead never really had the time to commit war crimes during the war. Therefore, the tank corps can still be admired in a purely military way. This false reasoning,[20] combined with the technical aura and the magic of war anecdotes, explains the undiminished fascination that this relatively small part of the museum is able to evoke. Thus, in the long run, the Tank Museum has to keep its tanks, but, on the other hand, it has to completely change visitors' views of those tanks, while deconstructing dozens of myths surrounding them.

This has to be done against the visitors' wishes, by the way. A recent internal survey found that 79% of visitors think the museum is "critical enough about war and violence", although from the museum's point of view only a few minor steps have been taken in that direction in the last two years. 16% believe the museum is "not yet critical enough" and only 4% think that the museum is "far from critical enough", as practically all professionals do, including the Tank Museum's historian. So the visitors would be more than happy to keep their view on tanks. There are four reasons for that:

First of all, due to the technical aura, visitors are generally not able to think of anything other than a technical perspective. To come up with these perspectives and make them interesting is the job of the museum, so there can be no blame here. The second reason is: Whatever new perspectives are used to look at tanks, they will never contribute to the convenient myths that brought the visitors to the museum in the first place. The entertainingly competitive stories about the best tank in the world, about the fastest model or the thickest armour won't be as entertaining any more once every aspect has been examined and differentiated. Thirdly, new perspectives are usually intellectually challenging. A cool story about the best gun in the world is

18 | Karl-Heinz Frieser (2005): Blitzkrieg-Legende. Der Westfeldzug 1940, München: Oldenbourg Wissenschaftsverlag, p. 64.; R.L. DiNardo, (2006): Germany's Panzer Arm in WWII, Mechanicsburg: Stackpole Co, p. 29.

19 | Sharon Macdonald (2007): »Schwierige Geschichte – umstrittene Ausstellungen«, in: Museumskunde 72 (1), pp. 75–84, p. 79.

20 | Christian Hartmann (2010): Wehrmacht im Ostkrieg, München: Oldenbourg Wissenschaftsverlag, pp. 492–494.

one thing; it is quite another to look at the cultural, social and economic influences that made the engineers design the gun in the way it was. The fourth reason has to do with inconvenience as well, but is a primarily German problem regarding the Second World War. There is a widespread feeling that historians, schools and media concentrate too much on the Holocaust and war crimes when dealing with the Second World War. It's a feeling of being overfed with guilt, so to speak. As mentioned before, the tanks seem to be disconnected from that topic somehow.[21] Therefore, whenever a museum starts to critically examine the historical contexts of the tank during this period, sooner or later inconvenient aspects like the war economy, forced labour and Auschwitz will come up, and this then again activates a reflex of denial. Simply put: To look at a tank from different points of view, to think about it rationally rather than just approach it emotionally and to deal with inconvenient aspects of its history means that the tank isn't that much fun anymore.

Thus, the new concept of the German Tank Museum is a real spoilsport. It specifically aims at the deconstruction of convenient myths. Tanks as technical objects are seen as starting points for broader historical contexts. These contexts still include the old perspectives of the museum: operational history and political history still have their place in the Tank Museum. But now economic history, cultural history and social history are added, the latter ones with a strong focus on the perspective from below, sometimes bordering on micro-history. That way the tanks play a dual role: They serve as a springboard for visitors to delve into areas of history they didn't expect in this museum. At the same time, they serve as anchor points and as a thread for visitors to follow, which are necessary to help them find their way through these new areas of history.[22]

This approach works for both contexts: war and peace. The Museum covers roughly 100 years of German history, including 10 years of World Wars and roughly one and a half decades of German out-of-area operations. But the 25% on wartime are and will continue to remain the more exciting phases for visitors. Whereas war was once a combination of tales of heroism, operational art on maps and numbers and data of tanks, it is now presented in the Tank Museum as a complex mosaic of politics, economy, cultural and social influences. In this way, visitors are encouraged to think about the enormous complexity of war.

One important piece of this mosaic is the human experience. The museum's old technical and sterile approach tended to make visitors forget that the machines on display were built by human beings, were filled with human beings and were used against (or at least intended to be used against) human beings. This problem was further worsened by the fact that the objects in question were specifically designed to

21 | E. Zwach: Deutsche und englische Militärmuseen im 20. Jahrhundert, p. 315.

22 | Hans-Ulrich Thamer (2006): »Krieg im Museum, Konzepte und Präsentationsformen von Militär und Gewalt in historischen Ausstellungen«, in: Zeitschrift für Geschichtsdidaktik, Jahresband, pp. 33–43, p. 41.

be CLOSED structures; to shut out the exterior by all means. So human beings were more or less absent in the exhibition, making the integration of the human experience in, around and in front of tanks during war a central task for the Tank Museum.

One very positive side benefit of this new approach is that a common figure for thinking about tanks in war is deconstructed in the process: The data duel. Whenever visitors think about wars including tank battles, they tend to compare the technical data of one tank model with another. Tank warfare is boiled down to a comparison of gun size, armour thickness and engine power. A real tank battle, of course, is an infinitely more complex affair, with literally hundreds of different aspects to be taken into consideration. Therefore, by making it clear that the data duel is a much too simplified point of view, visitors are sometimes made to question what tank war and (more importantly) war as a whole actually is.[23]

Peace periods are also conveyed explicitly as times of war preparation. Visitors tend to underestimate and trivialize the military history of the Cold War. Based on Eurocentrism, they often see the Cold War as a period of peace and stability. This problem is often exacerbated by the fact that a large number of visitors were part of either the East or West German armies of the Cold War. Therefore, the perception of the war machines is a completely nostalgic one. These visitors don't see war machines, they see memorabilia from their youth, connected with funny stories they like to share with their friends and family. Such an approach naturally clouds their perception of the Cold War tanks as fighting machines.

The Tank Museum, therefore, stresses the Cold War as a period of constant potential war on the one hand, clearly describing the shape this war would have taken. And secondly, the museum reminds visitors of the proxy wars fought during that period. Thus, it not only brings war back into the Cold War, it also adds an aspect of international history, indispensable for this period, even if the museum officially focuses on German military history.[24]

Apart from all the aforementioned problems and challenges, a tank museum has special advantages, too. First of all, the museum can capitalise on the immense fascination for lethal machinery. The big objects are magnets for visitors and put many of them in a very good and relaxed mood when they enter the museum. It's the museum's job to use this mood to open visitors' minds for new experiences. The question of the Shoah is once again a good example of that mechanism: generally, fans of the Wehrmacht will, at most, only reluctantly visit memorials like Bergen-Belsen, which is only a short drive away from Munster. Even if they were to enter the site, there is a good chance that they would be anything but open-minded. The tank museum, on the other hand, has them entering the museum in a positive and receptive mood. If the museum is then able to clarify the connection between tanks, tank produc-

23 | Azar Gat (2008): War in Human Civilization, New York: Oxford University Press.
24 | John A. Lynn (2003): Battle: A History of Combat and Culture, Cambridge: Basic Books, ch. XVIII.

tion, slave labour and the Shoah in a convincing and interesting way and thus without triggering reflexes of denial, these visitors can gain a new understanding of that topic, which they would not have otherwise. In a similar way, new scientific insights can also reach people who would normally not be accessible for scientific progress.[25] This leads to a second advantage of the Tank Museum: It lures many people into a museum who would normally never enter a museum. In their view, they are not really visiting a museum, but a technical collection. The Tank Museum, therefore, has the unique opportunity to open these peoples' minds for museums as a whole. Since visitors are presented with many more perspectives on their beloved vehicles than they expected and are (hopefully) entertained while learning new things, they may be more open for the general concept of museum afterwards. The third big advantage of a tank museum is that it can try out all the aforementioned steps without fear of failing. Even if visitors are not convinced by the new perspectives, even if they despise all the new texts and pictures between the tanks, they will still continue to visit the museum. The fetishism, which is an obstacle in educating visitors, ironically has an advantage in terms of the marketing side of the museum business: It is a very strong bonding agent.

4. HOW TO BRING WAR INTO A MUSEUM OF WAR MACHINES – AN EXAMPLE

Since early 2009, the Tank Museum has been working on implementing the aforementioned perspectives and concepts. However, in the case of the permanent exhibition, this has only taken the form of guided tours and multimedia guides so far. It takes an enormous amount of effort to rearrange the exhibition, which is absolutely necessary if the aims mentioned above are to be achieved. Therefore, the physical form of the exhibition is currently more or less as it was until 2008. If visitors are not guided by a human or a multimedia guide, it's pretty easy to still enjoy a purely technical showroom. The arrangement of the tanks in the halls makes it practically impossible to reasonably add information panels such as biographies and documents to the exhibition. A new arrangement of the entire exhibition is planned for 2015/16. After that, every visitor will be forced to think in a multifaceted manner. And only then will the Tank Museum be able to finally implement the most important dimension of war: the human dimension.

At least in a small area of the museum, the reform has begun already: The Tank Museum has a room called the Hall of Collections. There was never a collection strategy for this part, so it has basically become a store room for all the small things. Uniforms, decorations, equipment, manuals, military toys, weapons, and flags: ev-

25 | Sharon Macdonald (2207): Schwierige Geschichte – umstrittene Ausstellungen, pp. 75–84, p. 78.

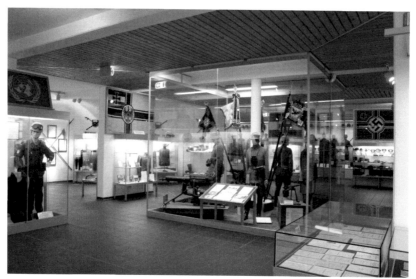

The Hall of Collections 2011
© *German Tank Museum*

erything has simply been brought together in this room. The room itself has no real internal structure and, therefore, there is no orientation for visitors. The displays are too crowded and explanations are reduced to the raw data of each object; no historical contexts are provided. The style is a very traditional one, which in several cases is highly questionable. The aesthetics of the objects are used without critical reflection. Therefore, decorations are laid out nicely on what seems to be blue velvet, because that is the way decorations are supposed to be shown. Weapons are presented in neat rows, clean and silent behind glass, with their technical data right at hand. Uniforms are put on happily smiling mannequins, appearing as they were tailored to be: Elegant, impressive, and manly. All in all, this room has the flair of a military shrine. There are hundreds of relics that demand admiration and nothing more or less.

As of December 2011, a radical restructuring is taking place: The number of objects has been drastically reduced to create space for the remaining objects. Many of the removed objects will be made accessible in open depots once the museum has expanded.[26] The remaining objects are rearranged in clearly distinguishable, yet connected areas, each one with a clear topic:

An area named "Cloth" showing uniforms
An area named "Gold" showing decorations
An area named "Wood" showing military toys
An area named "Iron" showing weapons

26 | Jörn Christiansen (2007): »Transparenz im Museum - Beispiel Schaumagazin«, in: Museumskunde 72 (2), pp. 45–51, p. 45.

The Hall of Collection will consequently be named Elements of War from 2012 onwards. Within the four areas, objects are part of a homogeneous, yet modular narrative with a consistent underlying main perspective:

Social history for the area "Cloth"
Cultural history for the area "Gold"
Everyday history for the area "Wood"
Modern technical history for the area "Iron"

The hall will be brighter, more spacious and have a modern design, with a broad offering of knowledge. Additionally, several educational devices will be integrated to enable the experience of learning with all senses. Each area has a specific mission far too complex to describe in more detail here. But how exactly does this approach bring war into the museum? War will be present as a topic within each of the four areas.

The most drastic change will happen in the area of weapons. Up to now, guns and ammunitions were shown as clean, technical objects. For the first time in the history of the museum, the new exhibition aims to show what these things actually do. (Ironically, when the topic of the effects of weapons was first brought up in the planning committee, nearly everybody thought of holes in armour plates and destroyed tanks. The technical dominance of the objects actually reached that far, even in the heads of the museum employees.) The concept explicitly calls for images of real battle injuries, of dead, wounded and maimed soldiers and civilians. These photos will be disturbing to many. Therefore, visitors will have to actively decide on whether they wish to see those pictures; we do not bank on simple shock effects. Shocking people can lead to a defensive attitude and thwart the learning process.[27] But if visitors choose to look at the pictures, we want them to be forced to think about the real nature of the objects around them; about their purpose and about their concrete history. War as an organized process of mass-killing will (hopefully) become evident to visitors through these pictures and objects. Although there are some concerns about how graphic displays of violence can sabotage learning,[28] the Tank Museum has decided that this step is necessary. This is certainly a big step in reorganising this area and images of this nature will surely lead to fierce debates, since they annoy those who just want to admire cool weapons.

In the case of uniforms, war will be represented through a specific choice of wartime uniforms that remain on display. Right now, formal military uniforms, primarily from officers, dominate the exhibition. This situation was largely due to the fact

27 | Christiane Beil (2003): »Musealisierte Gewalt. Einige Gedanken über Präsentationsweisen von Krieg und Gewalt in Ausstellungen«, in: Museumskunde 68 (1), pp. 7–17, p. 9.

28 | Wulf Köpke (2003): »Herzblut muss fließen, Krieg und Gewalt als Kulturereignis in einem Völkerkundemusem«, in: Museumskunde, 68 (1), pp. 48–52, p. 49–50.

*Part of the Small Arms
Collection in the Hall of
Collections, 2011
© German Tank Museum*

that these kinds of uniforms have a statistically higher chance of surviving the war and post-war period. This situation was worsened by the fact that the formal uniforms are, of course, technically more beautiful pieces; therefore, they were added to the collection far more often than the shabby uniforms of simple soldiers. Thus, the exhibition is now dominated by clothing that had nothing to do with the actual war. Therefore, the new display will specifically concentrate on uniforms of the rank and file. These shabby uniforms are the clothes that were worn by the masses during the bloody work of war and, therefore, are objects of far more historic importance. These uniforms will be the focus of this area and will be discussed in their role as dressed to kill. Furthermore, we aim to add biographies whenever enough information about the wearer of a uniform is available. This way the uniforms will hopefully remind visitors of the fact that the fabric was once filled with flesh – flesh acting in war, that is.

The "Gold" area will focus on the two-faced social mechanism that decorations play in the military, and especially in war: Encouragement and coercion. This approach aims to rid visitors' minds of the idea that these decorations are merely benign. It will hopefully make them think about the fact that they are instruments of social engineering and, therefore, are a part of the instruments that keep war going The "Wood" area will stress how toys were an instrument to familiarise children and adolescents with the military early on and, therefore, served as a tool to secure a

*Part of the Uniform
Collection in the Hall of
Collections, 2011
© German Tank Museum*

steady stream of easily malleable recruits for potential future battlefields. So beginning in this area, war and violence will find their place in the Tank Museum.

5. CONCLUSION

The process has only just begun. The Tank Museum is seriously undermanned, so the reform will take considerably longer than in a museum with adequate personnel. But it is interesting to see that even the first steps are evoking strong and decidedly varied reactions. The new approach is heavily criticised from different sides – from civilians, from the military, and from the museum's booster club.

Yet, at the same time, there is a wave of encouragement from other parts of the exact same groups. The reactions to the new guided tours, for example, range from outrage over this "newfangled blather" to enthusiastic praise for "the inspiring insights". Obviously, the integration of war violence into the Tank Museum will be a dynamic process. It will be painful for some and satisfying for others. But this fact in itself is encouraging. The question of how to represent war in the Tank Museum is relevant enough to stir a public debate; however low the number of participants may be at the moment.

The Tank Museum can therefore fulfil its mission as a museum: To be a forum for historical culture.[29] No matter how heated the debate gets and no matter how many visitors may be lost, we can be sure that the integration of a multifaceted view on war and violence in the Tank Museum is the right way.

29 | H.-U. Thamer: Krieg im Museum, pp. 33–43, p.37.

The Museum of Military History/Institute of Military History in Vienna: History, Organisation and Significance

Christian M. Ortner

The Museum of Military History/Institute of Military History in Vienna is today one of the last "traditional" federal museums, which, in terms of its legal form, is still largely based on the Research Organisation Act. It is a subordinate agency of the Federal Ministry of Defence and Sport and is currently divided into four departments (Administration, Collection and Exhibition, Military History Research and Marketing/Visitor Services). There are holdings in the amount of 1.2 million objects, and 2,000 to 4,000 new pieces are added every year. The main building of the museum is located in the Arsenal complex (still partially preserved) in southeast Vienna, which was designed as Vienna's third "defence barracks" in response to the revolutions of 1848 and 1849. Apart from the traditional military significance of the Arsenal complex, the site was also home to formations of the Royal and Imperial Artillery as well as the production facilities for weapons and ammunition, and a cultural institution was to be added to the sober character of the military functional building, which would reflect Vienna's importance at the time as the imperial city, royal seat and capital. The magnificent building was supposed to replace the imperial armoury, which had stored not only military equipment, but also trophies and other important historical objects since the times of Maria Theresia, and provide a new home to its historically valuable collections.

The construction of the museum building was the responsibility of a committee under the direction of the Director-General of the Artillery at the time, Feldzeugmeister (Lieutenant General) Baron Vinzenz von Augustin, which commissioned the architects Ludwig Förster and Theophil Hansen to build the museum. After the plans were presented in January 1850, construction began on the building in spring of the same year. Ludwig Förster, however, quickly withdrew from the project, which means that, ultimately, most of the credit for the realisation of the architectural design should go to Theophil Hansen. As the final stone of the entire Arsenal complex was laid in 1856, the exterior of the museum building was nearly finished, but

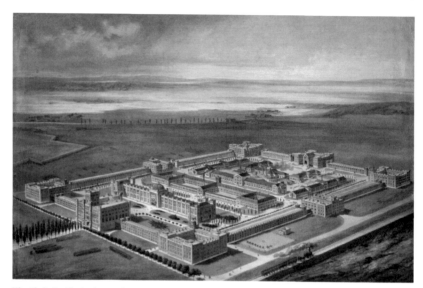

*The "k. k. Artillerie-Arsenal" in Vienna, around 1860 (Lithograph on paper),
Anonymous artist, HGM*

the interior design as well as questions concerning the exhibition of objects could only be addressed in the years after. As a result, the (imperial) armoury, which had already been cleared in the same year, could not move into the museum building, but had to be temporarily stored in the normal storage rooms of the Arsenal. Only the most important pieces and those of eminent art historical value were subsequently put on display in the first rooms of the museum building that were suitable for use. At the time when these holdings were combined with some other small imperial collections of the so-called court weapons collection, which was subordinate to the Grand Chamberlain's Office, at the end of the 60s of the 19th century, it was decided to include this collection in the new museum building (the Kunsthistorisches Museum, or Museum of Art History), which had been built in the meantime on the Ring. The only objects left in the Arsenal were fragments and collection pieces, which were considered to be insignificant at the time.

At the beginning of the 80s, the General Inspector of the Artillery at the time, Archduke Wilhelm, as well as the Director of the Artillery Armoury at the time, Feldzeugmeister (Lieutenant General) Baron von Tiller, considered the future of the museum and suggested establishing a new museum based upon the museum building and the still existing holdings, which would be devoted to the history and significance of the Royal and Imperial Army. In 1884, a separate board of trustees was established for this purpose, which was chaired by Count Hans Wilczek and in which Crown Prince Archduke Rudolf, Archduke Albrecht and Archduke Friedrich acted as protectors (in this order). In the following years, this committee was not only responsible for the necessary inventory and preservation of the collections, but

also for beginning a systematic study of the holdings and coming up with ideas for their exhibition. Finally, in May 1891, the museum was ceremoniously opened as part of a visit from the Emperor.

In the years that followed, the collections and the presentation areas were continually expanded, which meant that by the beginning of the 20th century the ground floor could also be used by the museum. The objects were exhibited on the basis of historical and systematic principles, which means that, ultimately, the Royal and Imperial Army Museum could be called the oldest "historic" military museum in the world. Likewise, the Emperor emphasized the importance of the museum, particularly in terms of cultivating tradition and upholding the image of the Royal and Imperial Army. Of course, the international orientation of the most significant traditional site of the military also seemed important. The perfect harmony of architecture and focus has made Vienna's oldest museum building an impressive Gesamtkunstwerk to this today.

During the First World War, the military use of the Arsenal complex predominated and thus it was decided to close the museum to visitors. The museum's holdings grew substantially during the war years and the Arsenal not only housed objects of the Royal and Imperial Army, but also trophies and spoils from the battlefields. The end of the Danube Monarchy created great problems both in terms of the focus of the museum as well as the collections themselves. The victorious powers understandably returned objects of foreign provenance and seized numerous Austrian military items and equipment as trophies. The successor states of the Austro-Hungarian Monarchy also requested their share of the old Austrian military history in the form of objects.

As a traditional site of the Austrian, Austro-Hungarian or Habsburg Army, there were initially no plans to integrate the museum into the new Republic of Austria, but the circle of war veterans, in particular, were very interested in its continued existence. The museum was finally reopened in 1921 and expanded two years later to include a new gallery featuring images of war.

After Austria's Anschluss to the German Reich in 1938, the Austrian Army Museum was put under the control of the "Head of the Army Museums" in Berlin and starting in 1940 was misused for propaganda purposes in support of current military campaigns and wars.

Under the threat of the allied bombing of Vienna, the Army Museum was also confronted with the necessity of storing holdings and collection objects in a safe location. Both the main building of the museum as well as the museum depot were hit and heavily damaged during air raids in September and December 1944/January 1945. Furthermore, the Arsenal was the scene of heavy ground fighting during the Battle of Vienna in April 1945, which resulted in further damage to the buildings and holdings. After the end of the fighting, the Arsenal as well as the museum housed within, including its depots, was reduced to a pile of ruins, in which anything valuable or useful was looted by soldiers as well as civilians. There were also acts of

Trough bombs and heavy ground fighting destroyed wing of the museum building, around 1945/46, HGM

significant devastation and wanton destruction. In June 1945, a Soviet battalion on the hunt for trophies claimed and seized part of the holdings that had "survived" so far. This mainly included the melee weapons and firearms holdings, of which 16,000 to 18,000 exhibits were carried off and are still considered to be missing to this day.

Besides substantial losses due to the looting of occupation troops and the local population, the collection of historic artillery barrels and guns, in particular, suffered significant damage, because the British occupying power used explosives to render the weapons inoperable. It didn't make any difference that most of the weapons were historic pieces, which were no longer usable anyway. The museum staff was further disillusioned by the fact that they could not bring back as many of the museum objects that had been stored in a safe location to protect them from the Allied bombing as they would have liked. The safe storage locations had also been looted and devastated. The fate of the naval collection, which came in part from the Museum of the Royal and Imperial Navy that had existed in Pula until 1918, was particularly tragic. These objects, which also included numerous ethnographic exhibits, had been stored in Valtice, which was now located on Czechoslovakian territory and was thus no longer accessible. It was not until 1948 that a staff member of the museum was able to inspect the storage location. It was found that most of the objects had "disappeared" in the meantime.

All in all, the museum was in a disastrous state in the early post-war years both in terms of structural conditions as well as the collections. Naturally, the important question to be answered, like after the First World War, was whether the reconstruction of a military or army museum was really warranted in the face of the enormous human and material losses of the Second World War. Unlike the situation at the

beginning of the First Republic, the occupying powers as well as the provisional Austrian Federal Government were very interested in rebuilding the museum, because it could play an important role in the on-going efforts toward re-Austrification. Although the government offices and the occupying powers were quite generous with their assistance during the reconstruction effort, the museum had to shoulder a remarkably large share of the reconstruction effort on its own in comparison with other federal museums. This once again concerned the collections and the museum's holdings, which were now appraised with an eye towards possibly selling them. In this respect, the collection of bronze artillery barrels once again played a key role, because the Austrian bell founders had just signalled their great need of this raw material to repair the losses suffered during the war. At the same time, other large equipment such as gun carriages, wagons, carts and other metal accessories were also interesting sources of revenue. Besides, many of the pieces had been damaged during the air raids and ground fighting and were considered at the time to be merely "junk"; the uniqueness of some other objects, however, was not recognised and these together with other pieces of the collection, such as brass fuses or artillery shells, were sold as scrap metal. This further reduction of the technical pieces of the collection as a result of these sales was enormous. Ultimately, the museum was reopened again on 24 June 1955 under the name of the Museum of Military History, which included the history of the Royal and Imperial Navy.

Today, the Museum of Military History in Vienna, which also serves as the Institute of Military History for the Ministry of Defence, is one of the most beautiful museums in Austria. The permanent exhibition, of course, focuses on the history of the Austrian/Austro-Hungarian armed forces from the 16th century up to the 20th/21st centuries. Contrary to the intention of the founders of the former Royal and Imperial Army Museum, Austria's military history is today considered in a wider perspective as an integrative branch of "general" history, social history, the history of technology as well as contemporary history. The interaction between society and the military as well as the traditional international character of the museum also make it a place for portraying Central European history.

Translated by Mark Miscovich

The Beauty of War and the Attractivity of Violence

The Concept for a New Permanent Exhibition at the Museum Altes Zeughaus

Carol Nater Cartier

Current State

In the middle of the old town of the Baroque city of Solothurn, there is a prominent 400-year-old armory, which has served as a museum for the past 100 years. It houses a weapons and military historical collection going back to the 16th century, serves as the repository for traditional myths on the history of Solothurn and the Confederation, and preserves the memories of the active service generation (i.e. Swiss men who served in the Swiss Army during the Second World War).

Today the Museum Altes Zeughaus presents itself as follows: The ground floor (cannon hall) exhibits cannons, which mostly originate from the second half of the 20th century. A few selected objects are placed in the spotlight to give a brief history of the Zeughaus and its collection, but most of the cannons are arranged in no particular order or context.

The weapons collection is exhibited on the first floor: Sabers, swords, rifles – sorted by weapon type – are displayed in the room's interior and hang on the walls in a decorative and aesthetic manner. This particular room was set up in the 1970s by the museum curator at that time and has not been altered since. It is intended to be the "Armory" and is supposed to represent the real value of the museum. It is the quantity of the weapons that characterizes the Solothurn collection and less the quality of the individual pieces.

The famous armaments hall is on the second floor. This is where the heart of the collection is located: The suits of armor. The original pile of armors was done away with in 2003 as each of the 400 suits of armor was individually restored and then set up chronologically into new "century" islands. The statement of the design remains the same: This is where we meet the brave confederates on the battlefield, as presented over the years in Swiss history books. However, the armor actually originates from a later period and was not (or hardly) manufactured for military purposes.

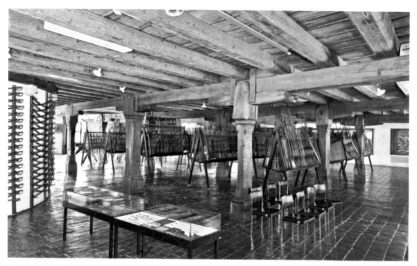

"Armory" - the museum's first floor as it has looked since the 1970s,
Kantonales Hochbauamt Solothurn (photo: gs)

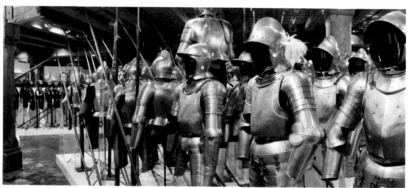

The heart of the museum's collection: 400 suits of armour
Museum Altes Zeughaus, Solothurn (photo: nh)

One of the oldest museum exhibitions in Switzerland is also located on the second floor (Tagsatzung von Stans 1481). The figures were set up in 1845 and commemorate the moment when the Canton of Solothurn joined the League of the Confederation in 1481. This is also a form of myth typically cultivated by history books in the 19th century.

Finally, the third floor exhibits uniforms: One room features clothing of Swiss in foreign service from the 16th to the 20th centuries; another room uniforms and headgear worn by the Federal Army since 1875. This room has remained unchanged since the 70s and primarily acts as a place of remembrance for veterans of the Swiss military.

One of the oldest museum exhibitions in Switzerland, established in 1845: "Tagsatzung von Stans 1481"
Museum Altes Zeughaus, Solothurn (photo: nh)

The main attractions of the museum are its objects and their staging. There are few texts to read and little context is provided. And yet, the Museum Altes Zeughaus still has 20,000 to 25,000 visitors annually, with nearly no advertising. Furthermore, it elicits emotions as well as enthusiasm among young and old: The guest book is full of compliments. For example, a young boy recently hit the mark when he wrote "this place is like nowhere else". He probably meant that the Museum Altes Zeughaus was not what he imagined a museum was supposed to be like.

The Museum Altes Zeughaus is indeed something special, and especially since it appears like time somehow stands still. It is literally a museum in a museum.

However, there is little question that the Museum Altes Zeughaus really needs a "face lift", both in terms of the museum's interior as well as exterior. Under the current conditions it is hardly possible to manage the museum in a sound manner. Just to mention a few of the current problems: the water pipelines are only installed on the ground floor, the building only has two bathrooms for both visitors and employees, there is no elevator, the offices are located on the 5th floor, the environmental conditions are anything but stable and the static structure of the building no longer complies with current law etc.

PLANNED IMPROVEMENTS

In terms of current developments in the national and international museum scene, it is to some extent difficult to fully understand how the museum continues to fascinate visitors in its current state. The Canton Solothurn, as the owner of the museum, has been aware for some time that operations cannot be maintained in their current form over the long term. As a result, a strategy paper was approved in 2008. The strategy calls for the thematic integration of the three larger cantonal museums to tell the history of the Canton Solothurn, divided as it were among the three

institutions. The Museum Altes Zeughaus focuses on the period of the Ancien Ré-
gime and specifically on the topic of "war and peace". Not surprisingly, this proposal,
reasonable in terms of contemporary developments in the museum world, polarized
opinion in Solothurn and caused emotions to run high. Local inhabitants, "weapon
fans" as well as representatives of the association for the promotion of the museum
feared the destruction of "their armory" and that the weapons collection would be
lost. They launched an effort to collect signatures both at home and abroad to save
the Museum Altes Zeughaus and even succeeded in getting the backing of the local
press.

It was at this time (2009) that I was appointed by the Director of the Office for
Culture and Sport to head the museum. The government underscored its support of
the strategic plans by selecting a woman to head a museum in a scene long domi-
nated by men, but created new waves in doing so. The start did not go exactly as
expected: I stood in the crossfire of various interest groups and quickly noticed that
the mobilized opposition would not stop placing obstacles in my path if we failed to
win their trust. It was now up to the museum staff to reposition the institution in a
manner that enabled the participating groups to once again find common ground.

Therefore, we drafted a museum concept as part of a small team. The concept
took the museum's tradition as its starting point and elaborated the rough outlines
provided by the strategy paper in more detail. We were confronted in this process
with issues similar to the agenda items at this conference: How can we do justice to
the unity of the museum and its collection without continuing to use the weapons
as simple, aesthetic ornaments on the walls? How can we display the richness of the
collection without glorifying the brave confederates and rehashing national myths?
How can we demonstrate what weapons are capable of without displaying blood and
violence in a striking manner? How can we succeed at maintaining the old, proven
materials while also remaining contemporary?

We ultimately concluded that it could work if the museum became a place for
dialogue and reflection. The weapons would be exhibited, but staged in a manner
that encourages visitors to reflect. Today, you can walk through the museum with-
out confronting violence or war. The idea was to move in a new direction for the
permanent exhibition.

The goal set forth in the museum concept is worded as follows: As a cultural-
historical museum focusing on military history, the Museum Altes Zeughaus pro-
vides a broad public with a place for dialogue and reflection on the topic of conflicts
and their solutions. At its core is the recurring issue of how people deal with conflicts
(armed conflict, diplomacy, subjugation, and non-violent protest) and what the vari-
ous types of conflicts have meant for the participants of different periods.

We also added three conditions to these rather abstract goals that the museum
must continue to fulfill:

- Maintain the unity of museum building and content: The building was originally constructed as an arsenal and continues to this day to store weapons and military items.
- Exhibition of the collection of armor: The collection of 400 suits of armor is unique in Switzerland and should be exhibited to the greatest possible extent.
- Contextual focus on the Ancien Régime: The French Ambassador resided in Solothurn from 1530 to 1792, the building was constructed during this period and Solothurn was a leading player in the mercenary trade with France. The oldest pieces in the collection date from this period.

We have made every effort to reconcile the various interest groups. I should note, however, that at this point we are still working on a very theoretical plan. There can be no doubt that completely new issues will arise once implementation begins.

IMPLEMENTATION: ARCHITECTURAL COMPETITION AND DESIGN COMMISSION

The "Neuausrichtung Museum Altes Zeughaus" project proceeded from paper toward implementation at the beginning of the year 2011. On the one hand, the Cantonal Construction Office solicited bids for the redevelopment and renovation of the building while we conducted a commission to study the design of the new permanent exhibition on behalf of the Office for Culture and Sport. This three-phased study commission has finished its work in August 2011: Five offices were invited to participate in the bidding and element LLC from Basel was awarded the contract in the end.

I would now like to briefly present the exhibition concept using some visualization as proposed by element. Although the initial draft will not be implemented one-to-one, it should nevertheless provide a good impression of how we plan to implement the difficult conditions set forth in the museum's concept.

THE NEW CONCEPT

The planned exhibition includes a prologue and is divided into three parts:
- Prologue: "Confrontation zone"
- Exhibition, section I: Reflections on weapons, conflicts and consequences
- Exhibition, section II: Historic part focusing on mercenaries (1530-1792), with Solothurn as the starting point
- Exhibition, section III: Zeughaus timeline on the historical development of weapons and military technology

Prologue: "Confrontation Zone"

Visitors are drawn in by weapons, sounds and spatial productions at various points within the entrance hall. They are confronted with the topics of threat, violence, power, rule, responsibility and self-control.

Through all the exhibition units, clearly labeled objects are available for visitors to touch and, where possible, take in hand. Visitors should recognize that the object represents power and, at the same time, experience the responsibility of holding a weapon in their hand. In addition, various interactive offerings are spread throughout the room.

Exhibition, Section I:
Reflection on Weapons, Conflicts and Consequences

In this section, visitors learn about topics such as weapons, war, peace, conflict, diplomacy, freedom, power etc. This section should clearly indicate that weapons and their users are neither demonized nor glorified per se, but rather have a wide variety of meanings. The focus of Exhibition, section I is an individual confrontation on the part of visitors with the aforementioned topics. The staging relies on a few, well-selected objects, which are intended to elicit emotions. Visitors interested in history can tap into the background information by topic or object and broaden their understanding. Visitors can come face-to-face with the following four topic areas in individual "booths": War and representation, war and art, war and diplomacy, war and suffering. You can walk into the four booths, which are individually designed and include a variety of interactive stations.

Visualization for the new exhibition, section I: weapons, conflicts and consequences
element LLC, Basel

Exhibition, Section II:
Historical Focus on Mercenaries (1530-1792)

This section provides visitors with the experience of a "historical world": They are led into the period of the Ancien Régime with its courtly, aristocratic structures and get a sense of the importance of the mercenary business for the society of the city-state of Solothurn. The exhibition highlights the cross-regional and international networks of the "good" society of Solothurn, explains how the mercenary family business operated, delves into the economic aspects and illustrates the destiny of the young men who were forced to go to war for little money. The focus in this section is on learning historical context.

The armor collection is the clear focus of the large installation specific to the room. The courtly world of the head mercenary is illustrated through a loose presentation that then transitions into a non-individualized mass of mercenaries.

Exhibition, Section III:
Timeline of Weapons and martial Technology

This section is a timeline of weapons and martial technology in accordance with the staging of the Zeughaus, i.e. running along the walls through all the floors. This section gives visitors a sense of the sheer volume of materials in the museum's collection. Excellent pieces will be presented in special displays. The timeline also provides context on the historical development of technology and links it to social developments.

Sketch for the planned exhibition, section III: "Zeughaus timeline"
element LLC, Basel

CONCLUSION

With this concept we attempted to maintain the unity of the museum and the collection as well as the traditional military focus of the institution. The three sections in the exhibition are intended to encourage visitors to reflect (in the section on reflection), emphasize a topical focus in the historical section and, with the help of the timeline, not only display objects from the collection, but also provide information on their use.

We have a military-historical collection that we intend to display in the future as well without overdoing the aesthetics and glorifying Swiss battles as it has been done in the past. We want to encourage visitors to think about conflicts, violence and warfare's general problem through direct "confrontations" with weapons. We hope that visitors will be forced to reflect upon themselves and their attitudes.

A Pedagogical and Educational Approach to the Two World Wars at the Royal Museum of the Armed Forces and of Military History in Brussels

Christine Van Everbroeck, Sandrine Place, Sandra Verhulst

As an introduction, I would like to quote several parts of a letter received from an angry mum several years ago. The woman was cross about an advertisement we had placed in a local newspaper in order to promote our "family trail", one of our annual events, which on that particular occasion focused on the extensive First World War collections.

"Dear Madam/Sir,
I feel compelled to write to you about an ad your museum ran in several newspapers.
 You are indeed a military museum, but do you really feel it necessary to glorify war? Surviving in the trenches and having fun with the entire family: weren't you shocked, even a little bit, while preparing the catchphrase for this ad?
 I find this ad not only shocking, but also lacking in respect towards those who had to live through the First World War, who had to serve in the trenches, who had to face the gas, and who fought for their country. Haven't you ever felt ashamed by presenting these events as a game? Moreover, I am horrified by the fact that you turn war into a game in the eyes of children. Do you ever tell them about the physical pain one endures when a bullet perforates a body? Do you describe to them the horror of being torn apart by a bomb? "Having fun with the entire family": do you show them images of wounded, bloody, amputated, or dead parents?
 [...] Are you proud of contributing, if only ever so slightly, to the trivialisation of the violence we witness every day? Are you at peace with your conscience when turning war into a game, as if it were merely virtual reality? Have you forgotten everything? Even if you never experienced war personally (neither did I, for that matter), have you erased the entire 20th century from your memory?

Today, we live in peace in Western Europe. Are you aware of the fact that this is pure LUXURY? Anyway, I showed your deplorable ad to a number of families in the neighbourhood and they all said they would never ever play this horrid and horrible game with their children. Even if you are at peace with your conscience, I do not congratulate you."

A letter like this obviously leaves one feeling somewhat upset. The ad that angered the mother shows two children, a boy and a girl, riding on a shell and holding a camera and a journalist's notebook. The drawing is, of course, inspired by the famous image of Baron von Münchhausen sitting on a cannonball. The activity this ad was promoting was called 'The little journalist during the Great War' and it consisted of a family trail leading the children and their adult companions through the First World War section.

Nothing horrid or horrible so far. Had the upset mother, who sent us the letter, actually taken the time and effort to come down to the museum and see how the activity was planned, she probably would have realised that the game wasn't at all about the glorification of war, nor was it presenting war as a game or trivialising violence. The children, who were put in the position of wartime reporters, got to follow a trail, which led them not only to learn about life in the trenches, but also to empathise with the soldiers who found themselves in this situation. They did so by completing, with the help of their adult companions, a series of playful challenges appealing to different skills and focusing on the various aspects of the First World War in general as well as on the impact on the individual soldiers in the trenches and the civilians in the occupied part of the country.

This 'incident', however, has taught us an important lesson, namely, that when planning similar activities in a military museum, it is not only of the utmost importance to reflect carefully on the content of your educational offer, but also, and maybe even more so, on the way you communicate it.

The reason the mum might have overreacted a little and sent us the letter on impulse, without actually coming down to the museum and checking out the activity for herself, has everything to do with the general public's bias towards our museum. One of the main problems we face on a daily basis is the negative connotation of the word ARMY in people's minds. It's no coincidence that many visitors call us the WAR museum and consider us to be a belligerent, bloodthirsty and sexist institution, most certainly not suitable for their children or, in the best of cases, only appropriate for their sons, when they are old enough to play war games.

All of this, of course, leads us to the more general issue of whether war BELONGS in a museum. Regardless of whether we like it or not, war is a substantial part of our cultural heritage, and cultural heritage is, in its turn, what we could describe as the core business of museums. Therefore, I personally do not think that we should ask ourselves IF war has its rightful place in a museum, but rather HOW it should be

represented, or, in our case, as we are in direct contact with the public, how the subject should be rendered to our visitors. This is often a very delicate matter.

As education officers, we develop a large number of tools and programmes for different target groups. During this lecture, though, we would like to focus on the activities that revolve around the First and Second World War and are aimed at six to eighteen-year-olds, who visit our museum in a family or a school context. Here, the first question that springs to mind is the extent to which it is legitimate to present a topic like war in a 'fun' way, and if so, where should we draw the line?

When devising activities for children as well as young adults, we try to use the richness of the museums' collections to the fullest. For people who have never visited the museum: seeing as we provide an overview of Western European military history from the 7th century up to the present day, we cover a wide range of subjects, extending from medieval jousting tournaments to the history of aviation and from 19th century Russian silverwork to works of art by Belgian painters from the First World War. Besides objects that are considered to be typically military, like tanks, uniforms or decorations, we also exhibit personal belongings of the soldiers, pictures and diaries, toys, sculptures, paintings and posters, hunting equipment, stuffed animals, and so on. We gladly draw on all of these when coming up with new activities for families and school classes.

Does this mean that we try to avoid the sensitive topic of war? Certainly not. Even if we do not, as the person writing the letter suggests, offer the audience a description of the horror of being torn apart by a bomb, or show them images of wounded, bloody, amputated or dead parents, we definitely talk about war by trying to place it in its historical context and by focusing on the lives of the humans, soldiers as well as civilians, who were involved in it. We feel it is important to try and provide an impartial view, neither propagating nor condemning war, thereby allowing the children to make up their own minds.

The Royal Military Museum's Educational Service saw the light of day more than 20 years ago and, of course, it still plays an essential role within the museum, as it is indeed in direct contact with the public. Right from the start, the service set out to "translate" the collections, i.e. to make them accessible and comprehensible to all audiences.

Over the course of time and strengthened by our accumulated experience, we have multiplied our approaches, techniques and themes in order to reach as many visitors as possible. Talking about war and its atrocities (violence, destruction and death) is certainly not easy, because the subject makes people uneasy or even disturbs and upsets them. We only have to look at certain reactions when talking about our work environment or at journalists from all kinds of media who visit us in preparation for an article about our activities. One question invariably pops up: "How can you come up with a playful activity about a theme as serious and culturally and historically loaded as war?"

In order to reach all audiences and all age groups, we use a large gamut of communication tools and we try to align ourselves with all motivations and sensibilities. We not only offer a year round programme of guided tours tailored to meet specific requests (the person in charge of the group can choose either a general tour or a visit focusing on a specific collection or a subject specially prepared for the occasion), but also thematic, supervised activities for children aged 6 to 12, workshops for teenagers, audio tours for both adults and children, playful books complementing temporary exhibitions or educational materials providing additional information. We also organize camps during the summer holidays, artistic workshops for adults in spring and autumn, a brand new game circuit each autumn break with an encore during the spring break and temporary activities linked to a special event (evening opening of all the museums in Brussels, theme days etc.). We also participate in several training programmes for both primary and high school teachers. These sessions aim at promoting our institution by exploiting the diversity of our collections. For the two world wars, for instance, we show teachers how to use the pieces of our collections to illustrate their lessons. The training sessions can be quite general in theme (for instance, broaching the subject of the First or the Second World War), but they may also focus on more specific aspects (by studying conflicts through propaganda, art at the front or oral testimonies).

Over the years, we have realized that when presenting our collections, we have to focus on the human and personal aspects in order to obtain the best results. "Universal" themes, such as music, art, communication, food, colour or animals, enable us to bring up the delicate subject of war, without running the risk of being accused of promoting war.

I will now give some examples of war-related themes, first geared towards children, then towards adults and, finally, towards individual visitors.

For our youngest visitors (children 8 to 14), a programme of supervised activities called Once upon a Time in the Great War enables us to introduce the First World War by means of 5 small games. In the first, we use a giant puzzle based on a map of Europe in 1914 to explain the different alliances or the neutral countries in a very visual way. Two sets of puzzle blocks based on period pictures from our documentation centre illustrate everyday life at the front (mealtimes, leisure, laundry, equipment upkeep etc.). We then talk about camouflage and the technologies invented during the war. For this particular topic, we use a drawing of a museum gallery in which 7 new weapons are hidden. Next, the children receive three period helmets; they can handle them and put them on in order to determine which piece of equipment – the Belgian helmet, the British Brodie or the German Stahlhelm – is the most effective one for the troops. We conclude the programme with a short quiz in which the children have to guess the items painter Fernand Allard L'Olivier selected for each entry of his war alphabet. The letters lead to a brief explanation, which completes the historical information provided up till then. This programme always takes place in the very heart of the First World War gallery in order to establish direct and

© Royal Military Museum – Brussels

constant contact with the collection. After each game, the group assembles in front of a particular object, for closer observation and commentary.

Now, for our second example. Last autumn we designed a new activity for adults. Dust your Vision of the Military Museum is a cycle of four mornings during which participants can express their artistic talents through our collections. After a brief 45-minute guided tour, participants are invited to create one or more art works under the guidance of an artist. Each session puts our participants in touch with a different collection and a different artistic technique (charcoal in the Arms and Armour gallery, watercolours in the First World War gallery, a collage of propaganda bills in the Interwar and Second World War galleries and pastels in the gallery about 19th century Belgium). Once the cycle is completed, the freshly created works of art are put on display at the museum for one month. Several adults, whom we had the pleasure of welcoming during the sessions in 2010 and 2011, told us they really saw the museum in a new light thanks to these workshops (some of them even admitted that without the "pretext" of the artistic approach, they would have never considered visiting a WAR museum!). Observing the objects, looking for their artistic value, placing them in their historical context, being able to pose all the questions they would have never dreamed of asking when accompanied by a larger group: all these methods provide a personalized and human approach to the conflicts.

Whenever possible, we try to establish direct contact between the visitor and the collection pieces, since that is the best way of forming a personal opinion. How better explain, for instance, the role and the effectiveness of helmets used by the various nations during the First World War than by offering the possibility of handling or wearing all of these helmets? How better evoke the living conditions in the trenches of the Yser Front than in the very heart of the reconstructed trench in the gallery about the 1914-18 conflict? Still, we are careful to keep visitors away from

the weapons, so we do not inadvertently pressure them into "playing at war". Unfortunately, there is a price to pay for this hands-on approach. In spite of our efforts in terms of a direct contact approach (for instance, we put crates with a selection of objects on permanent display in the 1914-18 gallery), acts of vandalism or theft have forced us to limit this hands-on method to guided tours and supervised group activities.

All of our educational service activities aim at highlighting the collections, but without falling into the treacherous trap I would like to conclude with. The Military Museum in Brussels depends directly on the Ministry of Defence for financing. This close link leads quite a few people to believe that the museum is some kind of recruitment office for the Belgian Army. We have to be quite vigilant here and constantly stress our scientific status, our quest for objectivity and neutrality and our critical spirit. We have to concentrate on one single goal: the transmission of historical facts without ever falling into subjective glorification or sounding like a promotional campaign.

We have already spoken about ways in which to present the First World War, but the Second World War, with its range of atrocities, is perhaps even more delicate a subject to raise. And this leads us to wonder how exactly are military museum supposed to evoke this conflict.

Are military museums to promote a pacifist message? Are museums supposed to preserve the past in order to teach younger generations how to avoid the disasters of that past?

© *Royal Military Museum – Brussels*

Military museums are constantly trying to inform, to testify, to put all elements at the disposal of the public, but, at the same time, they would like visitors to draw their own, personal, conclusions.

It is not always easy to remain perfectly unbiased, to give a totally objective account of events or objects that, even today, retain a dramatic resonance. When talking about collaboration with the enemy or Belgian Resistance during the Second World War, one is inevitably confronted with present day sensibilities. Most of the resistance fighters have now passed away, but their sons and daughters are adamant about defending their memories and would be very happy to turn the museum into a memorial honouring each and every one of them.

In the same way, collaboration is perceived differently in the various parts of Belgium and the debate about amnesty for people, who some see as idealists and others as traitors whose punishment is to be maintained, still rages more than 60 years after the facts. In this context, showing collaborators' uniforms is a delicate topic, as it can truly shock part of our audience and rekindle arguments.

Another example illustrates the same point. In the spring of 2009, the museum's newsletter announced the acquisition of Hermann Goering's white summer Luftwaffe service cap. Some readers were outraged and they deplored that the money spent on buying this artefact would have been better spent on acquiring souvenirs linked to "the victims, the Resistance fighters, and the heroes of victory". In his reply, the museum's general manager stressed the importance of being open and frank about even the darkest pages of history, but also promised to place the electrifying collection piece in "its inhumane context".

That is exactly why the information provided in the didactic panels, the guide books and the audio guides has to be carefully balanced and suited to present day realities. Presenting the Germans, who invaded and occupied Belgium twice in the course of the 20th century, as enemies is totally devoid of sense today. For the younger generations, Germany is an ally within the European Union.

In the case of the Second World War, it is difficult to limit explanations to the "daily" aspects of war and to forget about the more sensitive political aspects. That is why we offer more than traditional guided tours about the interwar period and the Second World War. Indeed, students can participate in a workshop about propaganda, based on political bills from times of war and times of peace. Through these bills, we try to convey the mechanisms applied in propaganda (the shock of images, the emotional weight of pictures, the simplification of messages, the stigmatisation of "the other" etc.) by exposing its dangers and by insisting on the permanence of propaganda, even nowadays, even in a democracy.

Teaching about the Second World War has now, indeed, become a political issue. Today, in Belgium, all educational programmes and all of society stress the need for memorial duties and civic spirit. Politicians see to it that the younger generations do not forget about the crimes of genocide, the crimes against humanity and the resistance against these crimes.

Therefore, are military museums supposed to make their mark as actors in the transmission of memory?

In order to attract teachers and to obtain the approval of school administrations for field trips, the pedagogical offer is almost compelled to work by means of government decrees and through the framework of civic spirit education. The Military Museum therefore joined an association comprising the Breendonk Memorial (a converted fort transformed into a transition camp for political prisoners during the Second World War), the Dossin Barracks (where Jews were grouped together before deportation and which is now the Jewish Museum of Deportation and Resistance) and the Territoires de la Mémoire (which uses the history of the Second World War to combat extreme right groups and tendencies). This association goes by the name of History and Civic Spirit and wishes to introduce pupils and students to the context of the Second World War and its repercussions in terms of political and racial persecutions, violations of human rights and the development of propaganda.

Luckily, the museum's collections go well beyond the strict framework of memorial duties. The extent and the variety of the pieces on display allow for a diversified approach, with room for political, economic, social, moral and military facts and figures.

However, the Military Museum's Educational Service not only wishes to turn the museum into an educational platform, but also into a place for enjoyment and curiosity.

About the Beauty of War and the Attractivity of Violence

Per B. Rekdal

*Figure 1: The poster motif
of the exhibition.
© Museum of Cultural
History, University of Oslo.
Photo: Ann Christine Eek*

Some 15 years ago, there was a discussion in our museum on whether we should cre-
ate a temporary exhibition about weapons as aesthetic objects. No one – from sweet
grandmothers to pacifist former hippies – found the idea ethically doubtful in any
way. The thought never occurred to them. This I found interesting.

Our museum – a museum of cultures and societies from all parts of the world –
has lots and lots of weapons, brought to us by missionaries, sailors, travellers, explor-
ers, ethnologists … It seems that everyone has a fascination with weapons.

Having spent an exciting childhood in a large, abandoned WW2 coastal fortress on the Norwegian coast, I knew this fascination. Weapons are at least in principle meant to be used for violence, and they are often connected to *official* power, so I thought why not combine beauty and violence, even beauty and war. This idea was met by anger and disbelief among the museum staff and some of them asked to be relieved of any duties in connection with such an exhibition. But this was just the initial reaction.

So the question became how does one go about making an exhibition that combines beauty, war and violence?

Now, the title of this paper "About the Beauty of War and the Attractivity of Violence" (the Norwegian title was "Om Krigens Skjønnhet eller Den Vakre Volden"), was meant as a teaser. I did *not* intend to create an exhibition about the beauty of war and violence itself. Today, I might have done so, but that's another – also potentially interesting – story. I wanted to create an exhibition about the aesthetics *surrounding* war and violence.

At first, my ideas went in the direction of having displays, for example, of military/political leaders giving enthusiastic speeches, and then the public could push them aside and see the real horrors of war – that kind of thing. But I found this approach too moralistic and sentimental, and besides, what would the public learn from that? Nothing! Everyone would nod and say "war – it's simply horrible."

So I wanted the public to be exposed to something they might not have thought about before. And I wanted to be honest about my own ambiguity. And yes, this was an "I" exhibition: the content was entirely mine.

My main focus in this paper is on the concept and the narrative structure, which I consider just as relevant today as in 1995. The exhibition itself was very simple, based as it was on a very low budget.

The introductory part consisted of an assortment of weapons, decoratively arranged, like in the old museum exhibitions, with a text reflecting upon the fascination with weapons, a fascination shared by the original owners of the weapons.

A second part focused on magical weapons and magical "uniforms". We displayed Japanese swords and the love poems dedicated to them, comic book magical swords, pictures of mythological swords, and a valuable copy of a Viking sword, presented as a gift to Heinrich Himmler on one of his visits to Norway in 1941 (it is said that he turned it down, because he wanted the original, which, of course, he did not get).

We showed a picture of a Marquesas warrior, with magical protective tattoos, and we even exhibited a large phone booth where the public could open the door and interrupt Clark Kent while he was changing into his real identity as Superman. In the next part, we turned our attention to the real world of military aesthetics, explaining how the beauty of uniforms

- is connected to the fact that power and glory usually go together,
- shows who our friends and our enemies are,

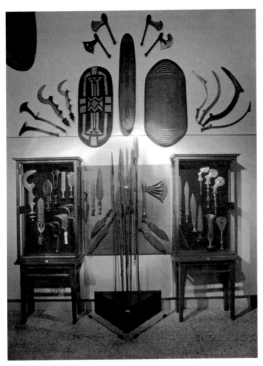

Figure 2: The introduction was a melange of weapons, in the old museum style.
© Museum of Cultural History, University of Oslo.
Photo: Jorunn Solli

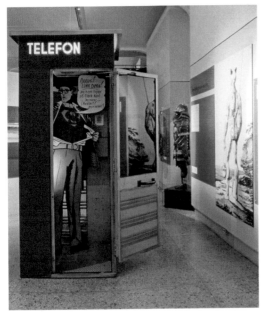

Figure 3: A phone booth for Clark Kent.
© Museum of Cultural History, University of Oslo.
Photo: Jorunn Solli

- indicates the exact function of the soldier wearing it in the military system, and,
- shows that the person wearing it has a legal right to exercise violence on behalf of the government and/or ruler.

In order to illustrate the aesthetics connected with different types of war, we displayed

- tribal warfare by showing parts of the documentary *Dead Birds* from New Guinea (1964, David Gardner),
- the splendid panorama of armies marching against each other in *Ran* (1985, Akira Kurosawa),
- the more modern machine aesthetics as represented by *Triumph des Willens / Triumph of the Will* (1935, Leni Riefenstahl), and
- computerized war by letting the public try to attack a target with an F-14 Tomcat on a computer (war games of that kind were primitive in 1995), reflecting upon how large armies have been replaced by highly competent, technologically sophisticated smaller units, etc.

Figure 4: Different types of war.
© *Museum of Cultural History, University of Oslo. Photo: Jorunn Solli*

The computer game served as a transition to the aesthetics of war as communicated to spectators. Here, visitors could sit in a comfortable chair in a Norwegian living room and watch the fighter planes of Operation Desert Storm (the liberation of Kuwait) take off into the beautiful sunset. On the wall of the living room, there was a romantic painting of a Norwegian nature scene and family photographs. Those who

Figure 5: A living room with TV news about the Gulf War, family photos on the wall, including a burnt to death Iraqi soldier.
© Museum of Cultural History, University of Oslo.
Photo: Jorunn Solli

let their eyes wander over these were surprised to find that one of the family photographs was a portrait of an Iraqi solider, burnt to death.

We then turned to Bennetton's use of a bloody uniform in its advertising at the time of the Balkan war: was it unethical or, on the contrary, an act of ethical bravery?

And what about a romantic, Boy Scout, war-like advertisement from the *Illustrated War Magazine* of July 1915: was it naively charming?

Figure 6: Benettons bloody uniform advertisement related to the Balkan war.
© Museum of Cultural History, University of Oslo.
Photo: Jorunn Solli

Figure 7: Advertisement from the Illustrated War Magazine, July 1915.

The next part dealt with the aesthetics of friends and enemies. The classification of people into mental types like thieves, rapists, Arians, Jews etc. during the 1930s is indirectly alive and well in the cartoons, where a "unibrow" or a "weak chin" is a sure sign of dubious mentality. Heroes, on the contrary, have strong chins, of course. We laugh about of this, but the typical cartoon hero is still a slightly softened version of the standard authoritarian regime type of hero.

We reflected upon the gradual making of enemies, starting with the German process of the 1930s, in which families found it more and more awkward to keep up good relations with neighbours and friends that happened to be Jews – the gradual distancing, the gradual disinterest, the gradual acceptance of the image of that person as an enemy – to the Balkan War again and showed parts of a modest anthropological documentary (Christie/Bringa, *We are all neighbours*, 1993) that happened to be filmed in a Bosnian village during the early stages of the war, when everyone laughingly denied that the war would have any influence on their relations with their neighbours, friends and relatives, and then, within a few months, how circumstances had changed and turned them into mortal enemies.

In 1995, the debates on the "Islamic threat" to "Norwegian culture and values" were not yet an issue, so we did not spend a lot of time on that in the exhibition, although we did use a xenophobic illustration, in which the standard 1930s "dangerous Jew" image is juxtaposed with an almost similar "dangerous Muslim" image from the early 1990s.

The general "normalization" of xenophobia in Norwegian society in recent years brings me to the last, and most difficult, chapter of the exhibition: The normality of violence. It was combined with a personal reflection on creating an exhibition like this, and a personal admission of avoiding the question of the normality of violence

Figure 8: (right) Poster for the exhibition "Der ewige Jude" shown in Munich, Vienna and Berlin, 1937-39;
Figure 8: (left) "Norwegians! We want your jobs. We want your houses. We want your country." Flyer, Norway, probably early 1990s.

because I found it too difficult. Nevertheless, I continued telling the audience why, with some examples. Anyway, this *is* a theme almost always avoided. The beauty of Japanese swords, yes, the culture surrounding them, okay, but connecting this beauty and this exotic culture to the "normal", down-to-earth use of a Japanese sword as a tool of execution? No way.

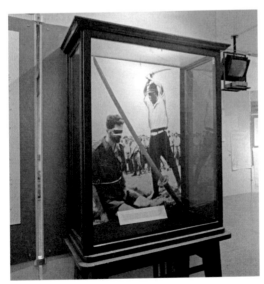

Figure 9: The beauty of Japanese words and the down-to-earth use of a Japanese sword.
© Museum of Cultural History, University of Oslo.
Photo: Jorunn Solli

*Figure 10: Shrunken heads
and texts about head-hunting
removed.
Copyright: Museum of Cultural
History, University of Oslo.
Photo: Ann Christine Eek*

In the 1970s, we removed the shrunken heads from our exhibitions – I am sure you all are familiar with them. They were taken down because they were like a "black hole", sucking in the visitors' attention and making it impossible to convey an – after all – reasonably sympathetic picture of societies that engaged in head-hunting. But removing them was, of course, a form of well-meaning censorship. In the everyday life of everyday people, trying to preserve normality is an understandable way to secure safety, survival, love and mutual respect. But in order to preserve this normality, humans are willing to go very, very far in accepting, even enjoying, or simply not reflecting on, violence against other humans.

Is it possible to consider a spectator of gladiator fights 2000 years ago as a person with high moral standards? How far away in terms of time and geographical distance do we find the turning point when we stop seeing a practice as a normal way of their life, and start seeing it as an obviously criminal way of our lives?

This is a theme that could and should be explored. It is perhaps difficult to handle conceptually in an exhibition, but it is probably a good thing in itself to make the public aware of the everyday importance of these questions.

The Beauty of War was a great success, although it was overshadowed a bit by another museum's exhibition on Norwegian home decoration, which, according to the exhibitors, was rather provincial, of course, gaining quite a lot of media attention. A journal of philosophy (Brenna/Sandmo, ARR 1/1996) enthusiastically devoted an article to the *The Beauty of War*, attributing to me far more advanced thinking than I've ever had.

And one morning, one of the gallery attendants came to me and told me that the day before, at closing time, there had been a "situation" with a lady. "She was really difficult", he said. "She refused to leave before she had seen and read all of it!"

Which brings me to my last point: When presenting difficult themes, trust that the public will be grateful for the invitation to think together with you – and take the risk that they may refuse to leave at closing time.

The Bomb and the City: Presentations of War in German City Museums

Susanne Hagemann

The aim of the following paper is to offer some insight into the design of permanent exhibitions of local history dealing with the Second World War. Over the last few years, I have had the opportunity to visit and document over 40 history exhibitions as part of a research project concerning "The Presentation of the Years 1933–45 in German Historical Museums". It is far from the case that all the exhibitions focused solely on the Second World War. With a growing amount of material, I was able to create a canon from a wide variety of different exhibitions. Specific exhibits belonged to this canon, but so did specific subjects of the museum's narrative and constantly reoccurring subject matter.

Among the objects, there are the "Volksempfänger" radio receiver, insignia and medals of Nazi organizations, bombs and gas masks as well as converted, improvised tools of the post-war period. Subjects that appear in the exhibitions, besides Hitler and other politicians, are Wehrmacht soldiers, Hitler Youths, the so-called "Trümmerfrauen", and ethnic German refugees from Eastern Europe. Connected with these are topics such as the suffering of the civilian population and their spirit of resistance against the Nazis, the "dark chapter" of German history, or the practical ingenuity of the Germans in times of hardship.

The research, which was supervised by the literary scholar Prof. Aleida Assmann (Constance) and the historian Prof. Rosmarie Beier-de Haan (Berlin), is driven by questions concerning remembrance and memory research as well as the politics of history. For that reason, in the following analysis of the exhibitions, the focus shall be on the interpretive space emerging from the presentation.

As is the case when examining texts or films, the exhibition shall be understood to be a medium which can be interpreted with regard to its many layers of information and connotation. Its statements emerge from the interplay of objects, images, light and color, text, sounds, and spatial mise en scènes. Usually, the individual object in an exhibition is ascribed the role of serving as a material condensation of the topic. Depending upon the manner of presentation, one single statement from all the various ones is emphasized while others are hidden. Additionally, the objects

displayed can and are intended to provoke emotions on the part of visitors. Within the contexts of this conference and its central question, "Does War Belong in Museums?", the following shall focus on a single object from the canon: the bomb. Many local history museums in Germany possess an undetonated bomb from the Second World War, which they present to visitors in their permanent exhibitions in various contexts and settings.

Not least in connection with the success of Jörg Friedrich's book "The Fire: The Bombing of Germany 1940-1945" (2002)[1], and the anniversaries of the bombings of various German cities, and the media presence of children of the war and German refugees, the topic of "aerial war" has been controversially discussed in the public discourse, revolving around issues such as historical responsibility, guilt and exoneration.[2] Intensified by the "Year of Commemoration 2005", 60 years after the end of the war, German history museums, on the occasion of local anniversaries of aerial bombardment by the Allies, prepared special exhibitions on the topic, for example, in Duisburg, Dresden, Osnabrück, and Freiburg. The object of "the bomb" thus acquired a new symbolic charge.

The bomb is usually displayed in sections dealing with the topics of the Second World War, aerial defense, and destruction by aerial bombardment. Those are topics that obviously have the greatest importance for the history of a city. For the urban population of the time, this period is obviously a formative part of their lives, and the bomb's place in the museum's narrative is that of a "pars pro toto" for a specific scene in the city's history.

THREE FORMS OF PRESENTATION

It was found that there were various, typologically comprehensible, stylistic means of exhibiting the bombs. In the museum literature, these forms of presentation are sometimes grouped into three categories, which can also be applied to the example of the bomb. These are documentation, mise en scène and ensemble. In order to provide an idea of the different variations, an outline of each shall be given including examples and a few pictures for the purposes of illustration.

1. Documentation
The first style would be the classic, chronological documentation. At first glance, this would appear to be a sober method of presentation, focused on the facts, with textual and pictorial material, for example on simple wall partitions, in which authentic objects are presented on platforms or in glass display cases. This form of presentation

1 | Jörg Friedrich (2002): Der Brand, Munich: Propyläen Verlag.
2 | Lothar Kettenacker (2003) (ed.): Ein Volk von Opfern? Die neue Debatte um den Bombenkrieg 1940–1945, Berlin: Rowohlt.

has a tendency to be scant and de-sensualized. It makes its arguments with words, pictures, and quotations rather than with "atmosphere". The fundamental critique of this form made by museologists is that history is not made perceptible to the visitors' senses. In the City Museum of Halle (Saale), the heavy exhibit "bomb" is displayed on a very low platform. Behind it, on a simple wall partition, are photos of well-known destroyed buildings and the label "American explosive bomb, 250 pounds."

Figure 1: Museum Halle (Saale), "American explosive bomb, 250 pounds"

A similar, altar-like presentation of a bomb is found in the City Museum Weimar (Bertuchhaus). There, the bomb is also displayed according to the same, seemingly redundant principle: on a small pedestal in front of a black wall partition. In this case, however, the textual material on the partition pertains to the final stand-or-die order of the Nazi leadership.

Incidentally, when it comes to the topic of the Nazis, the dominant color arrangement in German history exhibitions is black, red, and white. This generates a matter-of-fact seriousness, which amplifies that which is often referred to as "the dark chapter of German history."

The technical, sober descriptive text explains that the bomb is a "250 pound GP bomb." The English abbreviation "GP = general purpose bomb" is translated into German, and the specialist firm from which the museum obtained the bomb is named.

In the permanent exhibition of the Focke Museum in Bremen, the bomb is presented sitting alone on a simple pedestal. The label reads: "One of forty-one-

thousand-six-hundred-and-twenty-nine." The audio guide plays the sound of air raid sirens for five minutes.

How do these narratives of the "bomb war" in these three presentations now differ in terms of the documentary category?

The grand object in each case stands alone, emphasized in the foreground, exhibited with a certain ceremoniousness. A special meaning is apparently attributed to it. However, more decisive is the context. In connection with the "exhibited sound" in Bremen, the presentation can have the effect of stirring up emotion. If visitors can make a mental connection between the bomb and the piercing alarm, they can empathize with the situation characterized by menace, danger, and the fear of death in which the "population of Bremen" found itself during the war. The labeling of the object, by noting the number of bombs dropped in words rather than figures, intensifies this impression of the bombs' inescapable mass and enormous aggression. In Halle, the presentation of the bomb is followed by the next section of the exhibition, marked by a large banner with the inscription "Halle baut auf" ("Halle Builds"). The narrative of the museum thus makes a seamless transition from war to reconstruction, an important element not only in the founding myth of the GDR. Only the Weimar exhibition, by presenting the stand-or-die order issued by the Nazi leadership, makes a connection between German policies and Allied warfare. It makes an argument for the unreasonableness of the party leadership, who plunged "the people", that is to say the "Weimarer", into misery, since this attitude led to the prolonged bombardment of the city. This argumentation is problematic to the extent that it seeks to locate responsibility with "the Nazis", while at the same time suppressing the fighting spirit of the "Volksgemeinschaft".

2. Mise en scène

Correspondingly, the second form of presentation, mise en scène, seeks access by means of a stronger emotionalization. Rooms are elaborately designed in a scenographic manner with a diverse use of media such as colorful materials, true-to-life figurines, lighting, film pictures, sound, etc. The aim here is to offer visitors the possibility to emotionally immerse themselves in the events and to "experience" them. In this form of presentation, the event character of the exhibition has priority over the pure conveyance of facts. As a result of their aesthetic character or their "sensuous quality of impression", as Korff and Roth say, the authentic objects are ascribed "a stimulative value beyond the value of the object which makes them suitable in a particular way for historical experiences".[3] In the exhibitions from which the following examples are taken, the object is recontextualized, that is to say, it is staged in

3 | Gottfried Korff/Martin Roth (1990): »Einleitung«, in: Gottfried Korff/Martin Roth, (eds.): Das historische Museum. Labor, Schaubühne, Identitätsfabrik, Frankfurt a.M./ New York: Campus, pp. 9–37.

its supposed former context of use. The statements thus produced, gradually distinguish themselves from one another.

Relatively frequently, the bomb is staged directly after its impact, for example, in the City Museum of Münster.

Figure 2: City Museum of Münster, relief with a depiction of children

Here, the bomb lies between two sections of walls from famous buildings, which are named. It is not mere coincidence that a relief with a depiction of children is chosen here. Children, as per se innocent, strengthen the impression of the vulnerability and the victim status of the city in general.

The mise en scène is similar in Rostock. We are presented here with a gas mask, an air safety helmet, and the grate of an air raid shelter. "Psst!" is part of a propaganda poster that warns: "Pst! Der Feind hört mit!" ("Psst! The enemy is listening!")

The mise en scènes constantly attempt to create an impression of authenticity, to create a scenery as it must have existed right after the attack: the (undetonated) bomb lies amid ruins, broken construction beams, or as is the case, for example, in the Cologne City Museum, between the ashen remains of walls and broken insignia of Nazi rule such as the imperial eagle, swastika, etc. This presentation of objects aims to create an emotional effect and to set a cognitive process in motion by means of a spatial and bodily experience.

As Dr. Gorch Pieken has shown in his work, the Dresden Military History Museum also works with this spatial and bodily experience, as it is very strong in the architecture of Daniel Libeskind. The emotional effect is reinforced through

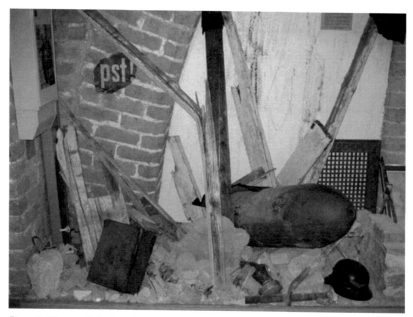

Figure 3: Museum Kröpeliner Tor Rostock, "Psst! The enemy is listening!"

performative installations, in which the bombing raid can be re-experienced in a reconstructed air raid shelter with wailing sirens and shaking walls, for example, in the special exhibition "Bombs on Duisburg – The Air War and City, 1940–1960" or in the hands-on exhibition "The Story of Berlin". The Imperial War Museum in London follows this manner of mise en scène in its well-known spectacular walk-in presentation of the "Blitz".

The focus of the mise en scène of the bomb "during" the bomb attacks is laid upon the history of violence, human victims and material destruction. But a distinction must also be made here concerning the meaning ascribed to the object through other presented objects and texts. The scenes of ruin and the photo series of other museums, to some extent, refer to buildings as "victims" and implicitly attribute responsibility either to "the Nazis" or the Allies. Implicit because at this point the political preconditions, namely the war and planned genocide begun and executed by the Germans, remain neglected in these narratives. By means of this, the door is left open for the interpretation that the Allied bombing was not a reaction to something, but rather was an act of pure aggression. Here, there is a recognizable emphatic reference to the discourse of victimhood that exists outside of museums.

3. Ensemble
A third formal category is that of the ensemble, in which both artistic means of design and substantive fragmentation are employed. A consciously arranged, often collage-like combination of objects opens up a space for making associations. In the

best case scenario, this can lead visitors to create new mental associations within already familiar material and offer food for thought. In the worst case scenario, it leaves visitors alone with the crudest and most traditional interpretive patterns. In the case of the history of the Second World War, a conflict arises from the necessity for the institution of the museum to take a concrete position and the usual notion of "responsible visitors", who are capable of thinking for themselves and thus achieving historical insight. Some well-intended elaborate designs can thus end up being too demanding in terms of content.

As the last section of this paper intends to show, the Bielefeld Historical Museum deals with the causes and conditions of the Allied bombing and an attempt is made to depict the destruction in a sophisticated way. The presentation there constitutes a hybrid category, in which substantive arguments are made, but the presentation is designed in an artistic and fragmented way.

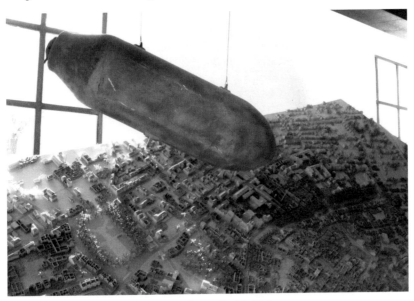

Figure 4: Bielefeld Historical Museum, Bomb over Model of Ruins

The bomb hangs threateningly, as if in the moment of being dropped, over a crooked model of the ruins of Bielefeld installed in the room. This model was created in the 1980s. There are similar models in a number of city history museums, for example, in Nuremberg, Hamburg, Münster, and Frankfurt am Main. Some of them emerged right after the war, with the goal of documenting the damage wrought by the war and as an aid in the discussion concerning the ways and means of reconstruction.

In the foreground, additional color photographs are exhibited, which were taken during or shortly after the attacks. The bomb is contextualized under the rubric of "arms production" and accompanied by metal working machines and corresponding

text. Under the headline, "The Bombing of Bielefeld", visitors learn that one of the goals of the air attacks, the destruction of the arms industry, was only partially achieved. The Americans and British particularly wanted to disrupt the course of production in the arms factories. But usually, according to the text, the air attacks inflicted minimal damage.

The ensemble, which both dramatizes and alienates, is also deployed by the curators of the Museum for Hamburg History. In the introductory text, "Under the Rule of the Nazis", one finds among other passages the following:

"Since 1939, the citizens of Hamburg have been affected by the Second World War in a number of ways: men died as Wehrmacht soldiers, the supply situation in the city deteriorated increasingly, but above all else the inhabitants suffered from the numerous bomb attacks."

The dominant object in the section dealing with the nocturnal "firestorm" of 1943 is an impressive, large bomb lying on the ground on a very low pedestal. The

Figure 5: Museum for Hamburg History, "Firestorm"

"firestorm" is additionally symbolized by the design of the room with blue light and yellow and red accents.

Leaning next to the bomb, in a corner, is the emergency exit window of a British airplane, and the display text commenting "Was the crew able to save itself?". Now does this question express concern for the Allied "liberators" or for the fate of the "enemy"?

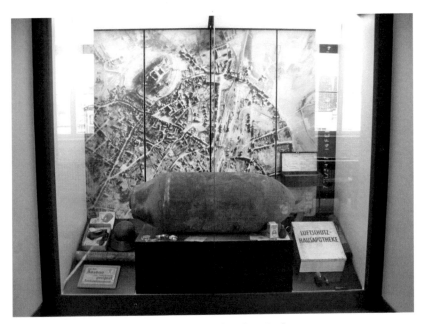

Figure 6: City Museum of Siegburg, "Cultural window-shopping"

Usually, in presentations of city history, the suffering of the German civilian population, or more exactly, the "Volksgemeinschaft", is always placed front and center. Changes of perspective of this kind are rare. Jewish victims are, if at all, usually named in separate sections, as if both histories did not overlap.

The last example to be considered here concerns the City Museum of Siegburg, in which the bomb is presented in a kind of "display window", along with a "home air raid first aid kit", the helmet of an air raid warden, a silver barrier tape (used to disrupt enemy radar) and in the background a vertical aerial shot of the bombed city. Here, visitors are confronted with an ensemble without accompanying text or commentary. The sociologist Heiner Treinen's concept of "cultural window-shopping"[4], which is often similar to a museum visit and in which the hoped-for educational effect is limited, imposes itself here. Similar to the Hamburg presentation, the bomb has a dominant presence, but the spectrum of possible interpretations is intentionally left wide open.

The reference to the topic of air defense and war via the arrangement of the objects is visible, but the broad field of meaning of life in war is only accessible to some of the visitors, namely the older ones. Without commentary, the objects on display cannot be understood, because they do not stem from the visitors' living experience.

4 | Heiner Treinen, (1988): »Was sucht der Besucher im Museum?«, in: Gottfried Fliedl (ed.): Museum als soziales Gedächtnis? Kritische Beiträge zu Museumswissenschaft und Museumspädagogik, Klagenfurt, pp. 24–41.

The confrontation with the "foreign" or "alien", one of the greatest potentials of the museum, which operates with material artifacts, is squandered here with regard to learning history and knowledge of historical connections.

The "experience" of the museum visit is reduced to a purely aesthetic one. Left without a statement and emphatic positioning on the part of the curators, the wordless presentation of the bomb in front of the aerial view of the destroyed city can congeal into an accusation leveled at the Allies.

Something emerges which the research group around Harald Welzer, currently involved in research on intra-family communication, would describe as "empty speech." What Welzer makes clear is that it is precisely this "empty speech" which characterizes inter-generational dialogue about the "Third Reich." He very plausibly works out how principal players (mostly the perpetrators) remain without contours. Historical events are described only in outline, so that it remains unclear what the actual point is and the events appear almost harmless. "Empty speech" consists in the indeterminate nature of the historical process, which is dealt with in an associative and indirect way. Thus, listeners are left to fill in the empty spaces with their own assumptions, in order to assign meaning to what the speakers say.[5]

SUMMARY

As we have seen, the way in which the bomb is presented and contextualized, as an object in the thematic field of the bombing of German cities, spans the spectrum of meaning from "witness of the authentic moment" to a symbolically inflated piece of evidence for accusing the Allies.

This paper has attempted to show that either the bomb, despite all supposed sobriety, is elevated to the status of a sacred object in order to emphasize the suffering of the victims, in this case, primarily members of the "Volksgemeinschaft", or the bomb is presented in such a way that visitors are introduced to the historical situation in as wide-reaching a way as possible. Here, the suffering of German victims is also placed in the foreground. The illusion that history can be "experienced" in retrospect stubbornly remains.

A third, rarer variant attempts to shed light on the historical connections from multiple perspectives and make them understandable to visitors. This is effectively supported by an unusual design breaking with conventional expectations.

Without wishing to speculate on the conscious or subconscious dispositions of the exhibition curators, many elements can be recognized, which illustrate how complicated it is to maintain the balancing act between the claim of museums to

5 | Harald Welzer/Sabine Moller/Karoline Tschuggnall (2002): "Opa war kein Nazi". Nationalsozialismus und Holocaust im Familiengedächtnis, Frankfurt a. M.: S. Fischer, p. 158.

convey knowledge about history in an enlightened manner while nonetheless, in light of the "negative history", offering positive possibilities for identification. Although a politically correct style of speech has made inroads into most museums, for example, in the way that various groups that fell victim to the Nazis are named, the main effort seems to be directed at generating a distanced, distancing "pacified" narrative, which is not uncommonly apologetic as well.

Thus, it can be said that war belongs in museums, above all, in city history exhibitions and in all sincerity. Although there is still much research to be done in this area, numerous conversations overheard between older visitors lead us to believe that the level of identification with local history and emotional involvement are very high. Visitors seek and find parts of their own life histories in the museum. They often use the exhibition as an occasion to pass on family history facing the displays. In Duisburg, in connection with the tours through the war exhibition, a regular coffee table discussion was set up in order to "intercept" the emotionally stirred-up visitors and to offer them a casual opportunity for conversation.

To concur with Aleida Assmann, war belongs in museums if for no other reason than the fact that it is part of the collective memory of cities and a generation-spanning part of many biographies. Assmann cautions against marginalizing this part of the traumatic history. Fear and mourning also need their space, otherwise inner resistance to dealing with the topic of war will be an expectable and understandable reaction.

Translated by Alex Locascio

THE TRAUMA OF WAR AND THE LIMITS OF MEDIA

War in Context: Let the Artifacts Speak

Robert M. Ehrenreich, Jane Klinger

Why would the United States Holocaust Memorial Museum (USHMM) be inter-
ested in participating in a conference on whether war should be displayed in military
museums and armories? The USHMM is not an armory. We have just a handful of
guns in our permanent exhibition on the Holocaust, and those were used in the
resistance and are in less than ideal condition. We are also not a war museum. We
are a museum on the history of the Holocaust and a memorial to the victims. The
USHMM, however, must deal with many of the same issues as war museums and
armories.

Since its founding, the Museum has grappled with how to depict extreme ex-
amples of horror and destruction without feeding people's propensity to glorify war,
stoking their macabre or voyeuristic fascination with terror, trivializing the event,
and, above all, sacrificing the victim's dignity – essentially making them victims for
a second time.[1] The USHMM's founders were anxious that the Museum – with its
pictures of atrocities – not become a museum of horrors. They extensively debated
the types and manner in which images would be displayed. To prevent visitors and
especially younger people from being bombarded with shocking and disturbing
photos, concrete privacy walls were placed in front of the monitors displaying the
more graphic images, allowing visitors to decide whether or not they wished to see
the displays. In hindsight, privacy walls were not the answer; their presence some-
times serving as an attraction to – as one barely teenage boy once put it to one of the
authors – the good stuff. Although one can never deter a determined viewer, the Mu-
seum is considering more subtle ways of screening such imagery in future exhibits.

The founders of the Museum also grappled with how much the permanent exhi-
bition should show about the war and especially about the perpetrators. The concern
was that exhibits about Hitler could become a place of homage for neo-Nazis, where
– it was feared – flowers and votive offerings would be left. The original plan for the
permanent exhibition thus contained little about Hitler, the Nazis, and the war itself.

1 | Edward Tabor Linenthal (2001): Preserving Memory: The Struggle to Create America's
Holocaust Museum, New York: Columbia University Press.

Although an interesting idea, the perpetrator-less exhibit gave the impression that an unseen force had committed the Holocaust, almost as if a meteorite had hurtled down and destroyed the Jewish communities of Europe. In the end, a portrait of Hitler and a large Nuremberg flag were reinstated in the exhibit plan, but they were placed behind a large, black, iron grill, thus separating the objects from the viewers and making it seem as if they were behind bars.

Such issues are minor, however, compared with the problem of conveying that the six million Jews murdered during the Holocaust were real people with real lives and families. How can an exhibition return the humanity to all the people murdered in the chaos of war when the numbers discussed are literally incomprehensible? Most institutions resort to exhibiting old photographs of long lines of people trudging with their few belongings in small suitcases and sacks. These exhibits lack power, however, in a day and age when people equate grainy, black-and-white photos with ancient history.

One way to return the humanity to the victims is to put the visitors in the victim's frame of mind, making the viewers think about what they would take if they were never to return home again. If asked, most people would probably assume that the refugees and victims were carrying clothing and some food, whatever transportable valuables they had left, official documents such as passports and family records, and work records, including job histories and recommendations. After all, why would someone sacrifice valuable space and weight to take something that is of no use? Is this true, however? Do people only take with them what is essential, valuable, or useful? Visitors would be surprised by the number of seemingly superfluous personal items that victims and refugees carried with them. Visitors would probably be equally astonished to learn that the people in the long lines were also creating or discovering new items along the way that they then proceeded to carry with them. These items were obviously important to the victims or they would have been abandoned. Perhaps they were mementos of the people's lost lives, symbols of their desire to start a new life somewhere else, or simply validations of their humanity – their ability to still appreciate beauty in the midst of ugliness?

The objective of this article is to show how displaying personal items in context can turn the huge numbers of victims back into individuals and return their humanity. Three case-studies will be discussed: personal items discovered near shooting pits in Ukraine; damaged photographs from Poland; and a piece of mica from the Theresienstadt Glimmerwerke (mica factory).

PERSONAL ITEMS FROM UKRAINE

A tenet of the Nazi Party from its founding in the 1920s was the elimination of what it termed the Judeo-Bolshevik threat supposedly posed by the USSR and its Jewish community. After conquering Western Europe, Nazi Germany turned its sights on

the Soviet Union, invading it on 22 June 1941 in an ideological war of annihilation codenamed *Operation Barbarossa*. To ensure the total subjugation of the region and make the rich farmland safe for eventual German expansion and settlement, four mobile killing-units, known as Einsatzgruppen, followed the German army into Soviet territory, killing anyone deemed a threat to German occupation, including Jews, Roma, and Soviet political officials. By late July 1941, the Einsatzgruppen – aided by locally recruited police auxiliaries and German police units – were murdering Jewish communities in their entirety: men, women, and children. Over a million Jews and tens of thousands of Soviet political officials, Roma, and disabled people were eventually murdered by the Einsatzgruppen and their collaborators by the spring of 1943.

The USHMM has extensive documentary evidence in its archives of the thousands of actions conducted by the Einsatzgruppen, including SS reports of the number of people shot at different locations and even photographs of the actions sent home by soldiers in the German army who witnessed the shootings.[2] We also have documentary and photographic evidence that a special unit known as Sonderkommando 1005 was established during Germany's retreat in 1943 to destroy the mass graves resulting from the massacres.[3] Commanded by SS-Standartenführer Paul Blobel, Jewish slave laborers were forced to exhume mass graves; cremate what remained of the bodies on huge, outdoor pyres; and then pulverize any extant bone-fragments in large crushing machines. Moreover, we have documentation recording the periodic shooting and replacement of the Sonnderkommandos with new Jewish prisoners brought in to obliterate their predecessors' presence as well as continue their work.

Some of the most emotional evidence, however, comes from the on-the-ground work of Father Patrick Desbois, with the USHMM's assistance.[4] Spurred as a youth

2 | For example, see Wendy Lower (2007): Nazi Empire-Building and the Holocaust in Ukraine, Chapel Hill: The University of North Carolina Press in association with the United States Holocaust Memorial Museum; Joshua Rubenstein/Ilya Altman (2007) (eds.): The Unknown Black Book: The Holocaust in the German-Occupied Soviet Territories, Bloomington: Indiana University Press in association with the United States Holocaust Memorial Museum; and Timothy Snyder (2010): Bloodlands: Europe Between Hitler and Stalin, New York: Basic Books.

3 | »International Conference on Operation 1005: Nazi Attempts to Erase the Evidence of Mass Murder in Eastern and Central Europe, 1942–1944«, 15-16 June 2009 at the Collège des Bernardins in Paris and co-organized by the United States Holocaust Memorial Museum' Center for Advanced Holocaust Studies, Yahad-In Unum, Collège des Bernardins, and the Université Paris IV-Sorbonne.

4 | Father Patrick Desbois (2009): The Holocaust by Bullets: A Priest's Journey to Uncover the Truth Behind the Murder of 1.5 Million Jews, with a foreword by Paul A. Shapiro, New York: Palgrave Macmillan with support from the United States Holocaust Memorial Museum.

by his grandfather's brief description of the fate of the Ukrainian Jewish population, Father Desbois helped found Yahad-In Unum in 2004 to determine what had actually occurred. He and his team have located hundreds of mass graves in Ukraine and Belarus since then and hundreds of bullet casing at these sites. They have also collected nearly 2,000 testimonies from eye-witnesses.

Displaying such compelling evidence may demonstrate the results of the murderous policy and the ruthlessness of the perpetrators, but it does not return the victims' humanity. These individuals, who were once part of an old and vibrant Jewish community, are reduced to pits of bones seemingly to be remembered only as victims for evermore. Changing them back into real people in the eyes of museum visitors requires displaying artifacts of their lives as well as their deaths.

Figure1: Rings recovered approximately 10 meters from a mass grave in Busk, Ukraine (United States Holocaust Memorial Museum, Acc. 2008.76.1–2008.76.5, gift of Father Patrick Desbois and Yahad-In Unum)
© Photo by Jane Klinger

In addition to bullet casings, Father Desbois' team found a number of wedding rings and other jewelry (Figure 1) roughly 10 meters from the shooting pits in Busk, Ukraine. These objects must have been purposely thrown away by the Jewish population when they were forced to undress and hand their personal belongings to their murderers. Knowing full well that they were about to die, these individuals discarded their most cherished objects in a last act of defiance rather than letting their murderers get their hands on them. Displaying these significant yet overly familiar objects in a manner reminiscent of how they were found (e.g., haphazardly in a stabilized but tarnished condition) would force museum visitors to connect with the victims in ways not possible otherwise. Most people appreciate that simply losing a wedding ring is a heart-rending experience; and the idea that these people deliberately threw theirs away makes the viewer appreciate the strength and fortitude of the victims even more. Thus, displaying these seemingly insignificant objects in the proper manner would force the visitor to appreciate that these victims were

individuals – making whatever final decisions were still possible up until the very end – and not just fodder for a murderous policy.

DAMAGED PHOTOGRAPHS FROM POLAND

The second case-study concerns a set of photographs that was donated to the USHMM by Lidia Kleinman Siciarz. Mrs. Siciarz was born in Łacko, Poland, in 1930 to Dr. Mendel Kleinman, a radiologist, and Aniuta (nee Szwarcman) Kleinman. Dr. Kleinman was mobilized by the Polish army during the German and Soviet invasions of Poland in 1939 but was soon captured by the Soviets. With Dr. Kleinman in prison, Mrs. Kleinman took her daughter to Pinsk and moved in with her parents. Dr. Kleinman escaped from a prisoner transport in 1940 and made his way to Pinsk. He then fled with his family to Turka nad Stryiem, where he worked in a local hospital until the German army invaded in 1941. Dr. Kleinman was once again arrested, this time being forced to live in the local hospital as a prisoner and treat German soldiers.

Mrs. Kleinman and her daughter remained in Turka nad Stryiem until 1942, when Mrs. Kleinman heard rumors of an action to take place the following day in which all non-essential members of the Jewish population were to be deported. Thinking quickly, Mrs. Kleinman sent her daughter in the middle of the night to Dr. Kleinman at the hospital, where the head nurse, Sister Jadwiga, hid her. Before leaving, Mrs. Kleinman gave her daughter a locked cosmetics case, making her promise to keep it safe. The young Lidia spent the next three years in hiding in Catholic orphanages in Lvov, Lomna, and finally Warsaw, where she remained until 5 May, 1945, when she was reunited with her father. Sadly, Mrs. Kleinman did not survive the Holocaust.

Although Lidia had lost the key over the intervening years, she had fulfilled her promise to her mother to keep the case safe. She and her father forced the case open and found it crammed with important documents and photographs from before the war. It is incredible to think that these photographs had survived six years of running, from 1939 in Łacko – when Mrs. Kleinman must have packed them – to her husband's and daughter's reuniting in 1945 in Warsaw. The value that these photographs held for Mrs. Kleinman – and then for her husband and daughter – must have been tremendous.

The photos were subsequently placed by an aunt of Mrs. Siciarz into another photo album using double-sided tape. Since the album also contained many materials from well after the war, Mrs. Siciarz removed the photographs by pulling them off the new pages. Pieces of double-sided tape as well as residues of the modern album paper remained on the backs of the photographs, causing a conservation dilemma. These newer materials had to be distinguished from the traces of the original glue and album pages adhered to the back of the photos, which were not harming the

photos and testified to the panic during which Mrs. Kleinman tore the photos out for safe keeping in the cosmetics case. Returning the photos to pristine condition would have meant destroying all vestiges of their Holocaust history. Thus, it was critical to remove the modern double-sided tape and album pages residues without removing the original materials.

Figure 2: Photo of Dr. Mendel Kleinman, Lidia Kleinman Siciarz (seated), and an unidentified cousin, circa 1937 (United States Holocaust Memorial Museum, Acc. 1999.113.97) © Courtesy of Lidia Kleinman Siciarz

Figure 3: Verso of Photo 2 before conservation (United States Holocaust Memorial Museum, Acc. 1999.113.97-BT, courtesy of Lidia Kleinman Siciarz) © Photo by Conservation Branch, USHMM

Figure 4: Verso of Photo 2 after conservation (United States Holocaust Memorial Museum, Acc. 1999.113.97-AT, courtesy of Lidia Kleinman Siciarz) © Photo by Conservation Branch, USHMM

As can be seen in the Figures 2-4, the conservators at the USHMM – including one of the authors – were able to do just that. The newer materials were stripped off completely while the original, Holocaust-era material remained intact, preserving the historical damage done to the photos and the overall integrity, power, and history of the objects. An exhibit consisting of a contextualizing narrative and the photographs mounted over a mirror, which would allow visitors to view both the front and damaged back of the photos, would make a simple yet powerful exhibit of the trauma faced and decisions made by Mrs. Kleinman as a person during one of the most tragic periods in history.

MICA FROM THE THERESIENSTADT GLIMMERWERKE

Emma (nee Pariser) Jonas was born on 14 December 1889 in Inowraclaw (now Inowrocław, Poland), which was part of German Prussia at the time. Mrs. Jonas was married to Martin Israel Jonas, who was born on 5 June 1885 in Lobsens (now Łobżenica, Poland), which was less than 100 km from Inowraclaw. They lived with their one daughter, Helga (nee Jonas) Carden, in Berlin, where Mr. Jonas was a business man.

Mr. and Mrs. Jonas successfully got their daughter on a Kindertransport to England in March of 1939, but they were unable to flee themselves. Mr. and Mrs. Jonas were arrested in early 1943 and taken to Hapsburgerstrasse collection center. They were then shuttled from center to center until mid-May, when Mr. Jonas suffered congestive heart failure. As a decorated World War I veteran, Mr. Jonas was taken to a series of nursing homes until he finally ended up in Berlin's Jewish Hospital. Mrs. Jonas was allowed to accompany him throughout these moves, eventually becoming an ironer in the hospital. Mr. Jonas died on 2 October 1944 at 6 AM, leaving his wife unprotected. The recently widowed Mrs. Jonas was deported to Theresienstadt on 24 November 1944, where she worked in the mica factory (Glimmerwerke).

A number of German industries had opened plants near Theresienstadt in order to take advantage of the ghetto's "free labor". The Glimmerwerke, or mica factory, opened in June, 1942 and existed semi-continuously until 1945. The female laborers who were forced to work there each day had to use extremely fine blades to split large mica cores into individual sheets of particular dimensions for use as electrical insulation. The work was extremely difficult yet monotonous. The women were constantly slicing their fingers in their haste to meet the ever-increasing production quotas. If quotas were not met, the workers had to continue working until the full amount was produced. In a world where life constantly hung in the balance, working past one's allotted shift had serious ramifications. Not only did it further exhaust an already seriously weakened and half-starved slave-labor force, it also meant missing the meager food rations back at the ghetto, making surviving the next day even more challenging.

Like so many people during the Holocaust, Mrs. Jonas found life in Theresienstadt and the mica factory horrific. She wrote many poems about her time there, including "In the Glimmer Splitting Factory":

The young and the old
Bent over figures
Sit and work
under forced obligation

Split the glimmer
The silver glitter
Until leaf and plate
are according to size

The left one has to hold
the right one has to split
at a pace that they will fit
and if the accord is lost it
will indicate sabotage, and
that threatens transport.[5]

The sound of the crackle and
fearful whisper
The ice cold hands
"I will not make it today"

A difficult plague
a rushing chase
Until 'glimmer' and knife cut the fingers

And if the controls want to weigh again
We stand in front of a heavy fearing question in every face

what are the weights?
So our life hangs on the tongue of the scale.

Not surprisingly, Mrs. Jonas suffered from bouts of depression so deep that she considered committing suicide. She did survive Theresienstadt, however, and was liberated by Soviet troops on 8 May 1945. She then spent the next sixteen years moving: from Theresienstadt to Deggendorf DP camp in 1946; to the UK in 1947, where she

5 | Transport to Auschwitz.

was reunited with her daughter; to Canada in 1957; and then finally to the United States in 1961.

Throughout these successive moves and sixteen years, Mrs. Jonas always kept a piece of mica from the Glimmerwerke with her (Figure 5). Why would she have done this, when her life in Theresienstadt was so harsh and painful? Did she consider the mica to be a talisman that had protected her from death? Did she want to keep it as a symbol of her strength and ability to survive even the most dire of circumstances? Did it simply appeal to her aesthetic sense? It would have been easy to have lost or discarded it over that time, not to mention that mica is a highly friable material that easily breaks apart. Mrs. Jonas must have deliberately taken care of the piece for it to have survived those sixteen years in transit. A display containing Mrs. Jonas' story, her poetry, and the mica would thus form a very powerful exhibit that would make the viewer think about Mrs. Jonas as a person – the choices she made, the actions she took, and how she was able to survive the Holocaust.

Figure 5: Mica carried by Emma Jonas after liberation from Theresienstadt (United States Holocaust Memorial Museum, Acc. 2004.230.1)
© Courtesy of Helga Carden; Photo by Jane Klinger

CONCLUSION

This article aims to show that properly conserving and displaying personal items with contextualizing narrative can help visitors see events from the victim's perspective and provide a glimpse of the struggle that these people were forced – as individuals – to endure in order to maintain their humanity in the face of adversity. Such artifacts and stories allow visitors to appreciate the large number of victims or refugees as individuals as opposed to faceless numbers, as well as to contemplate how they would have reacted to such events. These displays would demonstrate the true horrors of war and counter-balance more technical displays of the machines of war or deeds of particular soldiers, which tend to glorify battle. Obtaining such a result, however, requires approaching the topic from a completely different perspective and can only be accomplished by the proper conservation and exhibition of the victims' artifacts with associated, contextualizing narratives.

War Museums and Photography

Alexandra Bounia, Theopisti Stylianou-Lambert

1. Introduction

Museums and photography seem to have one thing in common. They are both considered unquestionable reflections of reality, that is, objective, authentic and credible sources of knowledge. Museums are repositories of real material testimonies of the past, and construct narratives, which are believed to be academic, historical and, as such, indisputable.[1] Thus, their voice becomes authoritative and influential. Photographs are also considered a "transparent" window to the truth,[2] or, in the words of Susan Sontag, a "species of alchemy",[3] representing unmediated and unbiased reality.

However, this is not exactly the case for either of them. Museums may hold *authentic* pieces of the past, but these are organised, arranged, and set in place as a result of a complex network of personal, social, political and economic circumstances and decisions. Photography is not much different. Just as museum professionals and academics make complex choices on what to include and exclude from an exhibition, photographers make similar choices on what to include and exclude from their photographic frame. As Sontag put it, "to photograph is to frame and to frame is to exclude".[4] Furthermore, photographers decide on which events to cover, and what images to share and with whom.

In this paper, we are going to discuss the use of photography in five, *young*, war-related museums – two in the Republic of Cyprus and three in the northern part of the island, which currently goes under the name of the *Turkish Republic of Northern*

1 | Richard Sandell (2007): Museums, Prejudice and the Reframing of Difference. London, New York: Routledge.

2 | Kendall L. Walton (1984): »Transparent Pictures: On the Nature of Photographic Realism«, in: Critical Inquiry 11(2), pp. 246–277.

3 | Susan Sontag (2003): Regarding the Pain of Others. London: Penguin Books, p.41.

4 | ibid, p.41.

Cyprus. We are going to focus on the categories of photographs used in these museums, the context in which they are presented, and how this influences their meaning, as well as the relationship between photography, memory and history. We are going to argue that a close comparative study of the use of photographs in museums can reveal how the *transparency* of photography and the authority of the museum interact with the subjectivity and the political (in the broad sense of the term) construction of historical narratives.

2. IMAGES OF WAR

In less than two decades, from 1955 to 1974, the island of Cyprus experienced several conflicts: an uprising against the British colonial regime (1955-59) which resulted in the island's independence in 1960; an inter-communal conflict between the two main communities of the island, i.e. the Greek Cypriot and the Turkish Cypriot communities in the 60s; a military operation by Turkish troops in 1974, which ended in the division of the island in two parts: the southern (Greek Cypriot) and the northern (Turkish Cypriot) part. To this day, UN forces patrol the Green Line (the line dividing the island in two) and Nicosia remains the "last divided capital in Europe". In 1983, the Turkish administration of the northern part formalized itself as the *Turkish Republic of Northern Cyprus* (TRNC), which is not recognized as such by any state (except by Turkey) or by any international organization. In 2003, an agreement was reached between the two parts that allowed crossing points to be created, so that people could move between the two parts. This access has led to major emotional trauma for people on both sides.

In direct response to these events, several museums and memorials have been created on both sides. In this discussion, we are going to consider the following: (a) the *Struggle Museum* (opened to the public in 1962, South Cyprus), (b) the *Museum of Barbarism* (opened in 1966, North Cyprus), (c) the *Museum of National Struggle* (opened in 1982, North Cyprus), (d) the *Peace and Freedom Museum* (opened in 2010, North Cyprus) and (e) the *Museum of Commando Fighters of Cyprus* (opened in 2010, South Cyprus). These museums seem to promote official, national(istic) views of what has happened and why, and they aim to reinforce national narratives and corroborate their views through the authenticity of the display and the accuracy of the presented facts. In these museums, as we will argue, photography is used as a means to construct strong national narratives by assuming the role of factual information and by appealing to emotions.

Museums of this kind, i.e. war memorial museums, usually hold three categories of photographs: (a) documentary/ photojournalistic images of events that took place during a particular war (such as killings, destructions, displacements etc.); (b) portraits of heroes or martyrs; and (c) images of military and political events as well as images of soldiers in social situations. The first category usually consists of

photographs taken by third parties, journalists or reporters more often than not, from countries not involved in the conflict. The second category consists of photos coming from periods before the events, when the soldiers were preparing for war, celebrating various family or other events, or sending back mementoes to their loved ones. Finally, the third category differs from the first in the sense that it aims to celebrate the military and its contribution, rather than present the tragedy of war.

All three categories are present in our case studies. Apart from the National Struggle Museum (in the north), which also uses colour photographs, the other four museums mainly use black and white images in their exhibitions. These are usually labelled, but more often than not are unattributed. Information about the photographers, their intentions, their alliances, their employers, or the original context of the picture or the circumstances of their shooting are usually not available. Placed in the museums as part of their narratives, these photographs serve as *currency* and visual proof, endorsed with the aura of the museum's authenticity.[5]

2.1 Documentary Photography as Proof

War museums often display a significant number of photographs as visual testimonies of the events described by texts and other exhibition media. Documentary photography, which is considered a mechanical reproduction of reality at a specific time and place, seems to exclaim: "See with your own eyes! It happened and it looked like this". This ostensible truth is the reason why the Museum of Barbarism in north Nicosia uses its iconic photograph.

The Museum of Barbarism is a small museum in the northern part of divided Nicosia, which aims to commemorate not an act of war, but an atrocity inflicted on innocent victims. It thus aims to emphasize the cruelty and cowardly behaviour of the other group and thus create the sense of the victimization of a community (the Turkish Cypriot one) for the purposes of nation-building. It is located in the former residence of Dr. Nihat Ilhan, a major, who served in the Cyprus Turkish Army Contingent in the 1960s. According to the museum narrative, his wife and three children together with a neighbour woman were killed in the bathroom of their home by Greek fighters during the inter-communal conflicts of December 1963. The house remained as it was until 1965 when it was opened to the public as a memorial space, and officially became a museum in January 1966. Repairs were made in 1975 and 2000, and the exhibition as it is today was inaugurated on 14 February 2000. Apart from the personal belongings of the victims, the museum narrative is constructed of photographs and a few artworks. Accompanying texts in Turkish and English quote

5 | Paul Williams (2007): Memorial Museums: The Global Rush to Commemorate Atrocities. Oxford, New York: BERG.

from the international press reporting on the event just weeks or days after it occurred – and thus become *impartial* testimonies of brutality and *barbarism*.

The selection of photographs is indicative: mutilated bodies, refugees, mothers and their children in despair. The most shocking photograph though is a bland snapshot of Dr. Ilhan's wife and her three children dead in the bathtub of their home (Figure 1). The bodies are stacked one on top of the other and the faces of the three young children are clearly visible. The photograph, framed in a gold frame like a family portrait, hangs on the wall just outside the bathroom of the house and thus invites the viewer to recreate the scene. This rather cruel photograph is the only image in the visitor handout available at the entrance. The repetition makes the photograph the visual highlight of the museum, demanding recognition of the event and thus the atrocities inflicted on Turkish Cypriots.

After overcoming the initial shock, research on the particulars of the photograph reveals some interesting information: this is one of a series of similar photographs and videos that were shot on the scene, days after the actual event. Apparently, the bodies were not removed immediately, so that international reporters had the chance to document and broadcast the event. Even though there are colour versions of it, the black and white photograph has been chosen for display. Most documentary style photography of the period appeared in black and white due to the fact that colour films were considered inferior to black and white ones and, therefore, many professionals avoided them. Furthermore, black and white photography was commonly used in newspapers, became synonymous with photojournalism, and thus lent it the aura of authenticity. The reason why a black and white photograph was chosen for display instead of a colour one is not known. Nevertheless, the chosen photograph seems more newspaper-like and therefore more *authentic*.

The display of dead bodies, the aura of authenticity black and white photography lends to the image, as well as the fact that the photograph is framed like a family portrait and displayed in the house of the victims, creates feelings of confusion, uneasiness and repulsion in visitors. Sant Cassia compared the images found on Greek and Turkish Cypriot propaganda material (published by their respective Public Information Offices) and suggested that Turkish Cypriots highlight the dead body more than Greek Cypriots.[6] Images of dead bodies are described by the author as wounds that "transform the body into an impossible object, and thus a barely recognizable subject".[7] This particular image of the dead woman and her children is present in almost every Turkish Cypriot museum dealing with the war as well as in the Cyprus/ Korean hall of the Istanbul Military Museum.[8] This is not

6 | Paul Sant Cassia (1999): »Piercing Transformations: Representations of Suffering in Cyprus«, in: Visual Anthropology 13(1), pp. 23–46.

7 | ibid, p.37.

8 | Yiannis Toumazis (2010): »Pride and Prejudice, Photography and Memory in Cyprus«,

Figure 1: Framed photograph of a murdered woman and her three children,
Museum of Barbarism, Photo by the authors.

surprising since it offers the iconic image of suffering, a wound able to reinforce a collective Turkish Cypriot memory that justifies division as well as proves the experience in the international media.

2.2 The Human Face of Tragedy: Heroes and Martyrs

While the Museum of Barbarism and other museums we will examine in later sections are populated with images of evictions, captives, victims, executions, bodies, bombings, burned and burning sites, the following two museums choose to highlight a different kind of photography: portraits of martyrs and heroes. The Turkish Cypriot *Museum of Peace and Freedom* (opened in 2010 in its present form) and the Greek Cypriot *Museum of Commando Fighters of Cyprus* (opened in 2010) are war museums in a more straightforward fashion. They display military equipment; the military has been involved in the creation of the first one, while a regiment is responsible for the creation and management of the other one. The Peace and Freedom Museum also pays tribute to Turkish and Turkish Cypriot soldiers who died in

in Elena Stylianou (ed.): Proceedings of the 1st International Conference of Photography and Theory, Limassol, Cyprus.

Cyprus during the events of 1974, while the Commando Museum commemorates the fights and fighters who defended the Greek Cypriot side.

The Museum of Peace and Freedom commemorates the most controversial historical event of modern Cyprus, i.e. the arrival of the Turkish army on the island in July 1974, what Greek Cypriots call the Turkish invasion, and what Turkish authorities prefer to call the *Peace Operation*. The museum is located quite near to the actual site of the event and right next to a cemetery where soldiers/victims were buried. The museum consists of a small building, an open-air display of military vehicles (*trophies of war* as we learn from the labels), a monument and a cemetery. The main building houses an exhibition devoted to the events and the leader of the operation, Colonel Ibrahim Karaoglanoglou, and has been there since 1975/6. The museum complex though, entitled *Museum of Peace and Freedom*, both as a reference to the operation's title and to its perceived consequences, was not inaugurated until July 2010 and, according to its staff, has since become a major tourist destination, mainly for tourists from Turkey. Responsibility for the site is divided: the main building is run by the Department of Antiquities, whereas the open-air part of it and the monument is managed by the military.

The Museum of Commando Fighters of Cyprus is the most recent war-related museum on the island. An initiative of the Cypriot Association of Commandos, it opened its doors in 2010. It covers the period from 1964 (when the association was created) till today with special highlights on the years 1964 and 1974. According to the museum's website, its aim is the: "... collection, preservation and exhibition of Commandos' objects, the study and archiving of their history, and the promotion of their ideas throughout the centuries. According to ICOM's classification, the Commando Museum belongs to the category of historical-technological museums that examine and exhibit a particular human activity in all its manifestations".[9]

The photographic material used in both museums is quite similar since special emphasis is given to portraits of soldiers and important military and political figures. In some cases, a person is singled out because of the role he played (not a single woman is highlighted) in the war efforts or, more often, the individual photographs are grouped together to provide a mosaic of personal and collective sacrifice. For example, in the Museum of Peace and Freedom, two separate grid arrangements display the portraits of the Turkish and Turkish Cypriot soldiers respectively who died during 1974. The number of headshots in both displays seems to be similar. The separation of the photographs of Turkish and Turkish Cypriot soldiers implies that both communities fought side by side, but also that *motherland* Turkey made equal sacrifices as the local population.

Usually portraits of heroes and martyrs consist of sober black and white headshots of soldiers in uniform or photographs their families have provided, in which

9 | Free translation from Greek, Cyprus Association of Commando Reserves (n.d). Retrieved from http://www.psek.org in August 2010.

the deceased is often smiling. Theses images seem to pursue more emotional than photojournalistic purposes. According to Barthes, the power of these portraits emerges from the fact that these people were not dead when their photographs were taken. The viewer knows that they are going to die and that they are already dead.[10] Furthermore, the viewer is asked to compensate for the lack of information, to consider the soldiers' lives cut short, their mourning families, their sacrifice and their bravery. This "imagined memory"[11] can be stronger and more effective than historical memory. However, the grid arrangement can depersonalize this personal and emotional feeling. According to Williams, "Although memorial museums typically aim to put a 'human face' on tragedy, the end result can be depersonalization, insofar as the person or people depicted are often received as little more than representative sacrificial victims of historical narrative".[12] From personal tragedy, the grid arrangement transports the viewer to abstract ideas such as sacrifice, history, memory and duty.

2.3 Celebrating Military Operations

The other kind of photography displayed in both the Museum of Peace and Freedom and the Museum of Commando Fighters of Cyprus is photographs of military and political meetings, organized operations performed by groups of soldiers, as well as soldiers in social situations. These photographs present either a well-organized and efficient army ready for everything or how the local population welcomed the military actions.

Since the Museum of Peace and Freedom celebrates the 1974 victory of the Turkish army, the overall message is that of a victorious army who helped liberate the suffering Turkish Cypriot community. A photograph of (we assume) a Turkish Cypriot child offering a glass of water to a Turkish soldier along with two other photos showing the arrival of the Turkish army hang above a map which marks the route of the army's landing (Figure 2). This photograph of the child, a potent symbol of the future, successfully summarizes the overall message of the exhibition. Similar images are displayed in other war museums. For example, Toumazis observed that a photograph of a Turkish soldier affectionately holding a Turkish Cypriot baby hangs in the Cypriot/ Korean hall in *the Istanbul Military Museum,* while a photograph of a Greek soldier holding a Greek Cypriot baby hangs in the Cyprus hall of the *War*

10 | Roland Barthes (2009): Camera Lucida: Reflections on Photography, London: Vintage Classics.

11 | Paul Williams (2007): Memorial Museums: The Global Rush to Commemorate Atrocities. Oxford, New York: BERG.

12 | Paul Williams (2007): Memorial Museums: The Global Rush to Commemorate Atrocities. Oxford, New York: BERG, p.73.

Figure 2: Arrangement at the Museum of Peace and Freedom, Photo by the authors

Museum in Athens.[13] Such images reinforce the belief that the Turkish and Greek armies respectively arrived in Cyprus in 1974 in order to protect and fight for their people and were received with gratitude and hope.

Perhaps not so surprisingly, the photographic material at the Museum of Commando Fighters of Cyprus tells a similar story. Portraits of soldiers and photographs of military leaders and groups are favoured over images of death, displacement and destruction. The general feeling is again that of a well-organized military group ready for everything, something that the tour guide, a commando veteran who fought in 1974, makes sure to emphasize to visitors. Even though the war in 1974 ended with Turkey occupying a large part of the island, the overall feeling in this museum is an optimistic one since, according to the museum's narrative, the fight is not over yet.

3. CONTEXTUALIZING PHOTOGRAPHY: IMAGE AND TEXT

How images work depends largely on how they are linked with text, the context they are found in or what the audience expects to find in a museum. All images are *polysemous* since they can imply different meanings, which usually depend on the viewers'

13 | Giannis Toumazis (2010): »Pride and Prejudice, Photography and Memory in Cyprus«, in: E. Stylianou (ed.): Proceedings of the 1st International Conference of Photography and Theory. Limassol, Cyprus.

knowledge of national, cultural and aesthetic characteristics which are embedded in the image.[14] Similarly, the meaning of photographs found in war museums can depend on the nationality and political views of the viewer, as well as cultural and social factors. To avoid this *polysemy*, museums use labels and text to direct the messages emitted by the photographs. According to Barthes, "the text directs the reader through the signifieds of the image, causing him to avoid some and receive others; by means of an often subtle dispatching, it remote-controls him towards a meaning chosen in advance".[15] We will examine how captions and the museum's context can *remote-control* meaning by favouring one interpretation over other possible ones. Let us take as an example the photographs found in two similar museums, which, nevertheless, offer very different narratives: the Greek Cypriot *Struggle Museum* in south Nicosia and the Turkish Cypriot *Museum of National Struggle* in north Nicosia.

The Struggle Museum in south Nicosia was established on 26 January 1961 by the Assembly of the Hellenic Community. The aim of the museum has been to "keep alive the memory of the struggle for liberation of the Greek Cypriots against the British, which was organized by the National Organization of the Cypriot Fighters (EOKA) from 1955 to 1959".[16] The direction was undertaken by an ex-EOKA fighter, Christodoulos Papachryssostomou, and was initially housed in a building donated by another fighter, Zinon Sozos. In 1966, the Museum was transferred to the Old Archbishopric Palace, where it remained for the next 30 years. The collection was re-arranged and the museum, as it now stands, opened to the public in April 2001. It has an active collecting policy and is simultaneously an archive of the memories regarding the liberation war.

On the other side of the Green Line of Nicosia, a different museum bearing exactly the same name describes a different version of the story. The National Struggle Museum in north Nicosia was established in 1978 and is currently housed in a building constructed in 1989 for the "purpose of immortalizing, displaying and teaching the generations ahead the conditions under which the Turkish Cypriot people struggled for their cause from 1955 till the present".[17] In this case, the museum, which was slightly rearranged a few years ago (in 2002), presents the national struggle of the Turkish Cypriot community in three stages: from 1878 to 1955, from 1955 to 1974 and from 1974 onwards. Even though the story starts with the arrival of the British on the island, the main emphasis is given to the two subsequent phases, in which Greek Cypriots emerge as the primary enemy.

14 | Roland Barthes (1980): »Rhetoric of the Image«, in: Alan Trachtenberg (ed.): Classic Essays on Photography, New Haven, Conn.: Leete's Island Books, pp. 269–285.

15 | ibid, p. 275.

16 | Aristidis Michalopoulos (2004): The Museums of Cyprus, Athens: Erevnites.

17 | Museum Guidebook, n.d., p.4.

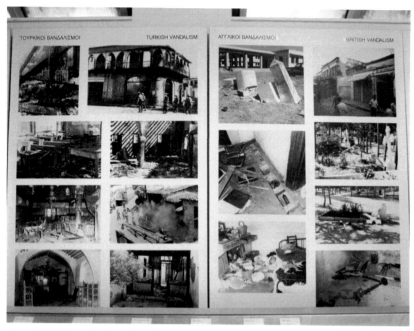

Figure 3: Turkish and British Vandalisms, Struggle Museum, south Nicosia,
Photo by the authors.

Although both museums have changed since 2000, their main stories, and even texts, remain unchanged. Both have been created for building community identity and as part of politically master-minded nation-building. Both attempt to represent the past as a continuous historical narrative with photography as one of the main ingredients for supporting this narrative.

The role of photography is clearly acknowledged by Papachryssostomou, the first director of the Struggle Museum: "The greatest success of the Museum, which fulfils its most vital aim, is the photographic salvation of the memory of the Struggle. Many thousands of original photographs save the memory of events and people. Most important among them are those saving the memory of events, which are exhibited in separate panels (Figure 3), each of which displays in a satisfactory manner one page of the Struggle. The most important of these panels are the following: 1. Actions of women, 2. Actions of youth, 3. Shelters / safe houses, 4. Arrests, 5. Sabotages,8. Actions of EOKA, 9. Turkish actions, 10. Turkish vandalisms, ... 12. The massacre at Kionelli, 13. Mourning, ... 15. The Secret school, 16. Holocausts, ... 19. Military operations, 20. Funerals of heroes, 21. The end of the struggle, 22. Revision of the history of the struggle, 23. The funeral of digenes (military leader of the liberation war)".[18]

18 | Christodoulos Papachryssostomou (1977): Guide of the Museum of National Struggle, Nicosia: National Struggle Museum (in Greek), p.10.

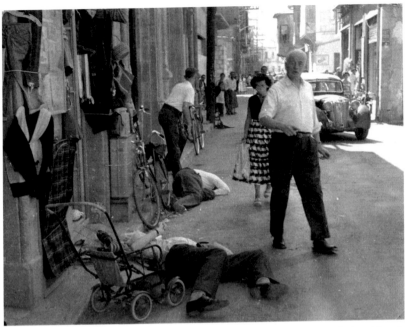

Figure 4: A photograph found in both the Greek Cypriot Struggle Museum (north Nicosia) and the Turkish Cypriot National Struggle Museum (south Nicosia), Photo by Robert Egby, 1956

The approach is quite indicative: the pre-eminence of photographs, both as documentary sources and as instructive media is evident. They are grouped in eloquent *pages*, each of them illustrating a particular event. And, if "one photo equals a thousand words" as the saying goes, each of these pages is considered equal to a narrative much longer and detailed than that of any number of words. The headings of the panels are enough to provide the framework for understanding the photographs and direct the meaning for visitors. The rest of the story is told via the violence of what is seen. The importance of this method of display and of the photographs themselves as evidence is further demonstrated by the prominent role these boards retained in this museum in its new exhibition of 2002.

On the other hand, in the National Struggle Museum of the north, the same medium is used to present the opposite story. The use of photography is similar here, although the number of photographs exhibited is not as large and each of them has its own caption. Still, the visual information is overpowering as small and large black and white photographs are displayed on almost every wall. Only one room in the museum displays colour images. The last section of the museum includes a brightly lit area, which has been designed to make the visitor feel "... the air of freedom and peace breathed by the Turkish Cypriots"[19] since 1974. The walls display colour photographs of progress and peace such as images of universities, hotels, natural land-

19 | Museum Guidebook, n.d., p.4.

scapes, cultural attractions etc. The rest of the rooms are filled with black and white photographs of war and destruction. Colour photography is equated here with progress and a bright future while black and white photography with the painful past.

The most fascinating observation though, when examining these two museums, is the fact that they use the same type of photography (documentary/ photojournalistic) to tell their different stories. Only one image is common to both museums: it is the photograph of a busy market street, with a dead body right in the middle of it (Figure 4). The caption in the National Struggle Museum reads "Our people cruelly murdered in the streets by EOKA". Therefore, the dead body is identified as that of a Turkish Cypriot and the enemy who is responsible as Greek Cypriot fighters. The same photograph is framed differently in the Struggle Museum of the south. It is included in a panel of similar photos entitled "Executions of British Intelligence Service Officers". In this case, the dead body is identified as a British officer and, therefore, a member of the *Other*, the enemy. Those responsible are still EOKA fighters. Within the context of this museum, though, this is an act of bravery, an act of protection of our *own* against the *traitors*, a justifiable and even commendable act. The nationality of the officer is not mentioned, as being of no importance, since it was not that which determined his fate. In other words, in the first case, the same photograph is used to prove the cruelty of Greek Cypriots, and the threat EOKA posed to the Turkish Cypriot community, while in the second, it is used to indicate the bravery, efficiency and righteous fight of EOKA for the liberation of an island tired of foreign rulers. Therefore, the meaning of the photograph changes significantly, according to the changes in the context of its display.

In both cases, history is told (or written) through images, which eventually form and reinforce a collective memory. But, since the use and framing of them is selective, a particular narrative is reinforced at the expense of another, a partial story is told, choices are made and silences are ensured. Since school visits in both museums are mandatory, a perpetuation of certain beliefs is ensured; both museums thus assure that collective memory will remain alive and uncontested.

4. PHOTOGRAPHY, MEMORY AND HISTORY

The war museums examined so far use photography as a form of memory that is taken over into the realm of history. These visual traces of place and time are displayed in institutions invested with credibility, labelled as *history museums*, and, therefore, become sources of historical *truth*. However, Nora (1996) warns that memory and history are far from being synonymous. He explains: "Memory, being a phenomenon of emotion and magic, accommodates only those facts that suit it. It thrives on vague, telescoping reminiscences, on hazy general impressions or specific symbolic details. It is vulnerable to transferences, screen memories, censoring, and projections of all kinds. History, being an intellectual, nonreligious activity, calls for analysis and critical

discourse...Memory wells up from groups that it welds together, which is to say, as Maurice Halbwachs observed, that there are as many memories as there are groups, that memory is by nature multiple yet specific; collective and plural yet individual. By contrast, history belongs to everyone and no one and therefore has a universal vocation."[20]

The use of photographs as discussed in the five museums resemble Nora's concept of memory, and, more specifically, of a public collective memory, more than that of history. The photographs are carefully selected to represent, express or (re-) create the memories of specific communities (Greek or Turkish Cypriot) and they function in a more symbolic and emotional manner than an intellectual and critical one. After all, "groups talk about some events of their histories more than others, glamorize some individuals more than others, and present some actions but not others as 'instructive' for the future".[21] Usually photographs are pre-selected because they have something to offer in terms of a predetermined narrative. Those that do not fit the narrative are usually omitted. Communities are interested in promoting certain collective memories because these memories can influence the present.[22] As a matter of fact, they can provide a history, which will help communities make sense of their world, provide beliefs and opinions and a basis for future decisions.[23] The following section presents the story of one photograph in particular, in order to highlight the selective power of memory.

One of the most famous photographs taken during the inter-communal conflicts in 1964 is by the British photographer Donald McCullin. The photograph shows a Turkish Cypriot woman in agony, her hands clasped to her chest, two women supporting her and a young child reaching for her (Figure 5). Even though the Cyprus conflict in the 1960s was the first major assignment for the Magnum photographer, he managed to become the first British photographer to be awarded the first prize in the annual World Press Photo contest in 1964.[24] This particular photograph received extensive international publicity, is repeatedly used by the Public Information Office

20 | Pierre Nora (1996): »General Introduction: Between Memory and History«, in: Lawrence D. Kritzman (ed.): Realms of Memory: Rethinking the French Part, Vol.1, Conflict and Divisions, New York: Columbia University Press, pp. 1–20, p. 3.

21 | Greg Dickinson/Carole Blair/Brian L. Ott (2010): Places of Public Memory: The Rhetorics of Museums and Memorials, Tuscaloosa: The University of Alabama Press.

22 | John Urry (1996): »How societies remember the past«, in: Sharon Macdonald/Gordon Fyfe (eds.): Theorizing Memory, Oxford: Blackwell, pp. 45–68.

23 | Barbara Misztal (2007): »Memory Experience: The forms and functions of memory«, in: S. Watson (ed.): Museums and their Communities, London, New York: Routledge, pp. 379-396.

24 | Paul Sant Cassia (1999): »Piercing Transformations: Representations of Suffering in Cyprus«, in: Visual Anthropology 13(1), pp. 23–46.

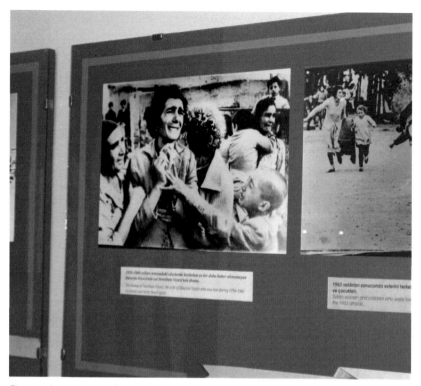

Figure 5: Arrangement of the 1964 photograph of a Turkish Cypriot woman in agony taken by Donald McCullin, Museum of Barbarism, Nicosia,
Photo by the authors.

in the north of Cyprus,[25] is instantly recognizable by most Turkish Cypriots and is displayed in both the Museum of Barbarism and the National Struggle Museum.

In the National Struggle Museum, the caption under the photograph reads "Pleas and tears from the mothers of the martyrs and the missing people of the 1963 conflict." Interestingly, the woman is not named nor is the photographer. Thus, it becomes a generic image of pain inflicted on the "mothers of the martyrs and the missing people" that characterizes a specific period. On the other hand, in the Museum of Barbarism, the caption names the woman and her lost husband, but also offers a different time frame than the one mentioned in the Struggle Museum: "The drama of Nevcihan Niyazi, the wife of Hüseyin Niyazi who was lost during (the) 1958–1960 incidents and never heard (of) again". The specificity of the caption might be due to the fact that the Museum of Barbarism is dedicated to the personal drama of a specific family and thus more personal information about the woman depicted is more appropriate. Then again, the British *Imperial War Museum North*, which also

25 | ibid.

uses the same photograph, names the photographer, while offering yet another date for the event it depicts. The accompanying caption on the museum's website reads: "A distraught woman flees the village of Gazabaran with her family after the killing of her husband, Cyprus, 1964. Photograph © Don McCullin". In this case, the photographer is named, and factual information like the name of the village and the exact date are mentioned.

The different captions reflect the different perspective of each museum and clearly display how context influences how a photograph is perceived. The National Struggle Museum offers the most general and vague description since the photograph is used among many which illustrate and support a broader perspective on historical events and their interpretation. The museum is interested in the *pain of our people* as a collective subject, and *our* suffering during a particular period. In this sense, details are not important; not when this happened or to whom in particular, but that this did happen to one of us, and therefore to all. The Museum of Barbarism adopts a more personal stance: the pain becomes something inflicted on each and every one, even the anonymous common people. So, it is through their pain that the anonymous become eponymous and the involvement of the community personal. Finally, the Imperial War Museum North takes a more factual and distanced perspective, while attributing the photograph to its author also means an appreciation of the photographer's individuality and possibly his artistic expression.

The vagueness of the dates of the photograph as presented in the three captions does not hinder the power of the image: the exact date though is not important in the first two cases, since it is not the event per se which is illustrated, but the suffering, the victimization of *us* because of the *others*. In the last case, though, the accuracy of attribution to both author and date claim a historical perspective and take distance from memory. In others words, whereas the two museums in north Cyprus use the photograph to create emotions and recall memories, the museum in Britain makes a claim to history.

This photograph, despite the fact of being well-known both in north Cyprus and internationally, is virtually unknown (or not used) in the south of Cyprus. The familiarity of a photograph and its display is a political decision. Communities choose what to remember and what to forget, and which photographs their members (and offspring) should be familiar with and which not.

Memories that might be too dangerous to activate are usually omitted. According to Misztal, "to remember everything could bring a threat to national cohesion and self-image. Forgetting is a necessary component in the construction of memory just as the writing of a historical narrative necessarily involves the elimination of certain elements".[26] The museums examined, in order to avoid the threat to national

26 | Barbara Misztal (2007): »Memory Experience: The forms and functions of memory«, in: Sheila Watson (ed.): Museums and their Communities, London, New York: Routledge, pp. 379–396, p.386.

cohesion, become collaborators in a collective remembering and forgetting by including certain photographs and excluding others.

Furthermore, photographs, as well as other objects displayed in war museums, are *read* according to the visual database one has in mind along with the context of the exhibition. After all, when confronted with images, we tend to remember what is familiar to us because it makes more sense to us.[27] If Figure 5 was presented in a Greek Cypriot museum and marked with the date *1974*, there is no doubt that it would have been identified by Greek Cypriots as Greek Cypriot refugees mourning the loss of their loved ones. If the audience expects to see the suffering and struggle of a specific community, it will unavoidably read the images in this context.

Papadakis (2006) demonstrates this point when he talks about some of the photographs he saw during his visit at the Museum of Barbarism: "Then I saw the photos of Turkish Cypriots refugees from 1963, tent after tent in long lines. They had been settled in an area of Lefkosha still called *Gochmenkoy* ('Village of Refugees'). The people were sitting outside, cold, ragged and sad, among puddles of rainwater. Children with their heads shaved were lining up with metal containers waiting for food, looking at me with black, empty, eyes in those familiar pictures. Had I seen them elsewhere, I would have thought they were Greek Cypriot refugees from 1974".[28]

For Papadakis and other Greek Cypriots, these images are indeed familiar. Not these *specific* images but this *type* of image. The Republic of Cyprus has long promoted images of refugees in order to highlight the *Cyprus Problem* locally and internationally. Similar images are embedded in the collective memory of both Turkish and Greek Cypriots, although they refer to a different conflict (1963 for the former and 1974 for the latter). Therefore, in the absence of text and context, the visual collective memory and political point of view of the viewer controls the meaning of photography.

5. CONCLUSIONS

Despite the fact that all the photographs displayed in the case study museums of this paper present a repertoire of similar events (refugees, murder, heroes/martyrs etc.) and follow a similar aesthetic (photojournalistic style or portraits), the messages communicated change according to the accompanying text, the context, the museum's central narrative and the preconceptions of the viewer. Similar images in both Greek and Turkish Cypriot museums seem to serve as reminders of the suffering and struggles of the people they represent, create symbolic boundaries between

27 | ibid.

28 | Yiannis Papadakis (2006): Echoes from the Dead Zone: Across the Cyprus Divide, London, New York: I. B. Tauris, p.84.

us and *them*, and become an efficient didactic tool for young school children who did not experience any of the events.

By examining the five case studies it became apparent that each museum focuses on different categories of photographs. One reason for this might be that they address different audiences and have different aims. The main audience of the Struggle Museum, the National Struggle Museum and the Museum of Barbarism is the local population, school children and tourists. The photojournalistic style is therefore more appropriate in order to promote an official view to tourists (they are also addressed in the labels, which appear in the respective national languages and English in all cases), and reinforce the attitudes and the opinions of future generations. The portrait style is chosen in the case of the Struggle Museum to combine commemoration with information.

On the other hand, the Museum of Peace and Freedom caters to the needs of Turkish visitors, who do not need to be convinced about Turkey's contribution. Similarly, the Museum of Commando Fighters of Cyprus, housed in the Association's headquarters, caters to the needs of veterans and the education of current commandos. Again, the need to convince an already convinced audience is minimal. In this case, the museums focus on commemoration and payment of tribute and thus portrait photographs and celebration scenes. According to Sant Cassia, "the image, and more specifically photography, has been used extensively in Cyprus to convince, facticize, demonise, and evoke".[29] However, this is not a uniquely Cypriot experience. Similar museum experiences can be found in other countries where history and heritage are closely connected to the dominant political system.[30] As we have seen, presenting issues from a critical historical perspective that is considered too political or sensitive appears to be *dangerous business*[31] for any museum. Especially in countries where conflict is still fresh and unresolved, museums appear to present straightforward narratives with the help of photography. In these cases, photography functions as a form of memory; a selective, emotional and vague form of memory that is vulnerable to changes in the text and context of the museum. In the catalogue of the Greek Cypriot Struggle Museum,[32] under a photograph of a British soldier

29 | Paul Sant Cassia (1999): »Piercing Transformations: Representations of Suffering in Cyprus«, in: Visual Anthropology 13(1), pp. 23–46, p.26.

30 | For Croatia see Christina Goulding/Dino Domic (2009): »Heritage, Identity and Ideological Manipulation: The Case of Croatia«, in: Annals of Tourism Research 36(1), pp. 85-102. For Cape Town see Charmaine McEachern (2007): »Mapping the Memories: Politics, place and identity in the District Six Museum, Cape Town«, in: S. Watson (ed.): Museums and their Communities, London, New York: Routledge, pp. 457–478.

31 | Dawn Casey (2007): »Museums as Agents for Social and Political Change«, in: S. Watson (ed.): Museums and their Communities, London, New York: Routledge, pp. 292-299.

32 | Gianni Demetriou (2008): The Struggle Museum: a simple wandering. Nicosia:

holding a gun amongst a group of children, instead of a descriptive caption, we read the popular saying "a photograph, a thousand words" (translation from Greek). In the case of war museums, it is worth asking "Whose thousand words?"

Acknowledgements

This research was facilitated by EuNaMus, (European National Museums: Identity Politics, the Uses of the Past and the European Citizen) a three year project (2010 – 13) funded by the EU Seventh Framework programme, in which the Department of Cultural Technology and Communication, University of the Aegean is a partner. (http://www.eunamus.eu/index.html)

Struggle Museum (in Greek).

The Monument is Invisible, the Sign Visible. Monuments in New Perspectives

Werner Fenz

The many arguments – the one in the title is, as you know, from Robert Musil – for and against different forms of memorial are linked by a central question: Is it (still) possible today to represent or at least repeatedly refer to the monstrosities of Nazi rule, the terror of a dehumanizing regime, the construction of concentration camps and their machinery of daily annihilation on the basis of the images of these horrors that were passed onto us after the fact? Can the representation of maltreated bodies, emotionally laden and expressively rendered in stone and bronze, function as an appropriate symbol of something that really happened? We are living in a time when images and their use are undergoing a radical transformation, above all, in the electronic media, which is resulting in a general desensitization to bodies that have been tortured and killed. Without in any way wanting to detract from the respect that is due to those individuals who have suffered such horrible fates, the question must be asked as to whether the artistic reflection of the almost endless array of imagery referred to above, or a small segment of it, can/should continue to be utilized as a method of commemoration and remembrance. In recent years, we have seen concepts emerge that are diametrically opposed to this kind of "petrification" of one of the most shameful chapters in our history.

For instance, Esther and Jochen Gerz created a lead-plated pillar in a Hamburg suburb on which passersby could inscribe their names. The *Judenplatz Holocaust Memorial* designed by Rachel Whiteread is a work in cast concrete suggesting a library and was the winning submission in a competition that specifically called for non-figurative designs – a specification requested by, among others, Vienna's Jewish community. These and numerous other examples illustrate the decisive shift that has taken place within memorial culture.

Three examples from Styria and Graz (realized by Helmut & Johanna Kandl, Jochen Gerz and Nasan Tur) will show the completely new perspectives of so-called monuments.

HELMUT & JOHANNA KANDL: A GUARDHOUSE – IN A PAST, IN A PRESENT (2009)

The call for submissions to create a "memorial signpost" in Aflenz an der Sulm – in Southern Styria – to mark the site of the former subcamp of the Mauthausen concentration camp was motivated in the first place by a desire to tear down the "wall of forgetting." However, the organizers of this competition were also interested in finding a well-executed response to the question of what kind of thematic and artistic quality can/must inform such a memorial in the year 2009.

Five artists and artist duos had been invited to take part in the international selection process. The call for submissions presented the participants with a number of clearly formulated and decisive guidelines. At the request of the awards authority – the Province of Styria, represented by the Institute for Art in Public Space – it was decided that there should be a departure from the static quality often characterizing symbols of remembrance and that the "signpost" required an alternative approach to the one seen all too often in many (too) large national, prestigious monuments. Beneath the outward appearance of a single or several objects, or whatever form the relevant statement took, functional mechanisms needed to be developed that could liberate the memento from its obligatory character, one which only operates externally.

It was not a single point, but rather the entire locus of events that should provide the starting point of deliberations, with the tools of art providing a stimulus for memory and reflection – on the one hand, by way of a direct confrontation with the contemporary artistic identification of the memorial site, and on the other, by way of an admonition that, rather than desensitizing, was anchored in the prevailing structures of the society. This challenge focused on the so-called open form of the artwork, on a form of artistic activity that does not seal itself off or – despite its possibly dynamic surface – cover over. What was required was a process of remembrance that remained open and took its starting point from the present, not one defined by the single "memorial visit" or by mere registration in passing. The rapid growth of xenophobia and a hatred of citizens who do not strictly conform to the system, open displays of right-wing radicalism and the repugnant activities of neo-Nazis made this focus seem all the more important and relevant to the awarding authority.

In the view of the expert jury, Helmut & Johanna Kandl fulfilled the specified conditions in an outstanding fashion. Their project *WÄCHTERHAUS* focused on the only building remaining in the external space, the former watch house. At the time the design was submitted, this unimposing ruin made of rough brick was (almost) hidden behind thick vegetation. The artists mounted the title of the project in illuminated lettering on the roof of the building, which can also be read as indicating the task their work admonishes us to fulfill: keep watch, remain vigilant. The description of the object's original function is thus recontextualized in the present. This seemingly small step in the transfer from the past (watch house) to the present (guardhouse)

is what makes this work a new and important contribution to memorial culture. It was clear to the artists from the outset that the building, as a fragment, would not only be included in the installation, but would in fact constitute its starting point and central focus. This is not a project about construction, but about supplementation with minimal means, which are skillfully and unerringly implemented. This supplementation is done in a way that makes the contemporary reference highly visible. Illuminated lettering in a clear font, which is diametrically opposed to the grotesque script of the Nazis and has been chosen deliberately to resemble the kind of signs to which we are accustomed, combines both content and admonition.

Helmut und Johanna Kandl, "WÄCHTERHAUS", Institut for Art in Public Space, 2009

The information is concentrated in the largest of three available rooms. One wall features a brief description of the location and what happened there, while on the wall opposite a screen provides pictorial and textual information. The latter confronts us with human rights abuses that are happening now, with violence, and with attacks on minorities in a wide range of situations. Historians and representatives of human rights organizations are working with the artists to ensure that this presentation in the *WÄCHTERHAUS* is constantly updated. This arc of connections, which has been extensively discussed among the scholars involved, is one of the means by which this "memorial signpost" has liberated itself from a "static character" and all previous forms of representation.

In a very direct sense, Helmut & Johanna Kandl have established a groundbreaking artistic form of memory. Its significance extends far beyond the concrete geographical and historical locus and establishes a new memorial typology – the

designation of an area using an available object that is loaded with memory. This object is neither reconstructed nor "improved." It is simply structurally maintained – a word with a dual meaning, a duality with which this artist duo works in many ways: past, present, watch house and guardhouse, securing memory and positioning it in the present.

JOCHEN GERZ: SIGFRIED UIBERREITHER (2008)

In 2008, the Styrian government and parliament decided to publicly recall the National Socialist abuse of power embodied by Sigfried Uiberreither, the one-time Provincial Governor and Gauleiter of Styria. Jochen Gerz dedicated himself to this task in response to an invitation from the Institut for Art in Public Space Styria. In the first part of his work, Uiberreither poses questions inside the gate of the city castle. He asks passers-by and visitors to the city questions at the site of what was and still is the seat of the Provincial Governor; questions of a National Socialist criminal on the complicity and silence of the others, the majority, not only back then at the time of the crimes, but also afterwards. Uiberreither himself is addressing us with the final declaration: "Without you I would never have become Sigfried Uiberreither". The questions confront us with the responsibility to intervene in the "course of things" and to draw on courage that has been all but lost.

In 63 Jahre danach (63 Years Afterwards), the second, very intensive part of recalling the past, Gerz began a work process with the public that evolved over the course of several months. What Gerz did was screen the public and integrate key

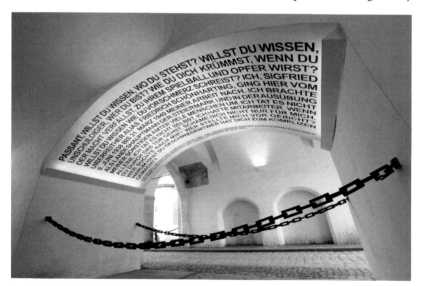

Jochen Gerz, "Sigfried Uiberreither", Institut für Kunst im öffentlichen Raum, 2009

groups and institutions – academics, politicians and readers – into a multistage pro-
cess. Their collaboration took place on the print media level. He won over the *Kleine
Zeitung*, one of the two large newspapers in Graz, for an extensive, engaged media
partnership. This was the only way in which he could put his concept into action. Ev-
eryday photographs from the Nazi period – "We are already familiar with the SS offi-
cer with his arm raised in salute" (Gerz) – were selected by academics from different
disciplines and published in several installments. Readers were then asked to select
the ones they considered the best. All the regional parliamentarians were persuaded
to compose texts for the photos. Finally, twenty-four text/image combinations were
selected, of which twelve were to be displayed in Styria and twelve in Graz at loca-
tions chosen by readers (We couldn't get permission for 2 of them in Graz and 4 in
Styria; decisions in 5 cases were based on political reasons). This type of approach
makes the artist into a kind of director who ensures that the course of the process is
followed and his plans are carried out. Each of the double panels, which presented
the material published in the newspaper on one side and the selected photo and text
on the other, was subtly designed to keep it as simple as possible. The inclusion of the
parliamentarians - a clear parallel to Haacke's Reichstag project - and the newspaper
readers was planned in such a way that the participants were not exploited for an
idea that was transformed into art in a grandiose way. That would have obscured
the context and undermined the transparency. In other words, the art form was
reconcilable with the form of communication, and the participants saw themselves
confirmed in their roles as actors who did more than provide a foundation for a
complex aesthetic creation. Nevertheless, the art revealed itself to be nothing less
than art, even if, in this visually stripped-down form, it reached the limits of what
many people view as art in a captive, well-known tradition.

Unfortunately, there is not enough time to deal with other projects by Jochen
Gerz and his ex-wife Esther in detail, although they were more or less the first ones
to emphasize the invisibility of the monument. But still, I have to mention two of
them:

1/ Once again, Hamburg-Harburg: Esther and Jochen Gerz (unlike Alfred
Hrdlicka with his "anti-monument" at Dammtorplatz 17) chose a radically different
monument concept. Theirs, a 12-metre high, lead-clad pillar, pushes for its own su-
persession. In the words of the artists: "We invite the citizens of Harburg and visitors
to the city to add their names to ours. The monument exhorts us to be vigilant and to
remain so. The more signatures the rod of lead bears, the more it will be sunken into
the ground until it finally sinks completely after an indeterminate period of time,
leaving empty the space once occupied by the Harburg Monument against Fascism:
For in the long run, nothing can rise up in our place against injustice". The monu-
ment now rests in the earth, sunken; its upper section is still visible in a glass shaft
next to the metropolitan railway station entrance.

2/ In Graz, the competition entry *Die Gänse vom Feliferhof* (The Geese of
Feliferhof = a training grounds of the Austrian army) was unanimously chosen by

the jury following a discussion. Even though the Austrian army has lost the courage to implement this concept, it is still considered one of the most important contributions towards a renewal of monument culture. (The Feliferhof shooting range is still used by the armed forces. It is linked to the violence of the Nazi regime in Styria in a number of ways. From September 1941 until the final days of the war, many executions were recorded and observed here by eye-witnesses.)

Four flagpoles have been placed in a straight line, across the field. The white flags bear simple, yet conspicuous red slogans: Death is the Price of Courage – People who Betray their Country are Decorated – Barbarism is the Soldier's Bride – We, too, are called Soldiers.

This concept is based on the same conviction as the one expressed in Hamburg: that responsibility – the responsibility for remembering – cannot be delegated. Consequently, the flags, as an aesthetic symbol, merely form a semiotic framework, for they are re-installed every time the Feliferhof is used. They are issued to a group of recruits who raise them mechanically. When the recruits leave the firing range, they have to remove the mobile symbols and store them away: for the printed flag fabric marks the presence of the soldiers. In this way, the presence and absence of the flags depend upon the presence and absence of the soldiers. Therefore, the symbols of memory and, hence, of the memorial as a project are related to a practical activity. The legibility (and effectiveness) of the symbols does not depend on what is being remembered (or is to be remembered) or not. Thus, the present/presence (not only that of the flags) is dependent on the consciousness of memory and the willingness to remember.

NASAN TUR: BULWARK AGAINST THE SOUTH-EAST?

Facts:

1/ There is a long tradition which reached its well-known culmination during the Nazi era: Graz, die "Stadt der Volkserhebung" (City of the People's Revolt), as a "Bulwark against the South-East". The most powerful radio station in Central Europe was built not far from the city in order to reach the so-called Untersteiermark (Lower Styria), which had ceased to be part of Austria at the end of the monarchy in 1918. As we know, foreign people – and the Nazis decided who was a foreigner – were treated as enemies or inferior people in the 1930s.

2/ The Landeszeughaus (Provincial Armoury), which houses the largest existing original armoury dedicated to the enemies from the South-East, is – as it is written in the folder, the flyers and the introductions on the web explaining the concept of the project – an important vehicle of social narratives revolving around the notions of "border fortress", "bulwark" and "defence against the Turks" – narratives with a long history that are highly relevant to the current day situation.

3/ As artists did in their concepts in the 1990s (system critical art), the Zeughaus and CLIO, an association for history and work in education, initiated the idea to think about possibilities for foiling the tourist attraction like a prepared mirror in an art piece. As part of a competition, the Institut for Art in Public Space invited four renowned artists and one artist group from that geographical, cultural and political area (Bulgaria, Turkey, Bosnia and, from Germany, a second generation Turkish artist), which is still widely treated today as a synonym of danger and menace. The most important point was not to create a branding for the collection, but calling for signs in the city thus people were going to be confronted with the social and political issues of the present concerning the construction of images of the enemy.

International competition: We were lucky to have two prominent representatives of the South-East, women curators from Croatia and Serbia, among the members of the panel of judges. After some enthusiastic discussions, the panel of judges decided (by majority vote) to propose the project:

NASAN TUR (the German-born Turkish artist)
Der unbekannte Ritter / The Unknown Knight

Installation view Landeszeughaus
Foto: J. J. Kucek

Let me share some of the jury's statements with you, because the declarations describe the artistic concept of Nasan Tur very clearly and explain why the majority liked it:

Quote: "At first sight, Tur's *The Unknown Knight* looks like a rather naive, although witty, idea. The artist intends to insert another "monument" into Graz, a city which already has a wealth of historical monuments. The first question is: who today in the age of "art in public spaces" needs another "monument", which is to be produced in the rather old-fashioned material bronze? Does Graz need it? Upon closer examination, however, Tur's simple idea appears to possess complex layers of meaning and is therefore open to multiple readings.

The jury is of the opinion that Nasan Tur's project corresponds best to the intention of the competition and its main guideline: "The point is to break up the current narratives about war, frontier and 'imaginary' enemies in a collective self-image of Styria, Austria and Europe by means of an artistic intervention". Tur's proposal challenges the collective memory invented and re-invented throughout the history of Graz, and his gesture should be situated in a wider (theoretical) context. Over the past thirty years, the historical discipline has finally accepted the fact that "historical writing is a construction, perhaps as imaginative as any literary creation". In contrast to traditional historical methodology which insists on "pure facts", contemporary historians are aware that "social events are 'constructions' rather than descriptions isomorphic with some 'objective' reality".[1] This conclusion seems particularly relevant when analyzing how the national past of a respective nation (or rather a nation-state) has been "remade" throughout the centuries. In this long process, historical "realities" have been forgotten and replaced by myths, now acting as the "real past". As is well known, the invention of an "enemy" is the constitutive element of every nationalist ideology, regardless of which historical period we observe.

With these remarks in mind, it could be said that *The Unknown Knight* is meant to initiate the process of "inventing the past", a past that never existed. This "new" past has yet to be invented as the artist plans to include a workshop with children in the project with the aim of creating new myths, legends and stories about the "Unknown Knight" (The fact that the "knight" is a figure that features in so many Hollywood movies from science-fiction films to contemporary fantasy films could provide additional material to stimulate the children's imagination).

The "Knight" is a project that relates to the historical context of Graz (Styrian Armoury), which Tur exploits on several levels. On an ideological level, he questions male bravery, militarism and, implicitly, patriotism by offering two figures of the "unknown knight" (one appears as a monument in the Griesgasse, and the other as a sculpture on the roof of the Landeszeughaus). On a visual level, Tur plays with the exhibits in the Styrian Armoury.

In this project, Tur also employs the usual channel through which a museum functions today, namely the museum shop, in which the multiplied versions of the "Knight" would be on sale (in paper armour, however), together with picture books illustrating the new legends coined by the children." (25 March 2011), end of quote

1 | Janet Abu-Lughold: On the Remaking of History: How to Reinvent the Past, 1989.

Stereotypes such as Graz as a "Bulwark against the (South-)East", "the Turks" as a "historical enemy", which continue to influence attitudes even today and are repeated without thinking or used purposefully. Nasan Tur's winning project of the international competition Bulwark against the (South-)East? challenges collective memory. Starting from the Landeszeughaus, the Provincial Armoury, the German-Turkish artist confronts the existing myths that are used to construct images of the enemy with the legend of the "Unknown Knight", invented together with schoolchildren in Graz. On postcards and in picture books, the aim is to carry tidings of the "Unknown Knight" out into the world and subsequently to inspire other legends.

For his interventions in public space, Tur deliberately falls back on the traditional bronze monument, adding breaks in terms of form and content: the "Unknown Knight" – the artist himself – appears as an inadequately armoured, vulnerable, anti-heroic figure that fails to comply with common narratives.

For all this, the project is not one that politically challenges collective memory of Austria's past, nor does Nasan Tur – unfortunately – address the topics of xenophobia and racism directly. However, by questioning the mechanisms and workings of collective memory, particularly the myth of the "enemy from the (South-)East" in current society, Nasan Tur generally (although not radically enough for me) joins those artists – some of their works we have seen before – who argue that the politics of memory have to be defined in a new way: looking to the past from the point of view of the present and incorporating the mode of acting, the overview on the urgent problems in society and breaking up the public's customary practice of perception.

MILITARY HISTORY, WAR MUSEUMS AND NATIONAL IDENTITY

Politics of Memory and History in the Museum – The New "Museum of the History of the Great Patriotic War" in Minsk/Belarus[1]

Kristiane Janeke

Introduction

It may seem strange to hope for some inspirations for the discussion of war and museum from, of all places, the politically and culturally isolated Belarus. However, in my opinion, casting a glance at Belarus can be quite instructive as the costly and complex rebuilding of the "Museum of the History of the Great Patriotic War"[2] is taking place at present.[3] It is amazing how, as a matter of course, the question whether war belongs in a museum is given an affirmative answer here.

The reasons for that lie partly in the historical experience and partly in the political aims of the government regarding history. The presentation of the war in the museum as a tool for historical policy is of great relevance to post-Soviet Belarus, though partly for other reasons than before 1991, and, furthermore, with new political and cultural potential.

1 | I would like to thank Elisabeth Karsten for her translation from German, http://www.elisabeth-karsten.de

2 | http://www.warmuseum.by

3 | Report (2010/2011): Up-to-date news about the concept and the building progress of the Museum of the History of the Great Patriotic war. Retrieved 1 November 2011, from http://www.minchanka.by/rasskazy/museum.html, http://news.tut.by/167278.html, http://www.realty.ej.by/project/2010/05/04/v_minske_nachali_stroitelstvo_novogo_zdaniya_muzey.html, http://www.nest.by/content/utverzhden-arkhitekturnyi-proekt-zdaniya-muzeya-velikoi-otechestvennoi-voiny-v-minske, http://www.comparty.by/gazeta/2010/04/o-novom-muzee-velikoi-otechestvennoi-voiny, http://belapan.com/archive/2010/10/22/420860/.

Figure 1: General view of the new museum building
© http://news.tut.by/kaleidoscope/168287.html (12.10.2012).

Figure 2: The information board at the construction site showing how the museum
complex will be integrated into the landscape © Kristiane Janeke

This article will elaborate on this thesis in three steps: A brief overview dealing
with the experience of war, the official policy of history and the increasingly diverse
memoryscape in Belarus (Figure 1) is followed by a selective comparison of the old
and the new concept of the exhibition (Figure 2). There, the question shall be raised
whether and to which degree the new exhibition concept[4] will offer an updated

4 | Koncepcija (2008) ėkspozicii Belorusskogo Gosudarstvennogo Muzeja istorii velikoj
otečestvennoj vojny, confirmed 30 March 2010, Minsk (unpublished), partly published in:
http://www.warmuseum.by/news/events/~group=1~year=2009~page=2~id=420, retrieved
1 November 2011.

Figure 3: The planned evening fireworks display is reminiscent of the historic fireworks display on the Red Square in Moscow on 9 May 1945.
© http://realt.onliner.by/2011/10/04/muz (12 October 2012)

interpretation of the war, which mirrors the increasing divergences of collective and individual memory and how this is reflected in the presentation and education. Finally, the possibilities of compensating the persistently narrow political margin specific to the museum are worked out (Figure 3). The whole paper is based on the overall thesis that recalling the core tasks of a museum can contribute to creating free space which emerges from the specific functions and possibilities of a museum as an informal place of learning and education.

I. CULTURE OF MEMORY IN BELARUS

The official name of the museum, The History of the Great Patriotic War, leads directly to the core of the problem. In Soviet historiography, The Great Patriotic War" refers to the years of 1941 to 1945, which are mostly regarded independently and are not seen in the general context of the Second World War. Considering it was based on the general narrative of the entire Soviet Union, this focus is understandable for the old exhibition. However, adherence to this historical view raises questions for a new concept of the exhibition concerning national identity and reference points of history in a now independent Belarus.

On 17 September 1939 Soviet troops occupied the Eastern Polish territories. This action was in line with the secret agreement of the Hitler-Stalin Pact.[5] This brought all the territories containing a Belarusian population under Soviet influence. Between the wars, the Western part belonged to Poland[6] and the Eastern part to the *Belorussian Soviet Socialist Republic* (BSSR), which in turn had belonged to

5 | David R. Marples (2001): »Die Sozialistische Sowjetrepublik Weißrussland (1917-1945)«, in: Dietrich Beyrau/Rainer Lindner (eds.): Handbuch der Geschichte Weißrusslands, Göttingen: Vandenhoek & Ruprecht, pp. 135–152.

6 | Werner Benecke (2001): »Kresy. Die weißrussischen Territorien in der Polnischen Republik (1921–1939)«, in: D. Beyrau/R. Lindner: Handbuch der Geschichte Weißrusslands, pp. 153–165.

the USSR since 1922.[7] This BSSR, which had been enlarged by previously Polish territories, was attacked by the Wehrmacht on 22 June 1941.[8]

At this time, Belarusian territories were characterized by a heterogeneous population of Belarusian, Polish, Lithuanian, Jewish, Ukrainian and Russian descent as well as by a variety of languages and religions. Consequently, the enemy was not confronted by a united Belarusian people or nation because the population was by no means homogeneous.[9] The differing developments of the various areas in the 1920s was still formative for the region, generating a wide range of expectations, hopes and fears towards the German Reich as well as towards the Soviet Union.[10] The country itself became the scene of sustained fighting between regular armed forces and other national and sometimes criminal groups.[11] In the course of the war, it is estimated that Belarus lost up to a third of its population,[12] although there are no exact numbers.[13] So far, research has generally assumed the death of 2.2 million people. In addition to soldiers killed in action, the loss of population consisted of prisoners of war who died, civilian casualties and forced labourers as well as the victims of the

7 | D. R. Marples (2001): »Die Sozialistische Sowjetrepublik Weißrussland« (1917-1945), in: D. Beyrau/R. Lindner: Handbuch der Geschichte Weißrusslands, pp. 135-152.

8 | Ibid. and Bernhard Chiari (1998): Alltag hinter der Front. Besatzung, Kollaboration und Widerstand in Weißrußland 1941–1944, Düsseldorf: Droste.

9 | Bernhard Chiari (2001): »Die Kriegsgesellschaft. Weißrussland im Zweiten Weltkrieg (1939–1944)«, in: D. Beyrau/R. Lindner: Handbuch der Geschichte Weißrusslands, pp. 408-425; Bernhard Chiari (2002): »Geschichte als Gewalttat. Weißrußland als Kind zweier Weltkriege«, in: Bruno Thoß/Hans-Erich Volkmann (eds.): Erster Weltkrieg – Zweiter Weltkrieg. Ein Vergleich. Krieg, Kriegserlebnis, Kriegserfahrung in Deutschland, Paderborn/München/Wien/Zürich: Ferdinand Schöningh, pp. 615–631.

10 | B. Chiari (2002): »Geschichte als Gewalttat. Weißrußland als Kind zweier Weltkriege«, in: B. Thoß/H.-E. Volkmann: Erster Weltkrieg – Zweiter Weltkrieg, pp. 615–631; B. Chiari: (1998): Alltag hinter der Front. Besatzung, Kollaboration und Widerstand in Weißrußland 1941-1944, Düsseldorf: Droste; D. R. Marples: »Die Sozialistische Sowjetrepublik Weißrussland (1917–1945)«, in: D. Beyrau/R. Lindner: Handbuch der Geschichte Weißrusslands, pp. 135–152.

11 | B. Chiari (1998): Alltag hinter der Front. Besatzung, Kollaboration und Widerstand in Weißrußland 1941–1944, Düsseldorf: Droste, p. 151.

12 | Bernhard Chiari/Robert Maier (2004): »Weißrussland. Volkskrieg und Heldenstädte: Zum Mythos des Großen Vaterländischen Krieges in Weißrussland«, in: Monika Flacke (ed.): Mythen der Nationen. 1945 – Arena der Erinnerungen, Berlin: Philipp von Zabern, Vol. 2, pp. 737–756.

13 | Mikola Iwanou (2001): »Terror, Deportation, Genozid: Demographische Veränderungen in Weißrussland im 20. Jahrhundert«, in: D. Beyrau/R. Lindner: Handbuch der Geschichte Weißrusslands, pp. 426–436.

Holocaust together with refugees, evacuated people, the repressed of the USSR and the people repatriated to Poland.[14]

Of the Jewish population (980,000 people before the war, which was 9.3 % of the 10.5 million inhabitants of the BSSR), only 120,000–150,000 survived as members of the Soviet Partisan movement, as soldiers of the Red Army or because they were evacuated. Altogether, 650,000 Belarusian Jews died. About 400,000 died on Belarusian soil, most of them in the Maly Trostenec extermination camp.[15] In addition to the decimation of the population, towns and villages were systematically destroyed.

After 1945, this complex war experience was summarily included in official Soviet memory. The central point of reference was the Great Patriotic War, in other words, the military history between 1941 and 1945, from the attack of the German Reich on the Soviet Union up to the conquest of Berlin, presented as the heroic defence of the Red Army against the enemy. In this view, there was room neither for their own victims, Jews, prisoners of war and forced labourers nor for individual experiences of war, not to mention a critical review of Stalinism. Moreover, since Moscow defined the war as a general Soviet achievement, there was no room left for national or personal memories.

This vacuum is now filled by Lukashenko's historical policy.[16] Lacking other uniting traditions, the Great Patriotic War has now been used as a founding myth for the Republic of Belarus to create and strengthen a collective national identity.[17] This has been accompanied by emphasising the specific Belarusian contribution to the victory over Nazi Germany, thus demonstrating one's own power as a display of independence and strength in the face of Russia.[18] The local partisans have become the symbol for the national fight of liberation which culminated in the liberation of Minsk on 3 July 1944 – now the National holiday of Belarus.[19] But what exactly the specific Belarusian contribution was is difficult to determine. At any rate, there is, in this seemingly nationalized version of memory, no room left for the complex

14 | ibid.

15 | B. Chiari/R. Maier (2004): »Weißrussland. Volkskrieg und Heldenstädte: Zum Mythos des Großen Vaterländischen Krieges in Weißrussland«, in: M. Flacke: Mythen der Nationen, p. 749.

16 | Olga Kurilo/Gerd-Ulrich Herrmann (eds.) (2008): Täter, Opfer, Helden. Der Zweite Weltkrieg in der weißrussischen und deutschen Erinnerung, Berlin: Metropol.

17 | B. Chiari/R. Maier (2004): »Weißrussland. Volkskrieg und Heldenstädte: Zum Mythos des Großen Vaterländischen Krieges in Weißrussland«, in: M. Flacke: Mythen der Nationen, pp. 737–756 and Astrid Sahm (2010): »Der Zweite Weltkrieg als Gründungsmythos. Wandel der Erinnerungskultur in Belarus«, in: Osteuropa 5, pp. 43–54.

18 | A. Sahm (2010): »Der Zweite Weltkrieg als Gründungsmythos. Wandel der Erinnerungskultur in Belarus«, in: Osteuropa 5, p. 46.

19 | B. Chiari (2001): »Die Kriegsgesellschaft. Weißrussland im Zweiten Weltkrieg (1939–1944)«, in: D. Beyrau/R. Lindner: Handbuch der Geschichte Weißrusslands, p. 410.

pre-war history or other aspects of national identity. Once again, the myth of a war of the people is preserved, a war in which the Belarusians faced the enemy as a monolithic block aiming, together with the people of the Soviet Union, at the liberation of Europe.[20]

This official historical policy is at variance with the memories of society.[21] This phenomenon is unique among the post-Soviet countries. After the collapse of the USSR, the other countries revived national memories with the aim of uniting society, on the one hand, and setting a contrast to the Soviet interpretation of history, on the other. Although Lukashenko is also aiming at national unity, his historical policy is not really suited for that. On the contrary, many Belarusians cannot identify with this official interpretation. They rather chose other points of reference for their national identity, like the Grand Duchy of Lithuania and the *Belarusian People's Republic* (1918/19)[22] or (negative) points of reference such as the reactor accident in Chernobyl, as well as, after the discovery of the mass grave in Kurapaty near Minsk in 1988,[23] the terror of Stalin. All this has to be considered in connection with regional and local history and a clear commitment to the Belarusian language. This inofficial view of history coincides with the ideas of the political opposition which contributes to its marginalisation.

This memory of society does not at all exclude the memory of the war.[24] The fact that almost every family in Belarus lost members in the course of war, occupation and annihilation weighs heavily.[25] This is deeply rooted in the communicative memory and the individual memory and complements the official patterns of remembrance. That in turn is connected to the enormously high number of victims in the Belarusian territories, comparatively much higher than anywhere else in Europe, as a result of World War I (1914-18) and the Civil War (1917-21), followed by the Polish-Soviet war (1919-29), the repressions, the collectivization and industrialisation by the Soviet Union in the 20s and 30s, and finally the tragic culmination of

20 | B. Chiari/R. Maier (2004): »Weißrussland. Volkskrieg und Heldenstädte: Zum Mythos des Großen Vaterländischen Krieges in Weißrussland«, in: M. Flacke: Mythen der Nationen, p. 738.

21 | Imke Hansen (2008): »Die politische Planung der Erinnerung. Geschichtskonstruktionen in Belarus zwischen Konflikt und Konsens«, in: Osteuropa 6, pp. 187–196; Elena Temper (2008): »Konflikte um Kurapaty. Geteilte Erinnerung im postsowjetischen Belarus«, in: Osteuropa 6, pp. 253–266.

22 | D. R. Marples (2001): »Die Sozialistische Sowjetrepublik Weißrussland (1917–1945)«, in: D. Beyrau/R. Lindner: Handbuch der Geschichte Weißrusslands, pp. 136–138.

23 | E. Temper (2008): »Konflikte um Kurapaty. Geteilte Erinnerung im postsowjetischen Belarus«, in: Osteuropa 6, p. 257f.

24 | Astrid Sahm (2008): »Im Banne des Krieges. Gedenkstätten und Erinnerungskultur in Belarus«, in: Osteuropa 6, p. 245.

25 | O. Kurilo/H.-U. Herrmann (2008): Täter, Opfer, Helden, Berlin: Metropol.

World War II,[26] which began for the region in 1939 with the occupation by the USSR or the Reunification of Belarus as it is described officially.[27] This term, the Reunification of Belarus, is also used in the in the new concept of the museum. However, it is also true that due to a lack of public debates and free research hardly anyone in Belarus is aware of the complexity of their own national history. Following the Soviet tradition, certain groups of victims have been excluded from memory. It is only now that a certain sensitivity is emerging.[28]

II. THE CONCEPT OF THE MUSEUM

So how is the museum positioned against this background? Since, until now, the State History Museum has not had a contemporary permanent exhibition, the museum of the Great Patriotic War has played the leading role in the historical master narrative. "The planned structure of the museum grounds must reflect its importance as an element of the social and cultural system".[29] The museum already had a clear mission when it was founded during the German occupation: the collection and preservation of material about the war and the occupation with the purpose of motivating the people to fight against the enemy. The first exhibition was opened in Moscow in November 1942 and another one was opened in Minsk in 1944.[30] Today's building has housed the museum since 1967 with a total of 16 rooms at various times, beginning in the 60s until the last rearrangement in 2005. Despite many revisions, the exhibition has mirrored the Soviet view of the war against Germany up until now.

The ongoing cooperation between the museum team and me proves that there is a wish for a new beginning. Furthermore, the new exhibition has been allocated a remarkably high budget by Belarusian standards. Whether it will be possible to view the war in future not only as a Soviet or Belarusian battle of defence, but rather

26 | M. Iwanou (2001): »Terror, Deportation, Genozid: Demographische Veränderungen in Weißrussland im 20. Jahrhundert«, in: D. Beyrau/R. Lindner: Handbuch der Geschichte Weißrusslands, pp. 426–436.

27 | D. R. Marples (2001): »Die Sozialistische Sowjetrepublik Weißrussland (1917–1945)«, in: D. Beyrau/R. Lindner: Handbuch der Geschichte Weißrusslands, pp. 146–149.

28 | A. Sahm (2008): »Im Banne des Krieges. Gedenkstätten und Erinnerungskultur in Belarus«, in: Osteuropa 6, p. 235.

29 | Koncepcija (2008) ékspozicii Belorusskogo Gosudarstvennogo Muzeja istorii velikoj otečestvennoj vojny, confirmed 30 March 2010, Minsk (unpublished), partly published in: http://www.warmuseum.by/news/events/~group=1~year=2009~page=2~id=420, retrieved 1 November 2011.

30 | Voronkova, I. Ju. (2001): »Sozdanie i stanovlenie Belorusskogo gosudarstvennogo Muzeja istorii Velikoj Otečestvennoj vojny«, Minsk.

as a site of European memory remains to be seen. A first answer to this question is offered by the new concept. This shall serve as the basis for a comparison between the current (old) exhibition and the plans for the new museum, which is illustrated by three topics: the content, the architecture and design and, finally, the education and communication.

1. Themes of the Exhibition

The current exhibition reflects the above-mentioned content of Soviet historiography. This narrative revolves around the victory, the stylization of Red Army soldiers as heroes and the partisan myth. Within this narrative there is no room for the presentation of the enemy and its motives, for the organisation and structure of the German policy of extermination, for the Holocaust, for the fate of the prisoners of war and the forced labourers, for collaboration, for Belarusian, Polish and Lithuanian national movements, for the "*Armia Krajowa*"[31] and for the terror of Stalin. After 1991, some of these topics were included in the exhibition, but until now there has been no nuanced and comprehensive presentation of these issues.

These subjects are to be presented in the new exhibition. I would like to select four examples to compare the respective presentations: the prologue, which covers the time before 22 June 1941 (a), the German policies of occupation and extermination (b), the partisan movement (c) and, finally, the memory of war (d).

Let me mention right away that the current presentation does not meet international museum standards. Often, there are no introductory and explanatory texts; exhibits are not consistently described and dated; copies are not always identified as such; information on origins is completely lacking; and quite frequently exhibits from an earlier or later period are used in a slipshod manner to illustrate an event. In addition, there is the undifferentiated use of photographs and documents which either cannot be assigned or are, in some cases, even wrongly assigned. Consequently, it is virtually impossible for the single visitor to obtain a differentiated view on their own, which thus reveals that the exhibition is designed to be experienced as part of a guided tour.

31 | Sigizmund P. Borodin (2003): »Die weißrussische Geschichtsschreibung und Publizistik und die Heimatarmee in den nordöstlichen Gebieten der Republik Polen 1939 bis 1945«, in: Bernhard Chiari (ed.): Die polnische Heimatarmee. Geschichte und Mythos der Armiia Krajowa seit dem Zweiten Weltkrieg, München: Oldenbourg Wissenschaftsverlag, pp. 599–616; Ivan P. Kren (2003): »Der Einsatz der Armija Krajowa auf dem Territorium Weißrusslands aus weißrussischer Sicht. Versuch einer Ortsbestimmung«, in: B. Chiari: Die polnische Heimatarmee, pp. 585–597.

a) Prologue

In historical or military-historical museums, it had been common practice until 1991 to begin the presentation of the war abruptly with June 22, 1941. The background of the German attack, the events prior to the war as well as the ideological reasons for the war in the East remained unclear. In many museums, this has remained unchanged. It is only since 1999 that visitors in Minsk, before entering the exhibition proper, have been informed about the emergence of the Nazi movement, the developments in Germany after 1933 and the actual course of the war on the Western Front from 1939 to 1941. This is followed by a description of the defensive preparations in view of the threat of war.

The precarious balancing act, which is also to be found in the new concept, can already be seen here. On the one hand, there is an emphasis on national events and developments in Belarus or BSSR and, on the other hand, an attempt to avoid a description of Belarusian national groups within the Soviet Union. This is very obvious in the elements of the exhibition pertaining to the Hitler-Stalin Pact. This agreement and the secret supplementary protocol are prominently displayed together with a map showing the planned division of Poland. However, in the current exhibition, this is followed by a description of the conquest of Eastern Poland on 17 September 1939, or what the exhibit calls the liberation of Easter Poland. No information on the situation of the BSSR and Eastern Poland prior to 1939 is provided. Because this complex situation described above[32] is not explained, a situation, in which the invasion of the Soviet troops was perceived both as a liberation as well as an occupation, makes it impossible to give a differentiated description of the national movement for the rest of the exhibition.

In the new exhibition, an entire room is dedicated to the Beginning of World War II and one element of it strictly focuses on "The Reunification of Western Belarus with BSSR".[33] The fact that this is no longer called liberation shows an, albeit careful, change from an attitude specifically directed against Poland to a perspective which is more guided by a national definition of the events. Regarding the Baltic States, however, even the new concept continues to speak of a "peaceful unification" in summer 1940.[34]

32 | B. Chiari (2001): »Die Kriegsgesellschaft. Weißrussland im Zweiten Weltkrieg (1939-1944)«, in: D. Beyrau/R. Lindner: Handbuch der Geschichte Weißrusslands, p. 410ff.

33 | Struktura (2011): Rasširennaja tematičeskaja struktura postojannoj ékspozicii Belorusskogo Gosudarstvennogo Muzeja istorii velikoj otečestvennoj vojny, Minsk (unpublished, p. 3)

34 | Scenarij (2009) ékspozicii Belorusskogo Gosudarstvennogo Muzeja istorii velikoj otečestvennoj vojny, 27 August 2009, Minsk (unpublished), p. 2.

b) German policy of extermination and occupation

Up to the mid-1990s, this field was exclusively used as a backdrop for the presentation of the victory, which shone all the brighter in contrast to the German atrocities. It mainly referred to fascistic atrocities, which were visualized by photographs, the remains of concentration camps and barbed wire scenes. To this day the exhibition relies on the sheer quantity of material without going into more detail on specific aspects. The presentation relies on individual exhibits, which in themselves could be a key to the narrative, but are not used as such. The example of collaboration gives a general idea of how the exhibition deals with its subjects. On the level of the exhibits, the theme is presented in a certain amount of detail, but there is no introductory and comprehensive text and the (inconsistent) descriptions of the objects do not provide sufficient information to allow visitors to orient themselves without prior knowledge. On the level of content, there is no differentiated presentation of pre-war history which might show that the population reacted to the war and the resulting circumstances in very different ways in terms of collaboration.[35] On the museological level, there is a lack of visitor orientation, which should take the different backgrounds of the visitors into consideration in the process of selecting and presenting the material.

The presentation of other topics confirms this observation. For example, the documentation of the policy of extermination deals predominantly with themes specific to Belarus, such as burned villages, the ghettoes and the various concentration camps within the territory of the BSSR.[36] All of this is prominently displayed in the current exhibition through original objects and a diorama. However, the documents and exhibits do not clearly show that the extermination was not only directed against the civilian population, but also and mainly against the Jews. To this day the Holocaust is a neglected topic in Belarus, although it is not taboo.[37] The failure to recognize and deal with anti-Semitic tendencies within Belarusian society before, during and after the war is still an obstacle to revision. For example, there is no mention of the fact that the victims of the concentration camp in Maly Trostenec, according to the latest research, between 60,000 and 200,000 people, were not only

35 | B. Chiari (1998): Alltag hinter der Front. Besatzung, Kollaboration und Widerstand in Weißrußland 1941-1944, Düsseldorf: Droste; B. Chiari (2001): »Die Kriegsgesellschaft. Weißrussland im Zweiten Weltkrieg (1939-1944)«, in: D. Beyrau/R. Lindner: Handbuch der Geschichte Weißrusslands, pp.408–425; B. Chiari (2002): »Geschichte als Gewalttat. Weißrußland als Kind zweier Weltkriege«, in: B. Thoß/H.-E. Volkmann: Erster Weltkrieg – Zweiter Weltkrieg, pp. 615–631.

36 | B. Chiari (2002): »Geschichte als Gewalttat. Weißrußland als Kind zweier Weltkriege«, in: B. Thoß/H.-E. Volkmann: Erster Weltkrieg – Zweiter Weltkrieg, pp.615–631.

37 | A. Sahm (2010): »Der Zweite Weltkrieg als Gründungsmythos. Wandel der Erinnerungskultur in Belarus«, in: Osteuropa 5, p. 50f; A. Sahm (2008): »Im Banne des Krieges. Gedenkstätten und Erinnerungskultur inBelarus«, in: Osteuropa 6, p. 242.

prisoners of war, partisans, underground fighters, inhabitants of Minsk and nearby cities, but mostly Belarusian and deported foreign Jews.[38] The uncertainty concerning the exact number of victims[39] is never mentioned either here or elsewhere in the exhibition.

Another, typically Soviet, way of exhibiting is the presentation of the fate of individuals. In almost every case, biographies are referred to, but they are not broken down into individual stories, but are used as a whole or as an anonymous presentation to provide a source of identification for visitors. The choice of people ranges from officers and references to their exemplary deeds to simple soldiers as far as they sacrificed themselves in battle as well as ordinary people who are described as typical fates so that visitors of the exhibition may identify with them.[40]

Similarly, the new exhibition also allocates a special room to the occupation. In accordance with the concept, it is isolated on the edge of the tour, so visitors are not necessarily exposed to that gruesome part of history, particularly since the intention of the room is to convey suffering and horror, grief and fear. The selection of topics is by far more differentiated than in the current exhibition and includes documentation of the occupational structure, the destruction of cities and villages, an overview of the various camps, the genocide of the Jews, the deportment for forced labour as well as collaboration. The central exhibit is, just as it is now, a diorama. The once officially approved content is to be supplemented by up-to-date information and presented with the latest projection technology.

c) Partisan Movement

The exhibition area on the partisan movement is by far the largest space in the current exhibition. This is due in part to the aforementioned history of the foundation of the museum.[41] At the time, members of the Partisan movement were asked to collect objects for the museum, and museum staff members also collected exhibits from the combat zones. In part, the reason for the enormous exhibition space, which currently includes a room on the ground floor, three large rooms on the first

38 | B. Chiari (2001): »Die Kriegsgesellschaft. Weißrussland im Zweiten Weltkrieg (1939–1944)«, in: D. Beyrau/R. Lindner: Handbuch der Geschichte Weißrusslands, pp. 422–424.

39 | O. Kurilo/H.-U. Herrmann (2008): Täter, Opfer, Helden, p. 139-148; M. Iwanou (2001): »Terror, Deportation, Genozid: Demographische Veränderungen in Weißrussland im 20. Jahrhundert«, in: D. Beyrau/R. Lindner: Handbuch der Geschichte Weißrusslands, pp. 426–436.

40 | B. Chiari/R. Maier (2004): »Weißrussland. Volkskrieg und Heldenstädte: Zum Mythos des Großen Vaterländischen Krieges in Weißrussland«, in: M. Flacke: Mythen der Nationen, p. 741f.

41 | Voronkova, I. Ju. (2001): »Sozdanie i stanovlenie Belorusskogo gosudarstvennogo Muzeja istorii Velikoj Otečestvennoj vojny«, Minsk.

floor as well as additional temporary exhibitions, lies in the Soviet version of history. In keeping with this way of thinking, the permanent exhibition also constructs an indivisible unity between the population and the partisans as well as an indivisible structure of the partisan movement itself.

The strongly fragmented structure of society in the region and the historical influences behind it, the changing political allegiances and the various occupations as well as the resulting individual survival strategies and their subjective experiences of the war[42] are not reflected in this presentation. Rather, the old myth of the partisan movement and even a certain romance of the forest are nurtured.

Again, many portraits are consistent with the pattern mentioned above. This area of the exhibition particularly reflects the unbroken power of the veteran union, which makes it difficult to change anything about the rooms and their contents. In many places, flowers are put in front of pictures or personal objects that turn the exhibition into a mixture of ideologically molded documentation and personal memory.

In the new exhibition, the partisan movement is also supposed to be represented prominently. In contrast to the occupation topic, the approach will be much more conservative and adhere to the old focal points. As in the old exhibition, the picture of the idealised world of the partisans will be kept alive.

d) Memory of War

In the current exhibition, remembrance and memory are not presented as a single subject. There is no discussion of their relevance today and no questions of the role and function the war might have in present day Belarus, what makes it a current topic and which attitudes regarding war in general prevail in society today. Considering the history of the foundation of the museum, the museum itself is the central exhibit for the memory of the war. This is reflected in the inscription on the current building, which can be read from afar: "The heroic deed of the people is eternal", in the architecture of the new building, in the creation of a memoryscape and, in both cases, in the interior design. As mentioned before, the current exhibition is a mixture between documentation and memory in its selection and exclusion of themes and in the massively biographical approach to its memorial function.

The new concept is to include a section on the topic of memory and remembrance.[43] It is supposed to be integrated into the room dedicated to Belarus in the first years after liberation; but the time frame is limited to 1944-50. A connection to the present day is still not considered. However, the exhibition intends to limit itself

42 | B. Chiari (2002): »Geschichte als Gewalttat. Weißrußland als Kind zweier Weltkriege«, in: B. Thoß/H.-E. Volkmann: Erster Weltkrieg – Zweiter Weltkrieg, p. 623.

43 | Scenarij (2009) ėkspozicii Belorusskogo Gosudarstvennogo Muzeja istorii velikoj otečestvennoj vojny, 27.8.2009, Minsk (unpublished), p. 14.

Figure 4: A view of the exhibition.
© *http://realt.onliner.by/2012/03/17/muz-4 (12 October 2012)*

to a mere documentary function and to minimize personal remembrance. But it will be impossible to take it out of the museum altogether, for the architecture alone provides remembrance a prominent position. Together with the exterior grounds and the large assembly spaces inside, this will form the Hall of Victory, which, besides depicting the defeat of the Third Reich and the conquest of Berlin by the Red Army, will focus on the victory parade on the Red Square in Moscow as well as symbols of victory like seized weapons, flags and National Socialist symbols of sovereignty. The idea is to convey impressions of joy and victory, as well as of grief and suffering. For visitors, however, a sense of joy shall dominate, presented by sounds and pictures of the 9 May fireworks, marching band music and photographs of happy homecomings of soldiers. This hall and the exterior grounds clearly reveal the influence of Moscow's Museum of the Great Patriotic War and thus the continuation of the Soviet/Russian interpretation of history.

2. Architecture and Design

That a critical revision of the exhibition is not politically desired is also reflected in the plan for the new building. Financed by the City of Minsk by order of the government, it uses Moscow's Museum of Great Patriotic War as a model and thus puts itself into the context of the Russian-Soviet master narrative. The architect, Viktor V.

Kramarenko, who has already received several awards and has built the main station, the National Library and the Minsk Hero City obelisk in the immediate vicinity of the museum, has been commissioned to build the museum. The museum itself was not involved in selecting the design.

The central reference point of the planned building is the celebration of the Victory of 9 May 1945 on the Red Square in Moscow. This event is reflected in the architecture too: the façade of the building will be made of large concrete panels, which radiate at an angle around the central obelisk. The names of all heroes of the Soviet Union (about 12,000 names) will be engraved here. In the evening, a laser show will be reminiscent of the historical fireworks. The four blocks of the building represent the four years of war (1941–44) and the four army groups which liberated the BSSR. A glass dome will rise up behind them, and the Hall of Victory will be located below the dome. Outside, 170 water jets will represent the 170 liberated villages. The entire campus, situated in the Park of Victory, will use – architecture, like in Moscow, to emotionally overwhelm visitors.

This use of design is continued in the interior and in the exhibition. The four blocks on the ground level will be connected by the Path of War, which will present weapons and heavy equipment with the specific intention of eliciting admiration for the technological achievements of the Soviet Union and to thus affirm the trust put into their victory. The exhibition on three levels will fit into the symbolic

Figure 5: The names of the heroes of the Soviet Union shall be engraved on the ray-like structures (about 12,000 names)
© http://news.tut.by/kaleidoscope/168287.html (12 October 2012)

architecture. According to the new concept, it is supposed to have an antimilitaristic orientation. How this is to be realised, however, is still unclear, since the work with the Polish [sic!] designer has only just begun. The main guideline of the museum is to approach visitors emotionally. The rooms are designed to represent different topics such as joy, pride, pain, grief and fear. With the help of mostly naturalistic scenes and dioramas, visitors shall gain an impression of the experiences of the inhabitants of Belarus during the war. In any case, the new exhibition will profit from a unified design, in contrast to the current exhibition, which was influenced by five different designers in its ten year period of constant rearrangement from 1995–2005.

Whether the plans for the building and its interior design can be realized as intended is questionable as a result of the economic crisis of spring 2011. The continuous devaluation of the Belarusian rouble has made the budget shrink. Taking this into consideration, the use of the net profit of the Subbotnik (Work Saturday) in April 2011 for the building of the museum or calls for donations on national television are a mixture of fundraising and a way of generating identification with the project.[44]

3. Means of Education and engaging Visitors

In terms of information transfer, the exhibition follows the old patterns to this day. Guides equipped with a wooden pointer give groups of children, teenagers and adults monologues, often lasting several hours. A slight variation on this is working with children directly in front of an exhibit. In the case of military historical museums, this is often supplemented by personal reports of war veterans.

Consistent and clearly presented exhibition texts to help visitors orient themselves are nowhere to be found. Attempts at new ways of educating visitors are, so far, only to be found in the design, for instance, in a special exhibition on the partisans (2011). In this specific case, the exhibition relies upon the highly naturalistic and accurate copy of an actual partisan´s hut in the woods, complete with the noise of approaching airplanes and the sound of gunfire to let visitors experience the authentic feeling of being part of it.

This form of communication is to be continued in the new museum, but there will be a stronger focus on addressing individual visitors. Clearly structured texts shall enable visitors to orient themselves without the help of an official guide. The current mixture of texts in Russian, Belarusian and sometimes both languages is to be consistently replaced by texts in several languages. Furthermore, visitors will be

44 | Subbotnik (2011): Report of the Belarusian television of the use of the money from the Subbotnik in April 2011. Retrieved 1 November 2011, from http://ont.by/news/our_news/0065985.

provided with audio guides as well as with audio, film and terminal workstations. So-called information booths will provide further information on the exhibition as well as the possibility of interactive participation in the form of a guestbook, where visitors can enter their personal thoughts and memories of the war. This approach is consistent with the design, which aims to provide visitors with the opportunity to explore the exhibition on their own, assisted by guiding systems, emphases on certain areas and relaxation zones. Present plans include a public storeroom within the exhibition as well as making the collection available electronically. Should these plans materialise, it could be something unique to Belarus and would also become an important source of historical research.

A look at the new concept, however, reveals that even the broadened spectrum of ways of transfer still follows the old pattern of educational work: interaction is still mainly considered as a means to emotionally address visitors through design, supplemented by offers to experience the historical situation in these productions, as, for example, in the planned external exhibition on the living conditions of the partisans. Dioramas are to convey the illusion of space into which visitors can immerse themselves. Flight and tank simulators are to be available for training. Interactive maps shall enable visitors to orient themselves in the historical space, but so far only concerning the lines of military fronts. Finally, the plan of a projected dialogue between a veteran of the partisans and a boy, which is to focus on the world of the partisans, their weapons and forms of battle, shows that the potential of such possibilities of participation has not been exhausted yet.

III. PERSPECTIVES

Thus, the question becomes what about the war in Belarusian museums? Which perspectives does the new concept of the leading museum offer for historical policy and the collective memory of the country or rather, how can the museum contribute to the development of a differentiated culture of memory?

As the overview has shown, the curators are severely limited. But to enhance the historical revision nonetheless the recalling of the core tasks of a museum can create free spaces which are derived from the museum as a place for informal and extracurricular learning and education. The collection may have a decisive impact in achieving this. As the collection is reinterpreted according to the broadened range of questions, new acquisitions and supplementing research may allow an emphasis on hitherto neglected aspects. Furthermore, the treatment of the space through architecture and design offers the visitor the possibility of approaching the content of the exhibition on their own terms. Finally, a critical process of reflection is initiated by the differentiated ways of engaging the visitor. As the policy of collecting, design and education combine the apparently still required political continuity with new

forms of dialogue and interaction, the museum can yet become a place of critical discussion of history and of future-oriented learning and thus approach a common European culture of memory of the Second World War.

This intention is reflected in the many ideas of the new concept, whose potential the museum can exhaust in practice without touching the core of the approved version of the concept. As the exhibition becomes more strongly directed towards individual visitors, it not only meets international museum standards, but also opens new spaces of experience in dealing with one's own history and memory. As the museum allows electronic access to the collection as well as to the archive, it not only offers visitors the possibility of an in-depth exploration of the exhibited theme, but also establishes a basis of scientific sources for further research and critical analysis. As the museum offers further information and service to visitors before and at the time of their visit, it fulfils already existing expectations concerning the visit of any exhibition, but also offers non-visitors and potential future visitors a chance to explore the history and the memory of the war independently. By offering multilingual information and imparting of the exhibition, the museum positions itself in a globalized world and, at the same time, becomes interesting for tourists and foreign museum experts, who in turn become dialogue partners for native visitors and museum colleagues. As dioramas are a vehicle to immerse visitors into history, it is part of a varied, and, for many Western visitors, surprising and fascinating design. At the same time, the use of visually overwhelming dioramas and panoramas, with their claim of objective interpretation, offers the possibility to critically reflect on their suggestive power and the possibility of conscious manipulation of visitors. As visitors have the interactive possibility to follow the development of military fronts, they are also enabled to reflect on the national and linguistic borders that the war simply ignored.

This enumeration of possibilities of conveying content, which are specific to the museum, could be continued. It is to be hoped that the expressed aim of the new concept that intends to maintain the museum as an island of mental purity shall not prevail, but instead that the courage to discuss will gain the upper hand. This would also have to include a broader documentation of the Great Patriotic War in the context of the experience of violence in the 20th century as well as its relevance for the present day. It would be this broadening of the subject, and not its restriction, that would contribute to legitimizing national identity and to using the memory of the war for the present.

Against the backdrop of the present situation in Belarus, the chances for this broadening of spectrum do not look good. However, a different picture begins to appear if one considers the very active and critical scene of museums here. Drawing on the museum's specific tasks and possibilities for combining continuity, dialogue and interaction, the museum could become a place for the critical analysis of history and future-oriented learning at a time when the last witnesses of the war are dying and fewer and fewer young people are actually interested in the war.

It would thus be desirable if the rest of Europe, in spite of the initially mentioned isolation of the country, intensified its cooperation with the Belarusian museums and thus contributed to their process of opening up.

Framing the Military-Nation: New War Museums and Changing Representational Practices in Turkey since 2002

Patrizia Kern

Over the last decade, a remarkable number of new war museums[1] have been established in Turkey. All of them are dedicated to important "foundation" battles in Turkish history. In contrast to the traditional display of weapons, belongings of veterans and documents, these museums also include dioramic structures as well as classical 360° panoramas. Most of them are not based on existing collections of arms and armory. Their visual design has become one of the dominant modes for representing war and has influenced representational practices in other museums.

This article aims at examining a few of these museums within their particular cultural and political context.[2] The starting point will be the first museum that used diorama installations, the Ataturk and Independence War Museum in Ankara, which was opened in 2002. In a second part, two projects will be described, which in their content as well as in their design refer to this first museum: the Panoramic Victory Museum and the 1453 Panorama Museum in Istanbul.

In describing the institutionalization processes and spatial arrangements, the article will address questions regarding the objectives and means with which the events in the museums are visualized; the notions of nation and territory that are conveyed in the exhibitions; if the representations are trivializing, and whether they aim at emotional manipulation, historicizing and/or learning. The following will also critically reflect on the "authenticity" of the objects and documents in

1 | I use the term "war museum" for historical museums dedicated to one particular battle.

2 | "Museumsanalyse", museum analysis, according to Joachim Baur, treats museums as cultural phenomena. By investigating case studies, it aims at gaining knowledge about their social, political and cultural contexts. From an external perspective, it aims at a critical understanding of these institutions, rather than at their improvement.

Joachim Baur (2011): »Zur Einführung«, in: Joachim Baur (ed.): Museumsanalyse, Methoden und Konturen eines neuen Forschungsfeldes, Bielefeld: Transcript, pp. 7–14, p. 8.

A young visitor at the 1453 Panorama Museum in Istanbul.

the exhibition in order to understand what they aim to achieve, and how they are perceived by the public.

THE ATATURK AND INDEPENDENCE WAR MUSEUM IN ANKARA

In October 2001, the Ministry of Culture, the Ministry of Defense and the Turkish Chief of the General Staff[3] took the decision to renovate the Atatürk Museum[4] which was located within the mausoleum complex of Mustafa Kemal Atatürk (Anıtkabir). Like all "mausoleums built by the state, guarded by honor guards, and visited in silence [...] [Anıtkabir is a] site[] of political legitimization".[5]

3 | The mausoleum had been administered by the Ministry of Culture until the administration was handed over to the Ministry of the General Staff in 1981. Necdet Evliyağıl (1988): Atatürk ve Anıtkabir, Ankara, p. 67. Also involved in the renovation plans were the Prime Minister's Office, and the Military History Archives (ATASE). Bora Öncü/ Görkem Öztürk (2002): Atatürk ve Kurtuluş Savaşı Müzesi tanıtımı ve Müze açılış töreni, in: Anıtkabir Dergisi, 11 (3), pp. 12–23, p. 12.

4 | The Atatürk-Museum was opened in 1960 and exhibited the personal belongings of Mustafa Kemal Atatürk.

5 | Nazlı Ökten (2007): »An Endless Death and an Eternal Mourning«, in: Esra Özyürek (ed.): The Politics of Public Memory in Turkey, New York, pp. 95–113, pp. 99–100.

The context, in which the decision to build the new museums was made, was characterized by the experience of a grave financial and economic crisis, which began in February 2001. Already in the late 1990s, but especially during this crisis "the memory of a strong, independent, self-sufficient state and its secularist modernization project that dominated the public sphere through the past century was challenged by the rise of political Islam and Kurdish separatism, on the one hand, and the increasing demands of the European Union (EU), the International Monetary Fund (IMF), and the World Bank, on the other."[6] Legal adjustments made in prospect of future EU membership comprised amendments to the constitution. First amendments made in September 2001, at least formally reduced the political influence of the army. But they certainly questioned the idea of a "military nation", i.e. the indivisibility of the nation from its military, which was promoted by the Turkish government, as well as by the army and other security forces, and which served to mask internal – religious or ethnic – conflicts.[7] Nevertheless, the role of the army as the guardian of the unity of the Turkish nation, its people and territory as well as the state's secular order is still largely accepted by the majority of the population.[8]

In contrast, corruption and mismanagement had led to a legitimization crisis of the governing parties, which were threatened with being voted out of parliament in the upcoming elections to the advantage of Islamist and Nationalist parties.[9] In this situation "[...] both the government and business circles evinced a heroic nationalist discourse. National-progressivist slogans such as "the economic War of Independence," [...] were coined. The rise of the "Islamist" movement also compelled the official nationalism to emphasize the image of Atatürk; the portrait of Atatürk became a kind of logo and was displayed at every opportunity."[10]

The plans for the design of the exhibition have to be read against this background. The museum was planned to be modernized and expanded by a sector right

6 | Özyürek, Nostalgia for the Modern, 2.

7 | Ayşe Gül Altınay (2004): »The Myth of the Military-Nation: Militarism, Gender and Education in Turkey«, New York.

8 | See Heinz Kramer (2004): »Die Türkei im Prozess der „Europäisierung"«, in: Aus Politik und Zeitgeschichte B33-34, pp. 9–17, pp. 11–12. See also S. Irzık and Güven Güzeldere (2003): »Introduction«, in: The South Atlantic Quarterly 102 (2/3), pp. 283–292, p. 284.

9 | In June 2001 the Islamist Virtue Party was prohibited by law. In August 2001, one of its wings re-united as AKP, the Justice and Development Party, which then under the leadership of Recep Tayyip Erdoğan clearly won the early parliamentary elections on 3 November 2002 with 34.3 % of the votes.

10 | Tanıl Bora (2011): »Nationalist Discourses in Turkey«, in: Ayşe Kadıoğlu/E. Fuat Keyman (eds.): Symbiotic Antagonisms. Competing Nationalisms in Turkey, Salt Lake City, pp. 57–81, pp. 64–65.

beneath the hall of honor and around the crypt. Plans foresaw an exhibition of paintings of decisive battles in Turkish history related to Atatürk.[11]

According to the exhibition catalogue, the museum was supposed to show the "difficulties on the way towards the Republic", and to give orientation for the future.[12] The past, in which the makers searched for orientation for the future, was the Independence War, which, in the official national narrative, symbolizes the end of an empire, and the "re-birth of the Turkish nation". Visualized in countless memorials throughout the country, but especially in the capital Ankara, and celebrated in numerous national holidays, it is the central historical period publicly remembered.[13] Perceived as a part of the Great War, it represents one of the foundation myths of the Turkish Republic and a main reference for national identity constructions in contemporary Turkey.[14]

In the Ottoman-Turkish experience, this Great War that began in 1914 did not end in 1918. At the end of World War I, the Ottoman Empire, an Ally of the Central Powers, was partitioned among the victorious powers and their clients according to the agreements of the Treaty of Sèvres.[15] When Greece, one of the occupying powers, started to expand its territories in 1919, Mustafa Kemal led a successful counter-offensive of the so-called National Forces revolting against the Ottoman leaders,

11 | The idea for painted battles came from the Chief of the General Staff Hüseyin Kıvrıkoğlu. Yury Baranov (2004): »The Secret Mission of Merchant Mikhailov«, in: Russian Military Review 1, pp. 66–69, p. 66.

12 | T.C. Generalkurmay Başkanlığı/Turkish General Staff (ed.): Atatürk ve Kurtuluş Savaşı Müzesi/Atatürk and the Independence War Museum, museum catalogue, Ankara n. d., p. 43.

13 | See Eviatar Zerubavel (2003): »Calendars and History: A Comparative Study of the Social Organization of National Memory«, in: Jeffrey K. Olick (ed.): States of Memory: Continuities, Conflicts, and Transformations in National Retrospection, Durham, pp. 315–337, p. 326.

14 | Foundational myths are "myhts [...], in which the national society or national state locates either its historic origin or its new foundation [...] (translation by the author). D. Langewiesche (2003): »Krieg im Mythenarsenal europäischer Nationen und der USA. Überlegungen zur Wirkungsmacht politischer Mythen«, in: Dieter Langewiesche/Nikolaus Buschmann (eds.): Der Krieg in den Gründungsmythen europäischer Nationen und der USA, Frankfurt/Main - New York, pp. 13–22, pp. 14–15.

15 | In the Ottoman-Turkish perception, Sèvres was "not only a disastrous conclusion to a war, but the final act in a tragic sequence of events. In ten years the Ottomans had lost three wars in quick succession. [...] The Balkan War had been over for slightly over a year when World War I broke out." Erik-Jan Zürcher (2008): »The Turkish Perception of Europe. Example and Enemy«, in: Michael J. Wintle (ed.): Imagining Europe: Europe and European Civilization as Seen from its Margins and by the Rest of the World, in the Nineteenth and Twentieth Centuries, Brussels (et al.) [Multiple Europes; 42], pp. 93–103, p. 101.

and, finally, the Greek army had to retreat. As a consequence of the victory in this so-called Turkish Independence War, a new peace treaty was signed in Lausanne and the Turkish Republic was established in 1923. The subsequent years until the death of Atatürk in 1938 were then characterized by numerous social reforms that aimed at modernization and Westernization.

In the mid-1990s, Turkey's secular republican state elites, who were losing influence to a new conservative urban middle class, had begun to remember this period as a "Golden Age." Anthropologist Esra Özyürek has called the memory practices of these groups "nostalgia for the modern".[16] A second part of the new museum was dedicated to this early Republican Era of the 1920s and 1930s.

Although not completely finished, the new museum was (re-)opened after nine months of work as the 'Atatürk and Independence War Museum' (Atatürk ve Kurtuluş Savaşı Müzesi) on the occasion of the (80th) anniversary celebrations of the "Great Offensive" (Büyük Taarruz), a decisive battle of the Independence War, on 26 August 2002. The opening ceremony was attended by politicians and military officers as well as by ambassadors from several foreign countries.[17]

THE BATTLE DIORAMAS

In the first new sections, dedicated to the Gallipoli battle and the Independence War, three battle dioramas are on display. Loudspeakers fill the rooms with the sound of battle and solemn music. Visitors, who stand in front of a faux terrain of trenches with life-sized mannequin soldiers, rocks and weaponry, share the troops' view of the enemy strike force. The installation between the wall panorama and the visitors, the special sound effects and three-dimensional displays aim at making the past present.

The "script" for the exhibition was written by Turgut Özakman, a famous script writer and novelist, who is known for his – anti-Western and anti-Imperialist – accounts of the Gallipoli battles and the Independence War.[18] The realization of the dioramas though, was handed over to the Moscow Grekov-Studio of military painting for obvious technical, but also political reasons.[19] The Russian painters had to obey particular "Turkish rules" when working on the wall panoramas:

16 | Esra Özyürek (2006): »Nostalgia for the Modern. State Secularism and Everyday Politics in Turkey«, Durham-London, pp. 62–63.

17 | »Memories of Atatürk and Independence War immortalized«, in: Turkish Daily News, 28 August 2002.

18 | Lerna K. Yanık: 'Those Crazy Turks' that Got Caught in the 'Metal Storm': Nationalism in Turkey's Best Seller Lists, EUI Working Papers RSCAS 2008/04. Accessible via http://cadmus.eui.eu/handle/1814/8002. (Last access: 6 March 2012).

19 | After 9/11, the military's overall pro-EU stance had taken a more conservative-

"Apart from the rules of battle painting, it was necessary to take into account Turkish national features. For example, Kemal Ataturk could be depicted only in poses seen on surviving photographs. No free interpretation was allowed. The commissioners, the Turkish Joint Staff and the Culture Ministry, even insisted that the Turkish President should be 160 cm tall, as he was in reality. In compliance with Turkish rules, works about Ataturk must be confirmed by authentic photos of him. His photos from the memorial museum in Ankara served as the accepted models."[20]

Also, the motives for the panoramas were chosen from a well-established repertoire of real events and myths: The "Battle of Çanakkale" diorama[21] presents asynchronous events like the landing of the Anzac troops at Arıburnu as well as the legendary Turkish soldier who carried a wounded enemy soldier next to each other. It depicts the commanders of the Turkish troops, and shows everyday life in the trenches, the wounded, and the common prayer of the soldiers.

Vis-à-vis the panorama a map illustrates the planned dismemberment of the Anatolian peninsula by the Allied forces by the Treaty of Sèvres. The memory of the imperialist powers dividing the country is one that is repeatedly used in Turkish political discourse. Politicians and nationalist groups have repeatedly used the term "New Sèvres" (yeni Sevr) to condemn EU pressure regarding minority rights. Fittingly, the term "national unity" (Milli birlik ve beraberlik) is increasingly found in discourse as well.[22]

nationalist tone. The overall perception was that the EU displayed "a negative bias toward Turkey" and that therefore, the attempt to become an EU member would be in vain, that, "Turkey need[s] new allies, and it would be useful if Turkey engages in a search that would include Russia and Iran." Tüncer Kilinç, Secretary of the National Security Council, in March 2002. Cited in Ümit Cizre/ Menderes Çınar (2003): »Turkey 2002: Kemalism, Islamism, and Politics in the Light of the February 28 Process«, in: The South Atlantic Quarterly 102 (2/3), pp. 309–332, p. 315. For an account of the "Eurasian Partnership" regarding military cooperation and tourism between Russia and Turkey, see Tunç Aybak (2006): »From 'Turkic Century' to the Rise of Eurasianism«, in: Gerald McLean (ed.): Writing Turkey: Explorations in Turkish History, Politics and Cultural Identity, London, pp. 69–84.

For the technical reasons, see Baranov: The Secret Mission, 66. The other option would have been Dutch studios or Korean artists, but the General Staff apparently preferred the Russian realistic style.

20 | Yury Baranov: The Secret Mission, p. 69.

21 | For a list of painters, see: www.panoramapainting.com.

22 | Zürcher, Turkish Perception of Europe, p. 101. It is "a term often used in Kemalist discourse, in particular by the army. Politics on the basis of ethnicity, religion or class are seen as contrary to this principle of national unity and therefore unlawful." Zürcher, Turkish Perception of Europe, p. 98, Fn. 8.

The two panoramas depicting the battles of the Independence War[23] are placed en face in a separate room. The room between the panoramas exhibits oil paintings depicting scenes from the defence of Gallipoli and the Independence War as well as portraits of Atatürk's companions and military commanders. The paintings aim at illustrating the closeness of the military leadership represented by Mustafa Kemal and his deputy Ismet (Inönü), the unity of the people, and their support of the soldiers and the National Movement; they give impressions from soldier's everyday lives, the cruelty of war, as well as the victories.

In this new section "the brave Turkish army stop[s] the strong European navies and armies with its national faith alone. The German military aid and the existence of German commanders such as Liman von Sanders are not mentioned at all. The true national essence, with Mustafa Kemal as its future leader, is identified as the real agent of this [...] Great War."[24] This "national essence" is "limited to specific groups: Anatolian peasants, young nationalist intellectuals from Istanbul – who served as reserve officers in the war – and low-ranking army officers."[25] The nation as represented in the portrait galleries is a "military-nation". The top-down view that has also dominated official remembrance remains very noticeable in the exhibition.[26]

MODERNIZATION AS A LINEAR SUCCESS STORY

The second of the museum's new sections is dedicated to the period from the Treaty of Sèvres to the social reforms of the 1920s and 1930s. It occupies a hall with eighteen vault galleries, in which around 3,000 photographs and objects accompanied by Atatürk quotes are on display.

23 | Sakarya Pitch Battle (Sakarya Meydan Muharebesi), 23 August - 13 September, 1921, 35 x 6 m and the Battle of Dumlupınar or Commander-in-Chief (Başkomutanlık Meydan Muharebesi or Büyük Taarruz), 26 August 1922, 35 x 6m.

24 | Erol Köroğlu (2006): »Taming the Past, Shaping the Future: The Appropriation of the Great War Experience in the Popular Fiction of the Early Turkish Republic«, in: O. Farschid/ M. Kropp/ and S. Dähne (eds.): The First World War as remembered in the countries of the Eastern Mediterranean, Beirut, pp. 223–230, p. 230.

25 | E. Köroğlu: Taming the Past, p. 227.

26 | The memory of the war was greatly influenced by the sources available: "Historiographical works on military, diplomatic and economic aspects of the war and memoirs of high-ranking soldiers and politicians, many of them reflecting the official perspective (often quoting from orders) and the top-down view". See M. Strohmeier: »Monumentalism versus Realism: Aspects of the First World War in Turkish Literature«, in: O. Farschid (et al.): The First World War as Remembered in the Countries of the Eastern Mediterranean, pp. 297–319, here p. 306.

Among the reforms presented are the adoption of the Western clock and the Gregorian calendar in 1926, the script reform in 1928 and the language reform in 1932 – measures that not only served to westernize and secularize society, but also to break with the Ottoman past and legitimize the party in power "as the founder of a new era".[27] In the context of the exhibition, the reforms are presented as unanimously welcomed by the people. The rigorous measures taken by the one party regime to enforce the new laws – such as death penalties for wearing a Fez, the Ottoman hat – are not mentioned.

The image of the nation remembered here is very much in line with the "nostalgia" mentioned above: "The early Republican days are depicted as a joyous time in which individual citizens were ideologically and emotionally united with their state".[28] This depiction can be interpreted "as a critique of contemporary Turkey",[29] which does not live up to the high values of this golden past. At the same time, "such nostalgic narratives stood against contemporary historiographic criticism of the 1930s as oppressive."[30] The narrative presented in this section is one of unity and progress towards modernity, but, in the context of the early 2000s, a modernity that is located "in the non-present."[31]

The origin of most of the objects remains unclear to visitors. They are presented without contextualization. Together with the Atatürk quotes the objects inserted in this arrangement play a crucial role as "authentic objects", as they confirm and testify the claimed facts and serve to support and legitimate the content presented.[32]

The busts and brief CVs of twenty so-called "civilian-soldier heroes and heroines" are on display alongside the corridor and are picturing the power-relations of the present under the rubric of 'the history of the nation.'"[33] At first glance, the selection of heroes of the nation seems to illustrate the ideal of the "military-nation", the civilian-soldier. However, at closer range, the ideal turns out to be restricted to a quite small and elitist group: Among the "heroes", there are only two "heroines", of whom one, Halide Edip Adıvar, impersonates the ideal of the westernized, educated woman. Despite the emphasis on the efforts of the little soldier, the so-called "Mehmetçik" and the contributions of civilians, most of the "heroes" portrayed in

27 | Esra Özyürek: »Introduction«, in: Özyürek: The Politics of Public Memory, pp. 1–15, p. 4.

28 | E. Özyürek: Nostalgia for the Modern, pp. 62–63.

29 | Ibid.

30 | E. Özyürek: Nostalgia for the Modern, p. 26.

31 | E. Özyürek: Nostalgia for the Modern, p. 11.

32 | Jana Scholze (2004): Medium Ausstellung: Lektüren musealer Gestaltung in Oxford, Leipzig, Amsterdam und Berlin, Bielefeld, pp. 122–123.

33 | Eilean Hooper-Greenhill (2000): Museums and the Interpretation of Visual Culture, London-New York, [Museum meanings; 4], p. 43.

the gallery do at least have the rank of general. Many later became members of the new Grand National Assembly.

Minorities are included in the exhibition only with the objective of presenting them as "others" or (internal or external) "enemies", against which the ideals of the "Turkish nation" can be shaped. Photos of "innocent Turks",[34] peasants, old women and children, presumably mutilated by Greeks, are on display. Besides the Anatolian Greeks, Armenians are presented as the second group of inner enemies,[35] who by deserting the army and through their guerilla activities, revealed themselves to be traitors.[36]

Visitors are guided linearly along the arch vaults, in correspondence with the linear narrative of a nation's struggle for independence and its successful modernization, which is uncritically presented as a pure success story.[37] This section, in sum, links the Independence War to the one-party regime of the Early Republic, its leader Atatürk and his reforms. It visualizes a narrative of progress whose narrative structure is reflected in the spatial arrangements of this section.

In comparison with earlier museum representations, the topic is now dealt with in a much more sensual and three-dimensional way. In its visual design the museum presents a caesura: Over the last decade, a remarkable number of museums have adopted the panorama form to present the battles.

Two of these projects were initiated by the Istanbul Metropolitan Municipality, which, as a consequence of liberalization policies in the 1980s, has vast resources at its command and is thus one of the "new players" in the museum sector on a national scale.[38] Since the mid-1990s, the Municipality has been dominated by conservative

34 | Cited from a text accompanying the exhibited photographs.

35 | Within the biographies, reference to the Anatolian Armenians is made twice: women joined the war to free their husbands that are said to have been tortured to death by Armenians (Kara Fatma); and Armenians "started harassing Muslim women" (Sütçü İmam). Turkish General Staff (ed.): Atatürk and the Independence War Museum, p. 141.

36 | See Hamit Bozarslan (2009): »Der Genozid an den Armeniern als Herausforderung: Erinnerung, nationale Identität und Geschichtsschreibung in der Türkei«, in: Kirstin Buchinger/ Claire Gantet/ Jakob Vogel (eds.): Europäische Erinnerungsräume, Frankfurt-New York, pp. 267–280, pp. 274–275.

37 | The exhibition thus does not reflect recent research and historiography which particularly highlight the character of this "modernization" of the state and the society as a time of mostly top-down revolution of a small elite and a cultural identity break. See, for instance, E. Özyürek: »Introduction«. Researchers also claim that those reforms only affected an urban minority, but did not improve life for the rural majority. See Erik-Jan Zürcher (2004): Turkey: A Modern History, London-New York, p. 206.

38 | Wendy M. K. Shaw: »National Museums in the Republic of Turkey: Palimpsests within a Centralized State«, in: Building National Museums in Europe 1750–2010. Conference proceedings from EuNaMus, European National Museums: Identity Politics, the Uses of

elites and, since 2004, by the AKP. Their cultural policies have focused "largely on strengthening exhibitions that emphasize Islamic heritage."[39] This article shall argue that the two projects present "adaptations", or counter-narratives, to what is presented at the museum at Anıtkabir.

RE-INTERPRETING THE FOUNDING MOMENT:
THE MINIATÜRK PANORAMIC VICTORY MUSEUM

The Miniatürk Panorama Victory Museum (Panorama Zafer Müzesi) presents the same events as the Anıtkabir museum, but with a shift in its meaning that corresponds to the interests of a new neo-conservative elite. The "museum" is comprised of one room located within Miniatürk Park in Istanbul and was opened on the occasion of the 80th anniversary of the founding of the Republic.[40]

Miniatürk, which had opened its doors to the public only about half a year earlier, is a nation-themed miniature park situated on the northern shore of the Golden Horn. As a cooperation between the Istanbul Metropolitan Municipality and the Kültür A.Ş., a joint-stock company, Miniatürk presents miniature models of cultural and natural heritage.[41] With its choice to also present models from Ottoman territories and its emphasis on the Turkic-Islamic heritage, Miniatürk is said to be an example of "neo-conservative memory" that illustrates how alternative memory practices have moved from their "marginal position toward the center."[42]

The Victory Museum is placed in a small building at the rear of the park, beyond the open-air exhibition. Divided into two parts, the left-hand and rear side of the exhibition space present a miniature diorama of battlefields, easily identifiable as Gallipoli, and a miniaturized Anatolian village scene. The right-hand wall of the museum exhibits a photo gallery with Atatürk quotes.

The first section, the miniature diorama with mannequins was not designed by a professional, but by a retired teacher. According to Christine Beil, miniaturized presentation forms of war served to "convey[] the impression that it [the war] was controllable, because visitors saw an infantilized, harmless and straightforward

the Past and the European Citizen, Bologna 28–30 April 2011. Peter Aronsson & Gabriella Elgenius (eds.): EuNaMus Report No. 1, Linköping University Electronic Press: www.ep.liu.se/ecp/064/038/ecp64038.pdf, 1093–1123, 1106. (last access: 6 March 2012)

39 | W. Shaw: Palimpsests, p. 1108.

40 | The Gallipoli part was only added in 2005, on the anniversary of the battle. W. Shaw: Palimpsests, p. 1109.

41 | The models are displayed in an open area and arranged in sections entitled "Istanbul", "Anatolia" and "Abroad" (meaning former Ottoman territories beyond the current state territory).

42 | E. Özyürek: Nostalgia for the Modern, p. 176.

picture of the war-related events. The war's atrocities were neutralized by shrinking it down to a few centimeters. [This] trivialization [...] freed the war experience from its unpleasant aspects, so that this experience could enter cultural memory [...] in the form of myths of battle and the heroization of the soldiers to war heroes."[43]

The aim is not to illustrate historical events or the cruelties of war, but to stage "the founding moment". The installation concentrates on the Anatolian peasants, while no historic person is recognizable among the soldiers. It is dominated by village scenes including the mosque at the centre of everyday life, and the famous ox carts with which civilians transported armory and food supplies to the front. The miniature diorama thus "appeals to a populist nationalism without emphasizing the person of Ataturk, and thus suggests a democratic means of commemorating national history."[44]

A closer look at the second part of the exhibition reinforces the impression of a shift in the interpretation of the founding moment. 18 photographs of Mustafa Kemal Atatürk, both in private and in official situations, accompanied by – mostly well-known – Ataturk quotes in Turkish and English, are put on display.[45]

The exhibition provides a complex and interesting interplay of images and quotes. The idea that all soldiers equally contributed to the making of the nation is, for instance, expressed in the following quote, which is accompanied by a portrait of Atatürk: "It is not me who won this victory. We owe this victory to our valiant soldiers [...]".[46]

Another image/quote pairing hints at the religious character of the nation and its founding moment: "Our religion is the most reasonable and natural religion. This is why it has become the last religion."[47] The quote dates from the same year as the

43 | „[...] vermittelte die miniaturisierte Präsentationsform [...] den Eindruck, dieser sei beherrschbar, denn der Betrachter sah ein infantilisiertes, harmloses und überschaubares Bild vom Kriegsgeschehen. Das Kriegsgrauen wurde neutralisiert, indem man es auf Zentimetergröße schrumpfen ließ. [...] Die Trivialisierung [...] reinigte das Kriegserlebnis von unangenehmen Seiten, so dass dieses in Form von Schlachtenmythen und der Heroisierung der Soldaten zu Kriegshelden Eingang in das kulturelle Gedächtnis [...] finden konnte." C. Beil: Der ausgestellte Krieg, p. 282. (Translation by the author.)

44 | W. Shaw: Palimpsests, p. 1109.

45 | Atatürk images and quotes have always been used for legitimation by different groups, see, for instance, Özyürek: Public Memory as Political Battleground, in: Özyürek: Politics of Public Memory, pp. 14–137, and Walter B. Denny (1982): »Atatürk and Political Art in Turkey«, in: The Turkish Studies Association Journal 6 (2), pp. 17–23. As historical sources the quotes are quite problematic since their tradition is very often unclear and they are usually used outside their original context.

46 | „Bu zaferi kazanan ben değilim. Bunu [...] kahraman askerler kazanmıştır." (Translation as in the exhibition.)

47 | "Bizim dinimiz en makul ve en tabii bir dindi. Ve ancak bundan dolayıdır ki son din

proclamation of the Republic. The related photograph was taken on the very same day as the founding of the Republic, on 23 October 1923. The image shows Atatürk amongst a group of men on the balcony of the building of the National Assembly. Next to Mustafa Kemal is a religious leader with a white turban, and all the men, including Atatürk, are holding their hands up and pray.[48] Thus, the religious aspect of the foundation moment is highlighted.

The nation as presented in the gallery is no longer only defined by the "myth of the military-nation", but also by the values of the new conservative, as well as economically potent middle class: "The new Turkish society won't be a nation of warriors. The new Turkish society will be a nation of economic activities".[49] And: "Economy is everything. Economy means all one needs to live, to be happy, to be civilized".[50]

The question of friend and foe is not addressed in the arrangement. The territory inhabited by the nation is not clearly defined, but the characteristics of the nation are. The presentation in the Victory museum reflects the neo-conservative memory that also dominates Miniatürk Park and reveals a subtle shift in the narrative of the founding of the republic via highlighting a different group of actors, while silencing another.

STAGING AN ALTERNATIVE FOUNDING MOMENT: THE 1453 PANORAMA MUSEUM

Only two years later, in 2005, the Istanbul Metropolitan Municipality and Kültür A.Ş. initiated a new museum. It was the first actually built in a "panoramic" form: The 1453 Panorama Museum. It was opened in 2009 as the first museum dedicated exclusively to the Ottoman conquest of Constantinople in 1453. The museum

olmuştur." (Translation as in the exhibition.) The quote is one of the best-known Atatürk quotes regarding religion. It dates to the period of the Liberation War period of 1919–1923 and to a context, in which the fight against occupation was rhetorically functionalized as a fight against the infidel occupiers. See Zürcher, Turkish Perception of Europe.

48 | Until the 1990s this image had not been in the canon of official Atatürk portraits, i.e. it did not appear in text books, documentaries on Atatürk on television or in mainstream print media. Since the 1990s, it has been used in Islamist publications on Republic's Day to highlight religious aspects of the founding of the Republic. Özyürek: Public Memory as Political Battleground, p. 115.

49 | The English translation here reads "nation", although the Turkish original uses "devlet", meaning "state" or "land": "Yeni Türk Devleti savaşçı bir devlet olmayacaktır. Fakat yeni Türk Devleti, ekonomi devleti olacaktır."

50 | "Arkadaşlar ekonomi demek her şey demektir. Yaşamak için, medeni insan olmak için ne lazımsa onların hepsi demektir. (Translation as in the exhibition.)

is located in a rotunda at the historic site where the Ottoman troops stormed the city walls and is thus close to Istanbul's historic old town and the conservative Fatih neighborhood.

It consists of two sections: First, a hallway exhibiting boards that recount the story of Istanbul and the conquest. The second part is made up of a hemisphere panorama of the conquest of Byzantine Constantinople by the Ottoman Sultan Mehmed II. in 1453. The panorama depicts the morning of the conquest. Visitors are positioned between the attacking army and the city walls, thus sharing in the glorious moment of conquest.

Originally scheduled for 2008, the 555th anniversary of the conquest, the museum obviously claimed national significance. According to President Abdullah Gül, the museum should serve "as a remembrance by all individuals of our great nation of the glorious days of our honorable history and the development of a historical consciousness [...]".[51] Nevzat Bayhan, the Director of Kültür A.Ş. and the museum, declared in an interview: "People had been waiting a long time for the panorama museum. Until today there was no museum dedicated to the conquest of Istanbul, which meant a big void for the city [...] For years the conquest of Istanbul has been celebrated with ship models that parade through the metropolis. One should definitely have the opportunity to feel the spirit of the conquest."[52]

Bayhan is referring to the annual celebrations including re-enactments, which have been taking place since the mid-1990s, when Islamist political organization appropriated the event. This appropriation has been interpreted as a shift of the national founding moment to the Ottoman period.[53] As in the other museums, no historian was involved in the planning of the museum.[54]

Before entering the panorama, visitors are led through a hallway that extends over two floors. It exhibits boards that offer a roughly linear narrative of the conquest, but highlight thematic aspects. Istanbul is framed as a historical capital of several empires. Its conquest was foretold by the prophet Mohammed and the quote is highlighted on one of the boards.

51 | President Abdullah Gül's entry in the museum's visitor book on 15 March 2009. Accessible via http://www.panoramikmuze.com/visitors.php (last access 6 March 2012). (Translation by the author).

52 | Interview with Nevzat Bayhan in: http://www.zamanavusturya.at/details. php?haberid=1633 (last access 6 March 2012) (Translation by the author.)

53 | Alev Çınar (2001): »National History as a Contested Site. The Conquest of Istanbul and Islamist Negotiations of the Nation«, in: Comparative Studies in Society and History 43 (2), pp. 364–391.

54 | The team consisted of computer specialists under the direction of renowned animation director Haşim Vatandaş, İstanbul Büyükşehir Belediyesi/ Istanbul Metropolitan Municipality, Panorama 1453 Tarih Müzesi/ Panorama 1453 Historical Museum, Istanbul 2009, 137.

The narrative as presented in the exhibition reiterates national ideology. Like the "Great War", the conquest signifies the end of one empire and the birth of another. But the conquest as it is presented in the museum is also a surprisingly peaceful one. The museum provides a new, alternative hero. It is not difficult to recognize the parallels to the Kemalist narrative. Like Mustafa Kemal, the historical figure of Mehmed is heroized and stylized. He combines "national grandeur" and "revolutionary fervour".[55] He dares the seemingly impossible. At the same time, and in contrast to Kemal, he shows respect towards the elders and the religious dignitaries at court. Mehmed II. is not only presented as a successful leader, but also as a foundation hero of a new civilization: Instead of destroying the city, Mehmed finances reconstruction works.

Hamit Bozarslan has called attention to the generosity of the Ottomans towards conquered peoples and Christian minorities as a part of the national narrative.[56] In the exhibition, not only does the young sultan spare the city's inhabitants, but he also appears as the bringer of liberty for suppressed minorities[57] by founding a new civilization in which, under the umbrella of Islam, all minorities can live together peacefully.

Regarding the relations to the West the Ottoman victory is presented as a result of the technological advance of the Ottomans that served as a role model for Europe. The presentation of Turkish tolerance and the support of art and culture by the Sultan as decisive factors and the origins of European Renaissance are also in line with the traditional nationalist narrative.

CONCLUSION

The Turkish military and government were leading agents in the institutionalization of the Ataturk and Independence War Museum. Against the backdrop of the perceived threat of political Islam, the adjustments in view of a possible EU full membership and the challenge of new parties and interest groups, the foundational myth of the Republic was invoked in order to stabilize national identity, give reassurance and to emphasize these groups' political legitimization.

In its narrative mode, the museum reflects representational practices that are inextricably interwoven with public imaginaries of nation, modernity and development, but also how those representational practices respond to contemporary challenges of globalization, European integration, and new media.

55 | „nationale Größe" und „revolutionären Eifer", see Rudolf Speth (2000): Nation und Revolution. Politische Mythen im 19. Jahrhundert, Opladen, p. 122.

56 | H. Bozarslan: »Der Genozid an den Armeniern als Herausforderung«, p. 271.

57 | One board highlights Mehmed as the "Hope of Christians and Jews", who were encouraged by the free lives of their fellow-believers to move to the Ottoman Empire.

The projects of the Istanbul Metropolitan Municipality further develop the form of dioramic/panoramic presentation, probably due to the importance and the symbolic value of Anıtkabir. Both the Panorama Victory Museum and the 1453 Panorama can be framed as sites of contestation[58] between secular elites and local authorities that explain existing conditions in society and legitimize political positions and decisions. They exemplify how strategies of re-interpretation and adaptations of the nationalist founding myth and of the time and identity of the nation are inserted and negotiated in museum space. While the museum in Ankara visualizes the political myth of the "military-nation", the other two represent a conservative interpretation. Still, they reiterate national ideologies.

While they react to political and historiographical discourse, such as a new interest in the Ottoman past and criticism of the early Republican nationalist period, they do not include current debates in the exhibition. The war experience itself is trivialized by forms of miniaturization. The main aim of the museums and presentations is to activate and stage political myths which serve as a source of legitimation.[59]

This boom in panoramic museums, however, is still going on: The installation and design of these new museums has had an impact on existing "traditional" museums and exhibitions. In 2007, the Harbiye Askeri Müzesi installed a new "Hall of the Conquest" (Fatih Salonu) including a diorama in cooperation with a team of artists, who were already involved in the work at Anıtkabir. The Naval Museum (Deniz Müzesi) added a panorama of Istanbul painted by Henry Aston Barker in 1801 to its existing "Fatih Salonu". All this confirms that the panorama now acts as a "code" for the museum representation of the conquest.

New projects like the Gallipoli Panoramic Museum or the Victory Museum at Polatlı near Ankara, where battles of the Independence War took place, are also under construction. The opening of a panorama museum at Gallipoli is scheduled for 2015.

58 | Ivan Karp (1992) (ed.): Museums and Communities: The Politics of Public Culture, Washington (et al.).

59 | R. Speth: Nation und Revolution, p. 142.

Contributors

Alexandra Bounia is an associate professor of museology at the University of the Aegean, Greece, Department of Cultural Technology and Communication. She studied archaeology and the history of art at the University of Athens and museum studies at the University of Leicester, UK. Her research interests are on the history, theory and management of collections and museums, the interpretation of material culture, and the use of audiovisual technologies as interpretive media. She has published in Greek and international journals and participates in research projects in Greece and abroad.

Robert M. Ehrenreich is Director of University Programs at the United States Holocaust Memorial Museum. University Programs promotes teaching and scholarship about the Holocaust nationally and internationally through a range of programs including faculty seminars, research workshops, and campus lectures. Prior to joining the Museum, Dr. Ehrenreich was a postdoctoral fellow at the Smithsonian Institution; a research associate at the University of Illinois, Urbana; a senior staff scientist at The National Academies; and an associate research professor at George Washington University. He is the author or editor of four books, an international journal, and over 30 articles and reviews on the Holocaust, Holocaust studies, and European history and prehistory. His most recent volume, edited with R. Clifton Spargo, is entitled *After Representation? The Holocaust, Literature, and Culture* (2009). Dr. Ehrenreich was awarded an A.B. from Harvard University and a D.Phil. from Oxford University.

Christine van Everbroeck, PhD in History, first taught at the Royal School for Cadets (military high school) before creating, now twenty years ago, the educational service at the Royal Military Museum.

Werner Fenz, born 1944, art historian. From 1969 on curator and between 1993 and 1997 head of the Neue Galerie Graz. Between 2003 and 2009 director of the Künstlerhaus Graz and the Institute for Art in Public Space Styria (2006 – 2011). Numerous projects in the public space and texts on contemporary art. Professor of Contemporary Art History at Graz University.

Piet De Gryse studied History at the Universities of Antwerp and Ghent and has been working at the Royal Military Museum in Brussels since 1982. In 1987 he became keeper of the arms and armor collection. He was appointed curator and became a member of the museum management team in 1991. He has published widely in the field of arms history and was chief editor of the Museum Journal, Militaria Belgica, from 1985 until 1996. Since 2010 he is chairman of ICOMAM, the International Committee of Museums and Collections of Arms and Military history, an international committee of ICOM.

Barton C. Hacker Ph.D. (University of Chicago, 1968), is curator of armed forces history in the Smithsonian Institution's National Museum of American History, Washington DC, and convener of the annual symposium on the social history of military technology as part of International Congress of the History of Technology. He has published widely on the history of military technology, the history of non-Western military institutions, and women's military history.

Susanne Hagemann MA, studied German Literature, Sociology and Media Studies in Göttingen and Berlin. She has worked for different institutions like the Deutsches Historisches Museum, Militärhistorisches Museum der Bundeswehr, Stiftung „Erinnerung, Verantwortung und Zukunft" amongst others and was a lecturer at the University of Konstanz in 2005. Her research focuses on the representation of the years 1933–45 in German historical museums. In 2008/2009 she managed an exhibition about „Identity" with young students from Berlin and Bucharest. At present she lives and works in Berlin.

Kristiane Janeke PhD, historian and slavicist, studied in Germany in Bonn and Berlin (Free University) and in Moscow, Russian Federation. Curating and exhibition management at various museums, i.e. the German Historical Museum and the Bundeswehr Museum of Military History, director of the German-Russian Museum in Berlin-Karlshorst, since 2008 freelance museum consultant and curator, main focus Russia / Belarus. Currently living in Minsk / Belarus where she is a consultant for the Museum of the Great Patriotic War (in cooperation with the Goethe-Institute), www.tradicia.de

Patrizia Kern MMag.phil., graduated in History at the University of Innsbruck with a focus on Media Studies. She holds an additional major in Ancient History from the same university. As a research and teaching assistant in the Department of Contemporary History at the University of Heidelberg from 2008–2009, her focus was on the history of the Turkish Republic. Since 2009 she is a member of the Graduate Program for Transcultural Studies within the "Asia and Europe in a Global Context" cluster at the University of Heidelberg, where she is pursuing a dissertation project on "Museums and memory politics in contemporary Turkey".

Jane Klinger earned her Masters of Fine Arts in Conservation in Florence, Italy, at the Villa Schifanoia, Rosary College Graduate School of Fine Arts. After graduating, she worked on international projects in Belgium, Italy, and Israel. She has held positions at Winterthur Museum, the Smithsonian's National Portrait Gallery, and the National Archives. Ms. Klinger is currently the Chief Conservator for the United States Holocaust Memorial Museum and is responsible for the conservation and preservation management of the Museum collections and the holdings of the USHMM Archives and Library. Ms. Klinger has also worked in Belgium and Israel, has taught basic paper conservation techniques in Brazil and Bolivia, has served as part of the teaching staff of the Society of American Archivists Preservation Management Training Program, and has presented papers to various professional groups in the United States and abroad. Ms. Klinger is a Fellow of the American Institute for Conservation and served on its board for a number of years. She serves as Vice President of the Washington Conservation Guild. Ms Klinger is currently pursuing a Doctorate with a focus on the preservation of the material culture of trauma at the University of Delaware.

Wolfgang Muchitsch first worked for the Universalmuseum Joanneum as a student during his vacations. He studied History and English in Graz and Oxford. After graduation, he worked as a university lecturer and project leader in Britain, Northern Ireland and Austria. From 1992 to 1995 he worked for the Department for Planning and Organisation Development of the University of Graz and from 1995 onwards he was responsible for art management in the Office of the First Deputy Governor of Styria. He has been the scientific manager of the Landesmuseum Joanneum GmbH since January 2003.

Carol Nater Cartier studied General History and German Literature at the University of Zurich from 2000 to 2004 and completed her Ph.D. under Prof. Volker Reinhardt at the University of Fribourg (CH) in 2009 on the subject of the Sphere of Influence of Nobelwomen at the Papal Curia during the 17th century. She completed a Certificate of Advanced Studies (CAS) in Museum Practice at the University of Applied Sciences in Chur and worked from 2005–2007 at the Historisches Museum Baden, including serving as project head of a special exhibition. She is currently the director of the Museum Altes Zeughaus in Solothurn.

Christian Ortner studied History with focus on military history. During his studies internships in the Austrian States Archives and in the Museum of Military History, Vienna (A). Since 1995 he has been working for the Museum of Military History, Vienna (A), first as curator for Militärtechnik, since 2004 as the interim director and since 2007 the director of the museum. Board Member of Museumsbund Österreichs (MÖ), Österreichische Gesellschaft für Heereskunde,

ICOMAM President of Österreichische Gesellschaft für Ordenskunde (ÖGO), Vice President of Österreichische Gesellschaft für Kulturgüterschutz, Lecturer at the University of Vienna, President of Dolomitenfreunde – Friedenswege. Museum des Gebirgskriegs 1915–1918 in Kötschach-Mauthen.

Gorch Pieken studied history, art history, and Dutch philology in Cologne. From 1995 to 2005 he was curator und head of the multimedia department in the German Historical Museum, Berlin. In that time, he also worked as author and producer of several documentary films for German and French television. Since 2006 Gorch Pieken is project director of the new permanent exhibition in the Bundeswehr Museum of Military History, Dresden. In 2010 he became Academic Director and Director of Exhibitions, Collections and Research at the Museum of Military History.

Sandrine Place, Master in Art History and Archeology, started working for the Royal Military Museum educational service in 2004.

Ralf Raths MA, was born in Goslar, Germany in 1977. He studied History and Political Science at the Leibniz University of Hannover and has been teaching Military History there as a Visiting Lecturer since his graduation in 2005. From 2005 to 2008 he worked at the University of Hannover. This included among other things the development of an e-learning internet portal for history students. The connection between history and new media is still one of his interests. Since 2008 he has been the Scientific Director of the German Tank Museum Munster.

Per Björn Rekdal was born in Aalesund, Norway in 1945. He wrote his thesis in Social Anthropology, University of Oslo, 1972 on the production and marketing of tourist objects at the Victoria Falls in Zambia, and has since then enjoyed operating in the margins between art and anthropology. He has worked at the Norwegian National Museum of Contemporary Art as well as the Ethnographic (Völkerkunde) Museum of the University of Oslo, where he was director. Another of his main interests is museums and the challenge of cultural diversity. He has devoted many years to the work of ICOM, as chair of ICOM Norway, chair of ICME (the International Committee for Museums of Ethnography/ethnology/anthropology/ etc), member of ICOM's Executive Council 2004-2010, and is now chairing a work group within ICME called "The Challenging Museum/Challenging the Museum". His current job is among other tasks to plan the exhibitions of a new museum building for the Museum of Cultural History, University of Oslo, a building that keeps being delayed ...

Theopisti Stylianou-Lambert is an assistant professor at the Cyprus University of Technology. She earned her PhD in Museum Studies from the University of Leicester and her MA in Visual Arts/Museum Education from the University of Texas at Austin. She received several awards and scholarships such as an Arts and Humanities Research Council Award (UK), an A. G. Leventis Foundation Scholarship (France), a M. K. Hage Endowed Scholarship in Fine Arts (USA) and a Fulbright Scholarship (USA). Her research interests include museum and visitor studies with an emphasis on issues of cultural consumption, as well as photography and visual sociology.

Sandra Verhulst has a background in classical archaeology and art history. She now works as an Education Officer at the Royal Military Museum (Brussels).

Margaret Vining holds an M.A. in museum studies and American studies (George Washington University, 1983). As curator of armed forces history at the National Museum of American History, she has organized numerous exhibitions and founded the Archive of Women's Military History. Her published works include A Companion to Women's Military History (Leiden: Brill 2012) and American Military Technology: A History (Baltimore: Johns Hopkins 2007), both co- authored with Barton C. Hacker; she has also contributed to many journals and books. Her current research centers on the impact of World War I on educational priorities at the University of Chicago.

Jay Winter, Charles J. Stille Professor of History, joined the Yale faculty in 2001. He received his B.A. from Columbia and his PhD from Cambridge. From 1979 to 2001, he was University Lecturer and then Reader in Modern History and Fellow of Pembroke College, Cambridge. He holds the DLitt degrees from Cambridge and an honorary doctorate from the University of Graz. He is the author of Sites of Memory, Sites of Mourning: The Great War in European Cultural History (Cambridge University Press, 1995); Remembering War (Yale University Press, 2006) and Dreams of Peace and Freedom (Yale University Press, 2006). In 1997, he received an Emmy award for the best documentary series of the year as co-producer and co-writer of 'The Great War and the shaping of the twentieth century', an eight-hour series broadcast on PBS and the BBC, and shown subsequently in 28 countries. He is one of the founders of the Historial de la grande guerre, the international museum of the Great War, in Péronne, Somme, France. His biography René Cassin et les droits de l'homme, co-authored with Antoine Prost, was published by Fayard in February 2011. The English version will appear in 2013. He is editor-in-chief of the three-volume Cambridge History of the First World War, to be published in 2014.